IMPRESSIONISTS

This is a Parragon Publishing Book This edition published in 2004

Parragon Publishing Queen Street House 4 Queen Street Bath BA1 1HE, UK

Copyright © Parragon 2000

ISBN: 1-40542-982-8

All rights reserved. No part of this publication may be reproduced, stored in a retrieval system, or transmitted in any form or by any means, without the prior written permission of the copyright holder.

The right of Antonia Cunningham to be identified as the author of this work have been asserted in accordance with Section 77 of the Copyright, Designs and Patents Act of 1988.

The right of Karen Hurrell to be identified as the author of the introduction to this book has been asserted in accordance with Section 77 of the Copyright, Designs and Patents Act of 1988.

Printed and bound in China

IMPRESSIONISTS

ANTONIA CUNNINGHAM

Introduction by Karen Hurrell

CONTENTS

Introduction		6
Eugène Boudin The Beach at Trouvi	lle	16
ÉDOUARD MANET		4.0
Fruit: Grapes, Peach	es and Almonds	18
The Lunch on the C	irass	20
Portrait of Emile Zo	la	24
Lunch in the Studio		26
The Balcony		28
The Port of Boulogr	ne in Moonlight	32
Argenteuil		34
The Grand Canal V	enice	36
The Bellevue Garde	n	38
Blonde Woman with	Bare Breasts	40
At Père Lathouille's,	Outside	44
Rose and Tulin	1at (Portrait of a Viennese, Iffia Diumer)	46
reose and runp		
Frédéric Bazille		
Family Reunion		48
Bazille's Studio		50
CLAUDE MONET		
Women in the Gard	en	52
Impression: Suprise		54
Poppy Field at Arge	nteuil	56
and the same of	The Bridge at Argenteuil	60
	Still Life with Fruit	62
And the second	River Bend	64
	Poplars, or the Four Trees	66
C. Telefort	Rouen Cathedral, The Portal,	60
	Morning Sun, Blue Harmony White Water Lilies	70
de to the	Water Lilies	72
	The Garden at Giverny	74
	Irises by a Pond	76
The second second	London, Parliament	78
	Water Lilies	82
	water Lines	
	ALFRED SISLEY	
	View of the St Martin	
	Canal, Paris	84
	Misty Morning	88
	Autumn: Banks of the Seine near Bougival	90
	Villeneuve-la-Garenne	92
	Road at the Forest Fringe of Fontainebleau	94
THE 23.	CAMBLE DISCAPRO	
The same	CAMILLE PISSARRO Pissarro, Self-Portrait	96
	Chestnut Trees at Louveciennes	98
Commit	Hoar Frost	100
	A Path Through the Fields (Pontoise)	102
	The Cabbage Garden near Pontoise	104
(Consentante)	Red Roofs, Corner of a Village	108
Bank of the River C	Dise	110
Double Portrait of (Gauguin (left) and Pissarro (right)	112
Woman Hanging of	it the Washing	114
Woman in an Orcha	ard (Spring Sunshine on the Field at Éragny)	116
Place du Théâtre Er	r: Church and Farm at Éragnyançais	120
Duquesne Basin Di	ançaiseppe	122
_ = = = = = = = = = = = = = = = = = = =	11	
PIERRE-AUGUSTE		
Lise with Sunshade		124
Mademoiselle Sine		126
Mme Alphonse Da	udet	130
Moulin de la Galett	e	132
Nude in Sunlight		134

C O N T E N T S

Path Climbing Up Through the Tall Grass	6
Madame Georges Charpentier	8
Dance in the Country	
Little Irene	2
Peaches	
Young Girls at the Piano	
Claude Renoir (Coco)	8
The Bathers	2
17.	
Armand Guillaumin	
Sunset at Ivry	4
The Seine at Rouen	6
EDGAR DEGAS	
The Bellelli Family	CONTRACTOR OF THE PERSON OF TH
Young Spartan Girls Provoking the Boys	
At the Races, in Front of the Stands	
The Orchestra at the Opera 16	
Ballet Rehearsal on the Stage	5
The Dance Class	2
In the Café (Absinthe)	
The Racecourse	2
Dinner at the Ball	174
Green Dancers	
Women Ironing	180
Woman in a Tub.	182
The Tub	184
Blue Dancers	186
Blue Dancers	188
Dancer: Opening with the Right Leg	190
GUSTAVE CAILLEBOTTE	
Pont de L'Europe	192
Street in Paris in the Rain	194
Bathers	196
BERTHE MORISOT	100
The Lilacs at Maurecourt	198
The Lilacs at Maurecourt In the Cornfield at Gennevilliers.	200
The Lilacs at Maurecourt In the Cornfield at Gennevilliers Young Girl at the Ball	200
The Lilacs at Maurecourt In the Cornfield at Gennevilliers Young Girl at the Ball Young Woman Powdering Herself Young Woman in a Ball Gown	200 202 204 206
The Lilacs at Maurecourt In the Cornfield at Gennevilliers Young Girl at the Ball	200 202 204 206
The Lilacs at Maurecourt In the Cornfield at Gennevilliers Young Girl at the Ball Young Woman Powdering Herself Young Woman in a Ball Gown Bildnis, A Young Lady.	200 202 204 206
The Lilacs at Maurecourt In the Cornfield at Gennevilliers Young Girl at the Ball Young Woman Powdering Herself Young Woman in a Ball Gown Bildnis, A Young Lady. MARY CASSATT	200 202 204 206 208
The Lilacs at Maurecourt In the Cornfield at Gennevilliers Young Girl at the Ball Young Woman Powdering Herself Young Woman in a Ball Gown Bildnis, A Young Lady. MARY CASSATT Profile Portrait of Lydia Cassatt, the Painter's Sister	200 202 204 206 208
The Lilacs at Maurecourt In the Cornfield at Gennevilliers Young Girl at the Ball Young Woman Powdering Herself Young Woman in a Ball Gown Bildnis, A Young Lady. MARY CASSATT Profile Portrait of Lydia Cassatt, the Painter's Sister Girl in the Garden.	200 202 204 206 208
The Lilacs at Maurecourt In the Cornfield at Gennevilliers Young Girl at the Ball Young Woman Powdering Herself Young Woman in a Ball Gown Bildnis, A Young Lady. MARY CASSATT Profile Portrait of Lydia Cassatt, the Painter's Sister Girl in the Garden Young Mother Sewing.	200 202 204 206 208
The Lilacs at Maurecourt In the Cornfield at Gennevilliers Young Girl at the Ball Young Woman Powdering Herself Young Woman in a Ball Gown Bildnis, A Young Lady. MARY CASSATT Profile Portrait of Lydia Cassatt, the Painter's Sister Girl in the Garden.	200 202 204 206 210 212 214 216
The Lilacs at Maurecourt In the Cornfield at Gennevilliers Young Girl at the Ball Young Woman Powdering Herself. Young Woman in a Ball Gown Bildnis, A Young Lady. MARY CASSATT Profile Portrait of Lydia Cassatt, the Painter's Sister Girl in the Garden. Young Mother Sewing. A Mother Holding her Child in her Arms Bathing.	200 202 204 206 210 212 214 216
The Lilacs at Maurecourt In the Cornfield at Gennevilliers Young Girl at the Ball Young Woman Powdering Herself Young Woman in a Ball Gown Bildnis, A Young Lady. MARY CASSATT Profile Portrait of Lydia Cassatt, the Painter's Sister Girl in the Garden. Young Mother Sewing A Mother Holding her Child in her Arms Bathing.	
The Lilacs at Maurecourt In the Cornfield at Gennevilliers Young Girl at the Ball Young Woman Powdering Herself. Young Woman in a Ball Gown Bildnis, A Young Lady. MARY CASSATT Profile Portrait of Lydia Cassatt, the Painter's Sister Girl in the Garden. Young Mother Sewing A Mother Holding her Child in her Arms Bathing PAUL CÉZANNE Still Life with Teapot.	
The Lilacs at Maurecourt In the Cornfield at Gennevilliers Young Girl at the Ball Young Woman Powdering Herself. Young Woman in a Ball Gown Bildnis, A Young Lady. MARY CASSATT Profile Portrait of Lydia Cassatt, the Painter's Sister Girl in the Garden. Young Mother Sewing A Mother Holding her Child in her Arms Bathing. PAUL CÉZANNE Still Life with Teapot. The House of Dr Gachet at Auvers	
The Lilacs at Maurecourt In the Cornfield at Gennevilliers Young Girl at the Ball Young Woman Powdering Herself. Young Woman in a Ball Gown Bildnis, A Young Lady. MARY CASSATT Profile Portrait of Lydia Cassatt, the Painter's Sister Girl in the Garden. Young Mother Sewing. A Mother Holding her Child in her Arms Bathing. PAUL CÉZANNE Still Life with Teapot The House of Dr Gachet at Auvers L'Estaque	
The Lilacs at Maurecourt In the Cornfield at Gennevilliers Young Girl at the Ball Young Woman Powdering Herself Young Woman in a Ball Gown Bildnis, A Young Lady. MARY CASSATT Profile Portrait of Lydia Cassatt, the Painter's Sister Girl in the Garden. Young Mother Sewing. A Mother Holding her Child in her Arms Bathing. PAUL CÉZANNE Still Life with Teapot The House of Dr Gachet at Auvers L'Estaque Mont Sainte-Victoire.	
The Lilacs at Maurecourt In the Cornfield at Gennevilliers Young Girl at the Ball Young Woman Powdering Herself. Young Woman in a Ball Gown Bildnis, A Young Lady. MARY CASSATT Profile Portrait of Lydia Cassatt, the Painter's Sister Girl in the Garden. Young Mother Sewing. A Mother Holding her Child in her Arms Bathing. PAUL CÉZANNE Still Life with Teapot The House of Dr Gachet at Auvers L'Estaque	
The Lilacs at Maurecourt In the Cornfield at Gennevilliers Young Girl at the Ball Young Woman Powdering Herself. Young Woman in a Ball Gown Bildnis, A Young Lady. MARY CASSATT Profile Portrait of Lydia Cassatt, the Painter's Sister Girl in the Garden. Young Mother Sewing. A Mother Holding her Child in her Arms Bathing. PAUL CÉZANNE Still Life with Teapot The House of Dr Gachet at Auvers L'Estaque Mont Sainte-Victoire Trees and Houses The Smoker. Apples and Biscuits	
The Lilacs at Maurecourt In the Cornfield at Gennevilliers Young Girl at the Ball Young Woman Powdering Herself. Young Woman in a Ball Gown Bildnis, A Young Lady. MARY CASSATT Profile Portrait of Lydia Cassatt, the Painter's Sister Girl in the Garden. Young Mother Sewing. A Mother Holding her Child in her Arms Bathing. PAUL CÉZANNE Still Life with Teapot The House of Dr Gachet at Auvers L'Estaque Mont Sainte-Victoire Trees and Houses The Smoker. Apples and Biscuits. The Card Players.	
The Lilacs at Maurecourt In the Cornfield at Gennevilliers Young Girl at the Ball Young Woman Powdering Herself. Young Woman in a Ball Gown Bildnis, A Young Lady. MARY CASSATT Profile Portrait of Lydia Cassatt, the Painter's Sister Girl in the Garden. Young Mother Sewing. A Mother Holding her Child in her Arms Bathing. PAUL CÉZANNE Still Life with Teapot The House of Dr Gachet at Auvers L'Estaque Mont Sainte-Victoire Trees and Houses The Smoker Asples and Biscuits. The Card Players Plaster Cupid	
The Lilacs at Maurecourt In the Cornfield at Gennevilliers Young Girl at the Ball Young Woman Powdering Herself. Young Woman in a Ball Gown Bildnis, A Young Lady. MARY CASSATT Profile Portrait of Lydia Cassatt, the Painter's Sister Girl in the Garden. Young Mother Sewing. A Mother Holding her Child in her Arms Bathing. PAUL CÉZANNE Still Life with Teapot. The House of Dr Gachet at Auvers L'Estaque. Mont Sainte-Victoire. Trees and Houses The Smoker. Apples and Biscuits. The Card Players. Plaster Cupid. Bridge Over the Pond.	
The Lilacs at Maurecourt In the Cornfield at Gennevilliers Young Girl at the Ball Young Woman Powdering Herself. Young Woman now Ball Gown Bildnis, A Young Lady. MARY CASSATT Profile Portrait of Lydia Cassatt, the Painter's Sister Girl in the Garden. Young Mother Sewing. A Mother Holding her Child in her Arms. Bathing. PAUL CÉZANNE Still Life with Teapot. The House of Dr Gachet at Auvers L'Estaque. Mont Sainte-Victoire Trees and Houses The Smoker. Apples and Biscuits. The Card Players. Plaster Cupid. Bridge Over the Pond. The Quarry of Bibémus.	
The Lilacs at Maurecourt In the Cornfield at Gennevilliers Young Girl at the Ball Young Woman Powdering Herself. Young Woman in a Ball Gown Bildnis, A Young Lady. MARY CASSATT Profile Portrait of Lydia Cassatt, the Painter's Sister Girl in the Garden. Young Mother Sewing. A Mother Holding her Child in her Arms Bathing. PAUL CÉZANNE Still Life with Teapot The House of Dr Gachet at Auvers L'Estaque Mont Sainte-Victoire Trees and Houses The Smoker. Apples and Biscuits. The Card Players. Plaster Cupid Bridge Over the Pond The Quarry of Bibémus. Apples and Oranges	
The Lilacs at Maurecourt In the Cornfield at Gennevilliers Young Girl at the Ball Young Woman Powdering Herself. Young Woman in a Ball Gown Bildnis, A Young Lady. MARY CASSATT Profile Portrait of Lydia Cassatt, the Painter's Sister Girl in the Garden. Young Mother Sewing. A Mother Holding her Child in her Arms Bathing. PAUL CÉZANNE Still Life with Teapot The House of Dr Gachet at Auvers L'Estaque Mont Sainte-Victoire Trees and Houses The Smoker Apples and Biscuits. The Card Players Plaster Cupid Bridge Over the Pond The Quarry of Bibémus Apples and Oranges Still Life with Curtain and Flowered Jug.	
The Lilacs at Maurecourt In the Cornfield at Gennevilliers Young Girl at the Ball Young Woman Powdering Herself. Young Woman in a Ball Gown Bildnis, A Young Lady. MARY CASSATT Profile Portrait of Lydia Cassatt, the Painter's Sister Girl in the Garden. Young Mother Sewing. A Mother Holding her Child in her Arms Bathing. PAUL CÉZANNE Still Life with Teapot The House of Dr Gachet at Auvers L'Estaque Mont Sainte-Victoire Trees and Houses The Smoker. Apples and Biscuits. The Card Players. Plaster Cupid Bridge Over the Pond The Quarry of Bibémus. Apples and Oranges	
The Lilacs at Maurecourt In the Cornfield at Gennevilliers Young Girl at the Ball Young Woman Powdering Herself. Young Woman in a Ball Gown Bildnis, A Young Lady. MARY CASSATT Profile Portrait of Lydia Cassatt, the Painter's Sister Girl in the Garden. Young Mother Sewing. A Mother Holding her Child in her Arms Bathing. PAUL CÉZANNE Still Life with Teapot The House of Dr Gachet at Auvers L'Estaque Mont Sainte-Victoire Trees and Houses The Smoker. Apples and Biscuits. The Card Players Plaster Cupid Bridge Over the Pond The Quarry of Bibémus Apples and Oranges Still Life with Curtain and Flowered Jug. Seated Peasant	
The Lilacs at Maurecourt In the Cornfield at Gennevilliers Young Girl at the Ball Young Woman Powdering Herself. Young Woman in a Ball Gown Bildnis, A Young Lady. MARY CASSATT Profile Portrait of Lydia Cassatt, the Painter's Sister Girl in the Garden. Young Mother Sewing. A Mother Holding her Child in her Arms Bathing. PAUL CÉZANNE Still Life with Teapot The House of Dr Gachet at Auvers L'Estaque Mont Sainte-Victoire Trees and Houses The Smoker. Apples and Biscuits. The Card Players. Plaster Cupid Bridge Over the Pond The Quarry of Bibémus Apples and Oranges Still Life with Curtain and Flowered Jug Seated Peasant Mont Sainte-Victoire Bathers.	
The Lilacs at Maurecourt In the Cornfield at Gennevilliers Young Girl at the Ball Young Woman Powdering Herself Young Woman in a Ball Gown Bildnis, A Young Lady MARY CASSATT Profile Portrait of Lydia Cassatt, the Painter's Sister Girl in the Garden. Young Mother Sewing. A Mother Holding her Child in her Arms Bathing. PAUL CÉZANNE Still Life with Teapot The House of Dr Gachet at Auvers L'Estaque Mont Sainte-Victoire Trees and Houses The Smoker. Apples and Biscuits. The Card Players. Plaster Cupid. Bridge Over the Pond. The Quarry of Bibémus Apples and Oranges Still Life with Cutain and Flowered Jug. Seated Peasant Mont Sainte-Victoire Bathers. GEORGES SEURAT	
The Lilacs at Maurecourt In the Cornfield at Gennevilliers Young Girl at the Ball Young Woman Powdering Herself Young Woman in a Ball Gown Bildnis, A Young Lady MARY CASSATT Profile Portrait of Lydia Cassatt, the Painter's Sister Girl in the Garden Young Mother Sewing A Mother Holding her Child in her Arms Bathing PAUL CÉZANNE Still Life with Teapot The House of Dr Gachet at Auvers L'Estaque Mont Sainte-Victoire Trees and Houses The Smoker Apples and Biscuits. The Card Players Plaster Cupid Bridge Over the Pond The Quarry of Bibémus Apples and Oranges Still Life with Curtain and Flowered Jug Seated Peasant Mont Sainte-Victoire Bathers. GEORGES SEURAT Bathing at Asnières	
The Lilacs at Maurecourt In the Cornfield at Gennevilliers Young Girl at the Ball Young Woman Powdering Herself Young Woman in a Ball Gown Bildnis, A Young Lady MARY CASSATT Profile Portrait of Lydia Cassatt, the Painter's Sister Girl in the Garden. Young Mother Sewing. A Mother Holding her Child in her Arms Bathing. PAUL CÉZANNE Still Life with Teapot The House of Dr Gachet at Auvers L'Estaque Mont Sainte-Victoire Trees and Houses The Smoker. Apples and Biscuits. The Card Players. Plaster Cupid. Bridge Over the Pond. The Quarry of Bibémus Apples and Oranges Still Life with Cutain and Flowered Jug. Seated Peasant Mont Sainte-Victoire Bathers. GEORGES SEURAT	

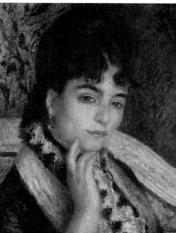

Introduction

HE Impressionists filled the hallowed halls of the French art establishment with light. As a group, they were critically derided, professionally shunned, and considered to be the most outrageous and untalented artists of the nineteenth century. But they were revolutionary, changing the course of art for ever. Today, less than 150 years later, the paintings of the Impressionists are some of the best-known and most loved works in the entire history of art.

Paris was in the throes of the *belle époque* when 19-year-old Claude Monet (1840–1926) arrived from Le Havre in 1859. The economic recession that had been a catalyst for the 1848 revolution was over by 1851, and Napoleon Bonaparte instigated a refurbishment of the city to reflect the prosperity and splendor of the times. Life in Paris changed dramatically, and its streets became a mecca for bright young things, who brought a sense of euphoria into a new café society. In such a climate of change, Impressionism should have flourished, but the French people, and the art establishment in particular, were reluctant to embrace its vivacity and refreshing approach to art.

Paintings were expected to be refined and conservative, calling upon Classical traditions and vested with moral rectitude. Art during this time was considered to be a reflection of the spiritual health of the nation. In a time when France was just pulling itself from the depths of spiritual and economic depression, it became all the more important

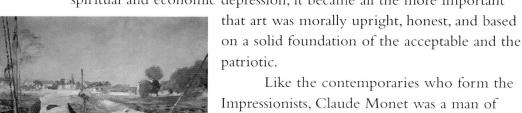

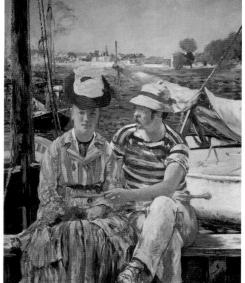

Impressionists, Claude Monet was a man of vision. When he was 18 he met Eugène Boudin (1824–98), and this was reputedly the determining factor in his decision to become a painter. Boudin was a landscape painter, and he painted out-of-doors, documenting with precision and originality the movement of water, air, clouds, trees. He was extraordinarily influential in Monet's life, and he is accorded the honor of being the Impressionists' first real

inspiration.

The academic tradition was strong in the French art world.
Success was defined by acceptance at the Paris Salon, a biennial exhibition, as was a good education at a

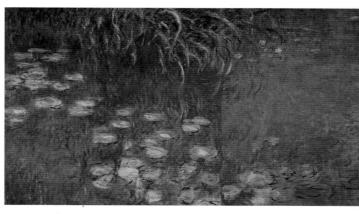

reputable institution such as the Académie des Beaux-Arts, which also controlled and organized the Salon. The Beaux-Arts was dominated by the great Neo-Classical painter Jean-Auguste-Dominique Ingres (1780–1867), who insisted that everyone must follow his style, with a strong emphasis on formal organization and traditional draftsmanship, copying the Old Masters, and drawing with a clear, defined line. Monet grudgingly attended the Académie Suisse, a small, private art school where he met Camille Pissarro (1830–1903), and then entered the studio of Charles Gleyre, a respected master who encouraged individuality. Pierre-Auguste Renoir (1841–1919), Alfred Sisley (1839–99), Frédéric Bazille (1841–70), and Monet were drawn to Gleyre's studio; the four became friends.

Édouard Manet (1832–83), the precursor of Impressionism, came from a prosperous Paris family and sought success in a conventional way, attaining Salon success in 1861 with *The Spanish Singer*. Pissarro also enrolled at the Beaux-Arts and studied there under landscapist Jean–Baptiste-Camille Corot (1796–1875). Edgar Degas (1834–1917), a close friend of Manet, enrolled at the Beaux-Arts in 1855.

In 1863 the Salon rejected so many submissions that the outcry led Napoleon III (1808–73) to create the Salon des Refusés, an alternative exhibition where work refused by the Salon could be hung. The exhibition was placed alongside the official show and met with a varied critical response. Manet stole the show with *The Lunch on the Grass* (1862–63), a summer picnic set in the woods, in which two businessmen are entertaining two nude women of questionable virtue. The painting caused such a stir that it brought him instant notoriety. He became the *enfant terrible* of the art world, a title that would remain with him for most his career.

In 1865 the Salon opened its doors to the budding Impressionists, showing Degas, Manet, Pissarro, Renoir, Berthe Morisot (1841–95) (who married Manet's brother), and even Monet, whose landscapes were favorably received. The next six Salon exhibitions

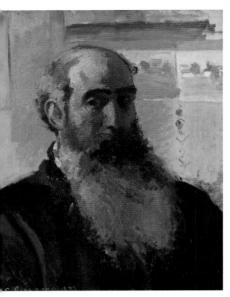

marked a period for the artists in which their work was alternatively acclaimed and then cast aside to be exhibited in the Salon des Refusés.

From 1866, Manet began to frequent the Café Guerbois. Many of the painters who came to be associated with Impressionism met here, such as Renoir, Sisley, Gustave Caillebotte (1848–94), and Monet, and they were known as the Batignolles group, since the café was situated in that region of Paris. Manet was the center of evening gatherings at the café, where animated

discussions on art and literature took place. He was friendly with controversial writers such as Émile Zola (1840–1902). Until his death in the Franco-Prussian War, Bazille attended the café almost daily, while Degas, Henri Fantin-Latour (1836–1904), Paul Cézanne (1839–1906), and Pissarro all made visits when they were in Paris. While never a political group, these young artists shared an ideology that was expounded in their regular meetings. When the Franco-Prussian War broke out in 1870, they dispersed. Their return, two years later, brought together a group hardened by their experiences during the war and more ambitious than ever.

Impressionism was a reaction against both the academic tradition and Romanticism, and its painters shared a common approach to the rendering of outdoor subjects. In historical terms, the word refers to the work of artists who participated in a series of group exhibitions in Paris, the first of which was held from April to May 1874 at the studio of the photographer Nadar. The artists represented at this, and succeeding exhibitions held by the group between 1876 and 1886, included Cézanne, Degas, Armand Guillaumin (1841–1927), Morisot, and, after 1879, Paul Gauguin (1848–1903) and the American artist Mary Cassatt (1845–1926).

The term Impressionism was derived from a painting by Claude Monet, *Impression: Sunrise* (1872), a view of the port of Le Havre in the mist, and was coined for the group by unfriendly critic Louis Leroy. The term was, however, quickly taken up by more sympathetic critics, who used it in an alternative sense to mean the impression stamped on the senses by a visual experience that is rapid and transitory. Monet, Renoir, Pissarro, and Sisley were Impressionists in the latter sense; beginning in the later 1860s and culminating in

1872–75, they chose to paint out-of-doors (en plein air), recording the changing conditions of light and atmosphere as well as their individual sensations before nature. They used high-key color palettes and a variety of brushstrokes, which allowed them to be responsive both to the character and texture of the object in nature and to the impact of light on its surfaces.

Degas was a new convert to the Impressionist dogma, vigorously defending the group's right to present their ideas to the public although not undertaking much of the technique himself. What drove Degas to support and help to organize the first Impressionist exhibitions was the implied challenge to establishment-led art. It was Degas who single-handedly convinced a large number of established artists to submit works to the first independent exhibition. Degas himself showed *Carriage at the Races* (1870–73).

Among paintings exhibited by Monet at the first exhibition were his version of *The Lunch on the Grass* (1865), which had been rejected for inclusion in the Salon exhibition of 1870 for being too subversive. He also included *Boulevard des Capucines* (1873), which was undertaken from the window of Nadar's studio and represents one of his most spectacular views of Paris. The critics labelled it crude and unfinished. Again, the critic Leroy had his say: "Are you telling me that that is what I look like when I stroll along the Boulevard des Capucines ... Are you kidding?"

Renoir submitted *Dancer*, which was appreciated by some critics, but Leroy again said that although the artist was deemed to have an appreciation of color, he lacked the ability to draw. He had

also chosen *La Loge* (1874), *The Parisienne, Harvesters*, and three other works to exhibit, and they were surprisingly well received, in contrast to the critical attention paid to some of his colleagues. Pissarro showed five works, including *Hoar Frost* (1873), which was considered by Leroy to have "neither head nor tail, top nor bottom, front nor back."

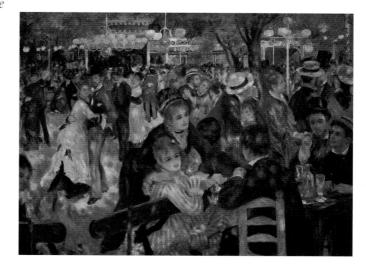

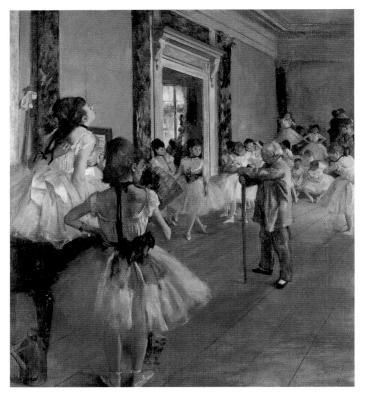

Cézanne was also represented with two paintings and Sisley supplied five. In general, the few good reviews that were received were written by journalists who were sympathetic to the aims and ideals of the painters; the remainder scorned the exhibition. The animosity of the critics was unanticipated. While the term Impressionism became accepted among most critics, there was a faction who called the group "The Intransigents," an expression which took its name from the radical political party that

had attempted to take over the constitutional monarchy in Spain. The Impressionists were seen by some as anarchic, threatening the very existence of the artistic tradition in France.

Many of the artists failed to sell anything at the first independent exhibition; these paintings were then auctioned the following year at disappointing prices. Another exhibition was not planned, but, in 1876, when the Salon once again rejected the their work, another show was launched in the gallery of Paul Durand-Ruel.

This exhibition was disastrous. The Impressionists had gained a reputation for being seditious, and many of the critics made no attempt to disguise their antagonism. This time Renoir was singled out for *Nude in the Sunlight*, painted in 1876. Critic Albert Wolff wrote: "Try to explain to M. Renoir that a woman's torso is not a mass of flesh in the process of decomposition with green and violet spots which denote the state of complete putrefaction of a corpse!"The painting was a precursor to the classic Renoir nudes, an elegant, sensual work embodying the Impressionist fascination with light.

Meanwhile Monet's technique had matured and he captured the natural world around him at his home on the Seine at Argenteuil with unrestrained enthusiasm. *The Basin at Argenteuil* and *Regatta at*

Argenteuil, both of which he painted in 1872, represent the decreasing emphasis on reality in his work; he sought more and more to capture the essence of a scene rather than to document it accurately. The result of this work was a stunning new vocabulary of painting, where every syllable and impression was represented with another dash of color; a flamboyant and confident expression of what Monet actually felt about a scene rather than saw.

Renoir's painting evolved to incorporate many of the elements that would eventually guarantee his success. At the Durand-Ruel exhibition he showed 15 paintings, and there had been some quiet interest from the public, despite the almost universal damning. In 1876 he rented a studio in the Rue Cortot in Montmartre, where he produced some of his most famous works, such as *Moulin de la Galette* (1876) and *The Swing*, which were painted simultaneously in the garden of his studio; The Swing in the mornings and *Moulin* in the afternoons. Both emphasize the fact of Renoir's grasp on Impressionism; the effect of light on his scenes is redolent with the charm that would make his work so accessible and popular. The subject-matter of both paintings was modern, a foray away from the staid Salon-type paintings that he was accustomed to painting.

Many of the Impressionists left Paris in search of the nature they longed to paint. Pissarro moved to Pontoise and then Éragny. Monet and Caillebotte found solace in their gardens at Giverny and Petit-Gennevilliers respectively. Renoir alone chose to remain in Paris, but he had found a stunning and overgrown sanctuary in his garden at Montmartre. The 1870s was a decade of growing success for him. His

studio at Montmartre was a hive of activity, becoming the central meeting place for many of his growing circle of acquaintances. He was one of the few artists in this circle to have achieved some financial success, and because he had not yet married and had no dependants, he had no responsibilities and was able to live on what he earned.

Renoir remained friends with Degas, for whom support within the group was diminishing. Until his final days, Degas insisted that he was not an Impressionist.

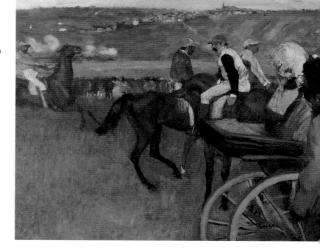

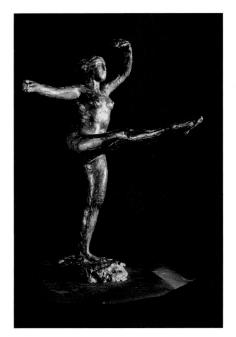

There are, however, arguments that his work adopted at the very least the emphasis on light that permeated the works of Monet, Renoir, and Pissarro. But Degas remained firmly involved with the movement. His appealing paintings of ballet dancers were painted in the 1870s, and the light reflecting on their tulles, the shimmer of net contrasting with satin bows and shadows marked in by color and not contours, all betray the growing influence of the Impressionists. The subtle effects of the tone and the contrast between the indistinct background and the exquisitely detailed ballerinas make these some of Degas's most popular works. His sketches were made from life, and although the paintings were completed in the studio, their

immediacy was not diminished. He introduced Mary Cassatt, a friend and admirer of his work, to the group. An American, born in Philadelphia, Cassatt arrived in Paris the year of the first alternative exhibition. She saw a Degas pastel in a picture-dealer's window and immediately recognized a kindred approach to art. Degas saw her work at the Salon that same year, and said: "Here is one who feels as I do."

Cassatt's work was rejected by the Salon in 1875 and 1877 and Degas suggested then that she join the Impressionists. She was delighted, saying: "I hated conventional art. Now I began to live." She adopted the Impressionists' use of color, lightening her palette and using sharp, broken brushstrokes. Like Morisot, her themes were predominantly feminine, but she was never sentimental or cloying. She came to personify the Impressionist movement almost as soon as she joined it, with works like *In the Cornfield at Gennevilliers* (1875) and *In the Loge* (1879), which emphasized all the qualities that eventually made the movement so successful.

Berthe Morisot, who painted with much less definition and emphasis on line than Manet, for example, became increasingly Impressionist, reveling in the freedom that the technique offered her. Her work has the same innate charm as Renoir's; the pleasure with which she painted enlivened her subjects. She had a gift for painting upper-class women in domestic situations in an unsentimental manner.

Alfred Sisley had become dependent on the dealer Durand-Ruel

to support his work, and when it became clear that his mentor had over-extended himself, he was left with virtually no means of survival. But his painting was developing in a unique manner—he had begun to focus on the use of motif in many of the works. The tree-lined road became a central theme, and it appeared in countless paintings. He painted in England, at Hampton Court on the Thames and at Charing Cross—scenes that had been undertaken by Turner, Monet, and indeed Pissarro over the years. He also painted at Argenteuil with Monet, reveling in the other artist's astonishing eye for color. Sisley remained loyal to the artistic vision of the Impressionists; he seemed to accept that fame was simply late in coming.

By 1877, the fortunes of the group were diminishing. Some of the artists had become disheartened enough to release themselves from the associations of Impressionism, but for the most part, they had great faith in their art. At the third Impressionist exhibition, held in that year, a body of grudging admirers began to emerge. The Impressionists were out in full force: Monet showed 30 paintings, Degas 25, Morisot 12, Renoir 21, Sisley 17, Cézanne 16, and Pissarro 22. But the new interest in the group was not reflected in sales and, despite some encouraging reviews, prices were low and for the most part they struggled.

By 1880, the tide had turned for the Impressionists, and the post-war economy had begun to pick up. Monet alienated himself from his peers by organizing his own show at *La Vie Moderne* in June

1880. On Renoir's advice, he also submitted two works to the Salon, one of which was accepted. Degas called Monet a traitor for denying everything the Impressionists stood for by showing at the Salon, but Monet was distancing himself from a group that had begun to expand beyond their original precepts into something quite different.

In 1878 Renoir also detached himself from the group, trying his luck again at the Salon. That year, one of his paintings was accepted, and the following year two were chosen. His work was celebrated by the art world, but the public still failed to come to grips with his vision.

Renoir's absence from the fourth Impressionist exhibition made his colleagues nervous. Pissarro said to

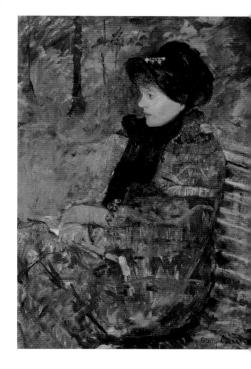

Caillebotte, who was organizing the show, "... if the best artists slip away, what will become of our artistic union?" The only Impressionist to exhibit at all eight of their shows, Pissarro had a large family to support and eventually they returned to his family in England, where they settled in South London, near Dulwich. Some of his most alluring landscapes were painted there.

Pissarro was firm friends with Cézanne. They worked together to develop a new, intellectual approach to their landscapes. Like Monet and Renoir in the previous decade, they sat next to one another, painting the same motifs over and over again. An onlooker remarked that "Cézanne plastered and Pissarro dabbed," making the distinction between Pissarro, who fulfilled his Impressionist promise, and Cézanne, who worked in his characteristic broad, heavy brushstrokes.

Cézanne met Renoir, Pissarro, Sisley, and Monet in the early 1860s, and he entered the first Impressionist exhibition, showing *The House of the Hanged Man, Auvers* (c. 1873), which was met with enormous hostility from both the public and the critics. The reception of his work did not improve with time, and by the third Impressionist exhibition he had lost interest and faith in the aims of the group, resigning in 1887.

Sisley also left the group, doubting the possibility of any future unity and concerned about the "Intransigence" label. He had clung to his vision for the group of painters, and had remained loyal to their aims. He waited patiently for recognition, which, sadly, did not come until after his death. In a desperate bid to draw attention to his work, he presented it to the Salon again in 1879. It was not accepted, and he entered the 1880s with a resigned attitude, wanting the luxury of

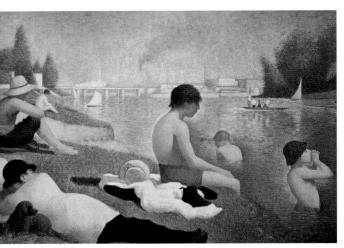

exhibiting solely with the Impressionists but understanding the reality of his situation. He moved around France constantly, and was obliged to call upon the generosity of patrons and friends in order to keep his family together.

By the early 1880s, the feeling of cohesiveness that had originally brought the Impressionists together began to dissolve under the pressure of emerging factions and rivalries. The sense of a shared approach to nature among the landscape painters had also dissolved, so that each artist increasingly took individual directions. Renoir focused on nudes and portraits, feeling that "he had gone to the end of Impressionism." Pissarro began to look for a way forward from Impressionism. In 1885, he met Georges Seurat (1859–91), who developed a theory called Divisionism; this, combined with a Pointillist technique, offered what seemed to Pissarro to be the antidote to the "unpolished and rough execution" that had plagued the Impressionists. He worked with Seurat until the final Impressionist exhibition, but abandoned the technique in 1890 and returned to a further exploration of Impressionism.

Monet, too, was deeply dissatisfied with his work, but unlike Renoir and Pissarro, he never wavered in his belief that Impressionism was the right path. Even his latest paintings developed with a single-minded logic lacking in other artists' work. In his search for the instant impression, he, paradoxically, had to abandon some of the dogmas of Impressionism. The selection of the right motif for his series paintings took on great importance: his poplars by the river, Rouen Cathedral, London, Venice, and, above all, his water-garden, became the focus of his search for "instantaneity," or the impression of an instant, and they were to absorb his interest until his death.

Ironically, as the group fell apart, Impressionism began to have a tremendous impact both on French painting generally and on the art of other countries; this continued well into the twentieth century. Either directly or through developments after the 1880s, such as Neo-Impressionism and Post-Impressionism, Impressionism influenced modern art in such fundamental features as a loosening up of brushwork, which abolished the traditional distinction between the finished painting and the preliminary sketch or study; a concern for the two-dimensional surface of a painting, which is defined by the patterns and feeling of movement of the paint on the ground; and a use of pure, bright colors.

KAREN HURRELL

EUGÈNE BOUDIN (1824–98) The Beach at Trouville, 1864

Celimage.sa/Lessing Archive

N older artist and a follower of Jean-Baptiste-Camille Corot (1796–1875), Eugène Boudin was a landscape artist who painted mainly along the coast of northern France. He was one of the first people to advocate painting in the open air, rather than sketching outside and producing a finished composition in the studio. This had become more viable from the 1840s when oil paints in tubes replaced the pigs' bladders that had been used before. Tubes meant that the paints did not dry out so quickly, as the cap could be put on, making it easier to paint outdoors.

Even so, many artists did not see why they should adapt their palettes according to the natural light around them, or indeed paint landscapes under natural light conditions.

Boudin's influence on Impressionism came through his meeting with Claude Monet (1840–1926) in 1858. Monet soon came under his influence and remarked in later life: "If I became a painter, it was thanks to Boudin."

Boudin also painted the French at play, usually by the sea, an idea that was not especially prevalent at the time and was quickly taken up by the young, modern group of artists who came to be known as the Impressionists.

His paintings are frequently loose and sketchy and rarely have a central subject but rather small figures under a large, bright sky. In his old age, Corot referred to these renditions as "meteorological beauties," and dubbed Boudin "king of the skies."

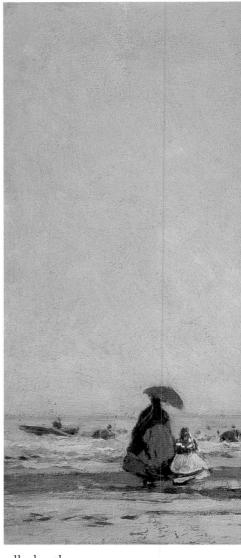

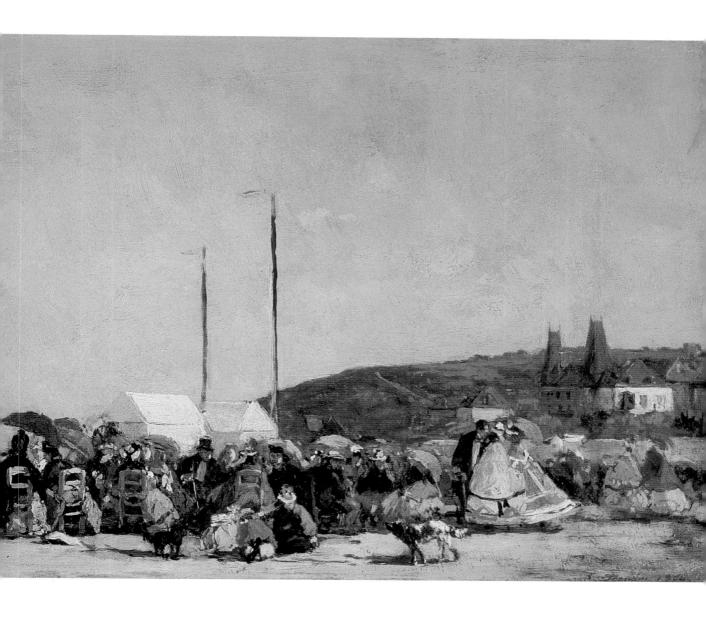

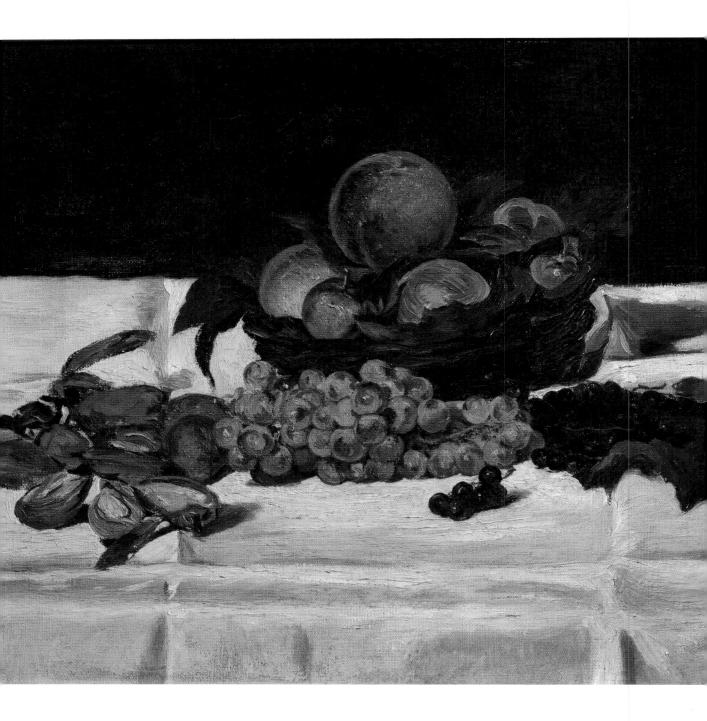

ÉDOUARD MANET (1832–83) Fruit: Grapes, Peaches, and Almonds, 1864

Musée d'Orsay, Paris. Celimage.sa/Lessing Archive

DOUARD Manet came from a wealthy family and trained in the traditional manner in Paris between 1849 and 1857. He soon ventured into the two broad artistic movements of Realism and Impressionism, accomplishing a bold transition between the two. He is regarded as a founder of modern art, a father of the Impressionist movement, and the last figure of great Classical art. Despite the accolades Manet himself did not claim any of these exalted titles.

His versatile style of painting, controversial approach to subjects, and dextrous experimentation with sharp natural lighting and bold color have made his works uniquely distinct, placing him at the forefront of artistic debates.

What is most striking about *Fruit:* Grapes, Peaches, and Almonds is Manet's use of a dark palette, with contrasting areas of shade cast between the white-gray of the tablecloth, and the dark-brown backdrop, providing a familiar element. The interesting arrangement of the fruit basket on one side, and the knife and glass object

on the other, can easily be likened to the still life paintings of Paul Cézanne (1839–1906), such as *Still Life with Bread and Eggs* (1865), a style continued in Manet's *Still Life with Melon and Peaches* (1866). The detail of the fruit is executed to a very high standard, and our attention is drawn to the color of the peaches and presentation of the grapes.

ÉDOUARD MANET The Lunch on the Grass, 1862-63

Musée du Louvre, Paris. Celimage.sa/Lessing Archive

ANET revealed his revolutionary nature when he presented *The Lunch on the Grass*, under the title *The Bath*, to the Salon in 1863. Inevitably, it was rejected and when it was shown at the Salon des Refusés, an alternative exhibition inaugurated by Napoleon III (1808–73), it caused great scandal and controversy. The public and critics alike were outraged at what they perceived to be a mockery of the Great Masters. Although the juxtaposition of dressed men and undressed women was acceptable in the 17th-century *Pastoral Symphony* (c. 1510) by artist Giorgione (Giorgio Barberelli) (c. 1477–c. 1510) in the Louvre, a modern interpretation was considered indecent.

Many Classical paintings showed nudes in a landscape, but to turn the nude (Victorine Meurent, Manet's favorite model) to face the viewer squarely, placing a scattered picnic, a pile of clothing, and two fully dressed men (one of Manet's brothers and Rodolphe Leenhoff, Manet's future brother-in-law) beside her, was considered offensive.

Even the critic Théophile Thoré (1807–69), a friend of the controversial poet Charles Pierre Baudelaire (1821–67), dismissed it as an "absurd composition," only mentioning in passing "the qualities of light and color in the landscape and indeed [the] very true bits of modeling in the torso of the woman."

The younger artists, who came to be known as the Impressionists in the 1870s, regarded the spirited Manet as their figurehead and leader, although he always distanced himself from them professionally and never exhibited in any of the group exhibitions.

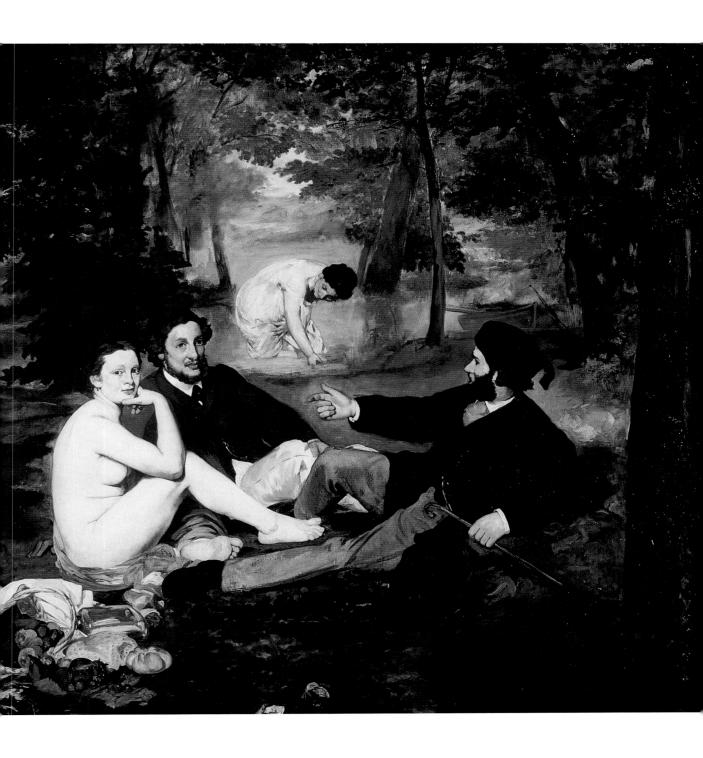

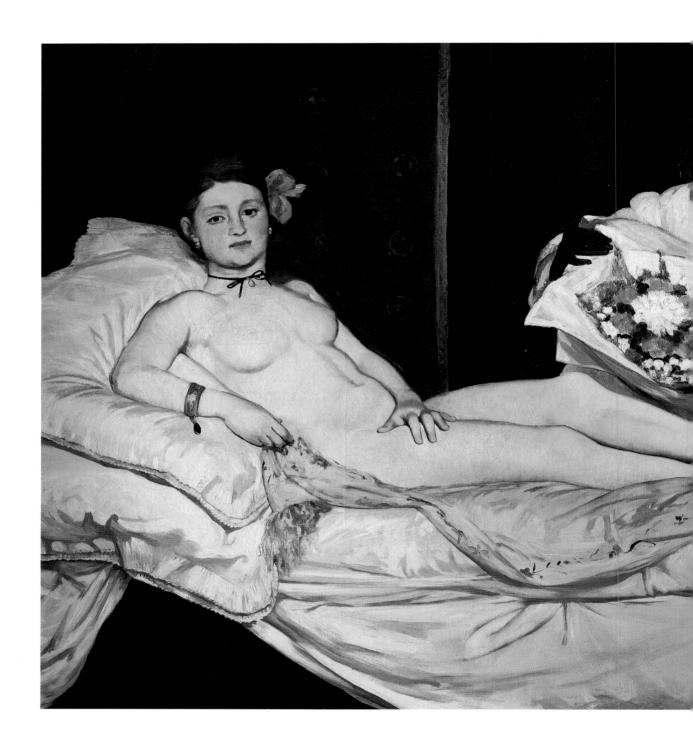

ÉDOUARD MANET Olympia, 1863

Musée d'Orsay, Paris. Celimage.sa/Lessing Archive

LYMPIA, exhibited at the Salon of 1865, shows a nude in a pose reminiscent of works by Titian (c. 1485–1576), Velásquez (1599–1660), Goya (1746–1828), and Jean-Auguste Dominique Ingres (1780-1867). Like The Lunch on the Grass (1862-63), it was shocking in its modernity. First, Manet's nude stares out at the viewer, unsmiling, challenging. Second, she is wearing high-heeled slippers and a black ribbon around her neck, items that emphasize her nudity. She is no reclining Venus but a prostitute. Emerging from the shadows, a black maid brings flowers from a client, although they give the woman no pleasure, while crossing the bed is a black cat, a traditional symbol of sexual activity. Although the gesture is a conventional one, the reason why the woman covers herself with her hand is hardly chaste—you, the viewer, in the position of client, have not paid to see her.

The style, which is almost clinical, also has a fragile clarity. The subtlety and finesse of the modeling of the figure is typical of Manet's work and makes viewers even more acutely aware of the woman's body, increasing their discomfort. Her body contrasts with the dark, simplified background and flashes of color (the bouquet and the flower in her hair). Yet it remains in harmony with the pale, silk shawl and the white linen of the bedclothes.

ÉDOUARD MANET Portrait of Émile Zola, 1868

Musée du Louvre, Paris. Celimage.sa/Lessing Archive

MILE Zola (1840–1902), writer and childhood friend of Paul Cézanne (1839–1906), was a staunch supporter of Manet, whom he first championed in the journal *L'Événement* in 1866. The two men became lifelong friends.

As in traditional portraiture, Zola is surrounded by books and writing materials—*L'Événement* is in the "fan" of journals behind the inkstand. His pale face glows in the darkness. The book in his hand, the Japanese prints, an engraving of Manet's *Olympia* (1863), and a glowing Japanese screen all indicate an interest in the avant-garde.

The emphasis on black and white tonal values is typical of early Manet. The book of Japanese prints, so newly arrived in Paris and a source of great interest to the artistic and literary worlds, glistens and is the focal point of the painting. The fine modeling of the face and hands contrasts with the looser brushwork of the trousers; the studio lighting picks up details such as Zola's ear, knuckles, and the bridge of his nose.

Manet's limited palette may not yet reflect that of the Impressionists, but his refusal to "make things up" corresponds with their desire to paint straight from nature. Zola describes how Manet refused to let him move during the long sittings: "No," he said, "... I can do nothing without Nature. I do not know how to make things up... . If my work has any real value today, it is because of the exact interpretation and truthful analysis." The painting was well received at the Salon of 1869.

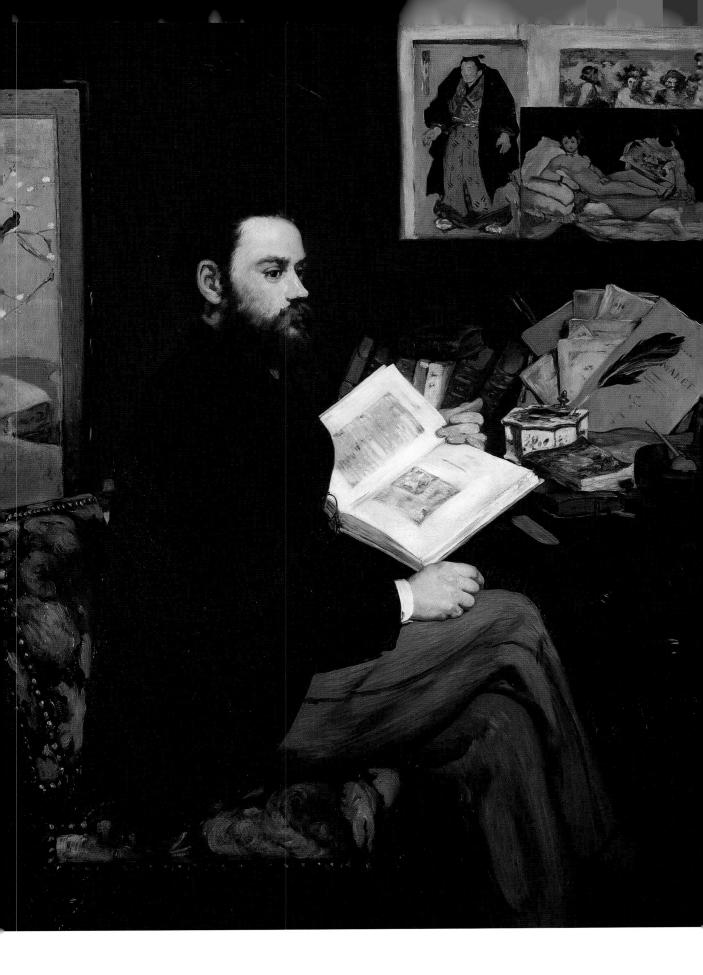

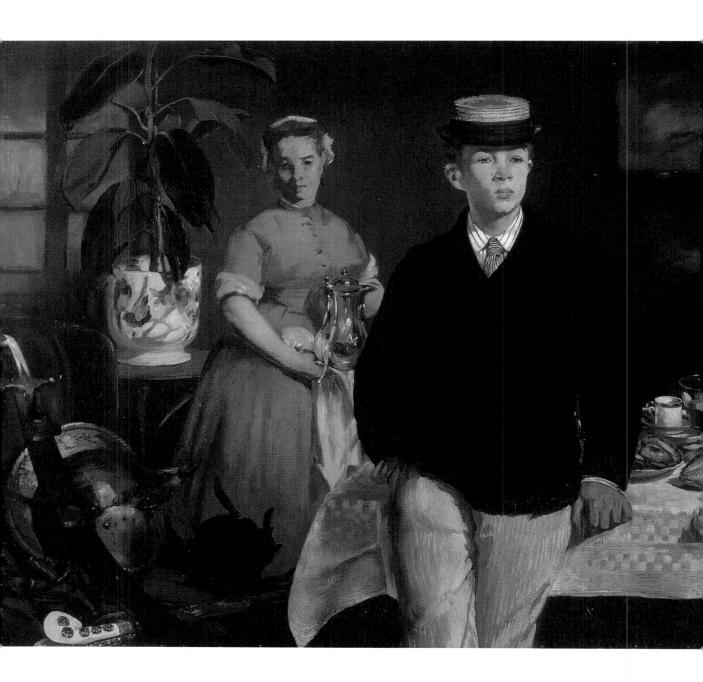

ÉDOUARD MANET Lunch in the Studio, 1868

Neue Pinakothek, Munich. Celimage.sa/Scala Archives

UNCH in the Studio is one of Manet's most enigmatic paintings. A narrative is implied but not clear and the props on a chair are the only reference to the studio mentioned in the title.

The boy, who is clearly going out, is the main focus, and ignores the other figures. The lunch—the half-peeled lemon reminiscent of Jean-Baptiste-Siméon Chardin (1699–1779) and 17th-century Dutch still-life paintings, the half-filled wine glass and the glistening coffee cup—command the viewer's attention and are typical of many of Manet's compositions. A pot and an ivory-handled sword shine in the gloom on the left. A black cat washes itself—a humorous detail that creates a visual link with the boy's jacket, and brings to mind the dog in *The Balcony* (1868–69)—an animate element in an otherwise frozen scene.

Manet again uses predominantly grays, blacks, and white with the odd splash of color. As in *The Balcony*, an interplay of triangles binds the picture together. There are the triangles of the figures—the boy, woman, and weaponry; of the bright patches of the man's hand, the boy's face, and the ivory handle; the flattened triangle of the handle, plant pot, and the length of tablecloth; and the up-tilted triangle of the pot, the handle, and the boy's face.

The influence of photography is evident in the cut-off figure on the right, although this "snapshot" effect sits oddly with the otherwise static quality of the scene.

ÉDOUARD MANET The Balcony, 1868–69

Musée d'Orsay, Paris. Celimage.sa/Lessing Archive

XHIBITED at the Salon of 1869, this picture met with public bewilderment. Despite their proximity, the three figures have no personal interaction. A fourth is barely visible. The Impressionist artist Berthe Morisot (1841–95) (seated) is painted the most heavily and stares, black-browed and intense, into the street. Fanny Claus (1846–77), the violinist, is painted with a light touch, in marked contrast with Morisot, and seems diaphanous and sketchy. She looks ahead, absent-mindedly putting on her gloves. Antoine Guillemet (1843–1918), the landscape artist, is also less firmly modeled than Morisot, and looks ahead. Yet all of them, posed as if for a formal photograph, avoid looking to camera. The scene is enigmatic, the players isolated in a frozen scene, which even the little dog fails to enliven.

Painted in the studio, contrary to the Impressionist doctrine, *The Balcony* is fiercely geometric: the shutters confine the space; the house interior is black and flattened; the horizontal railing cuts the picture and the figures in two, while the diagonal and vertical bars point toward each figure. The figures form a triangular mass and the heads, bright against the dark background, also create a triangle, a shape reiterated in the balcony design. Again, Manet uses a limited palette, with an emphasis on blacks and whites. The contrast of bright colors—green shutters and balcony, the blue cravat, red fan, yellow gloves and green umbrella—also create their own directional forces within the canyas.

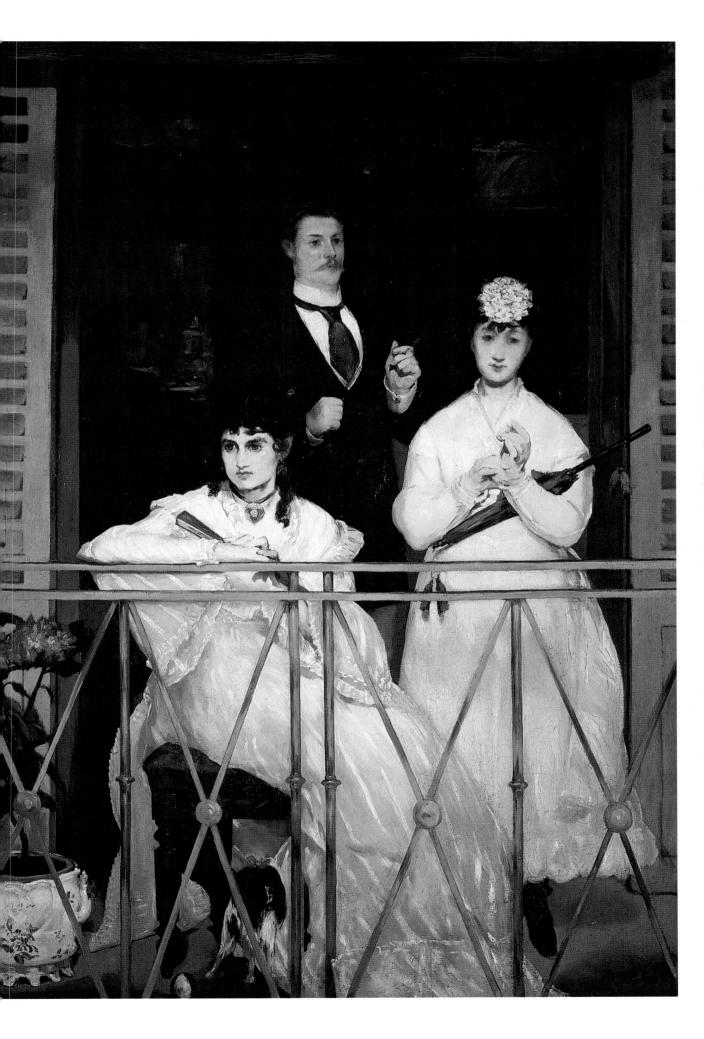

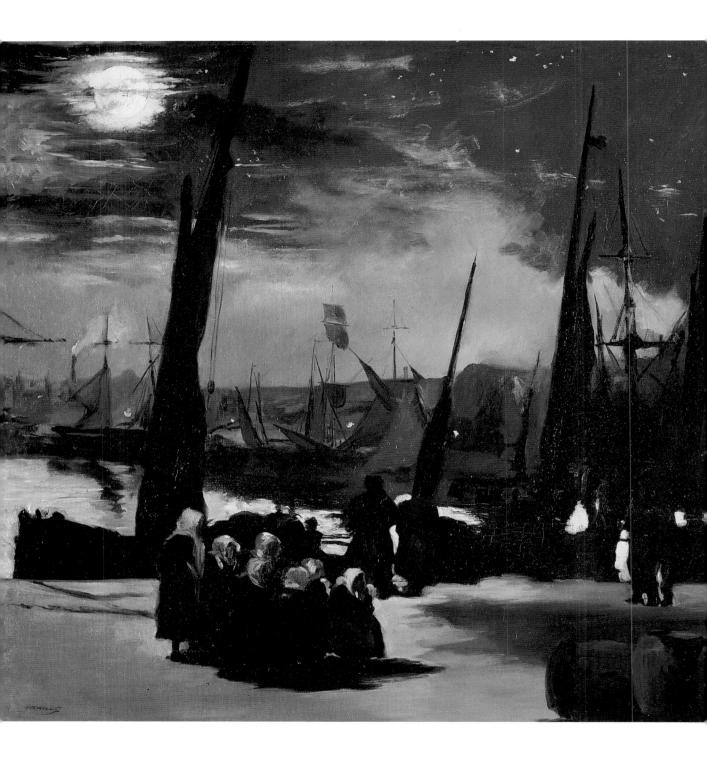

ÉDOUARD MANET The Port of Boulogne in Moonlight, 1869

Musée d'Orsay, Paris. Celimage.sa/Lessing Archive

ANET and his family spent the summer of 1869 at Boulogne, where he painted several harbor and sea scenes. This is a dramatic nocturnal scene with women huddled, apparently waiting, on the quay, their white headscarves, the water, and the quay lit by moonlight. Although enigmatic, raising questions about a possible narrative, this is a less intimate painting than figure groups such as *The Balcony* (1868–69), or *Lunch in the Studio* (1868).

Manet painted a harmony of blues, grays, blacks, and whites, with a thick impasto in several places, notably over the moon—X-rays reveal that it was originally lower down. Although the palette is dark, the style of the painting is beginning to show impressionist-type brushwork in places.

The ships in the harbor and the cloudy sky are reminiscent of Manet's first "historical" painting, the *Battle of the Kearsage and the Alabama*, which he painted for the Salon in 1864, depicting a recent sea battle in the American Civil War off Cherbourg. This mingling of history, reportage, and narrative is also evident in some of his other works, such as *The Execution of Maximilian* (1867), based on shocking news reports of the death of the Austrian Emperor of Mexico.

The strong verticals of the masts in the foreground are an interesting design device, possibly showing the early influence of Japanese prints, which were beginning to be imported and which became so important in the development of European art.

ÉDOUARD MANET Argenteuil, 1874

Musée des Beaux-Arts, Tournai. Celimage.sa/Lessing Archive

HIS is one of the first "impressionist" paintings that Manet produced. The subject matter is contemporary, the palette is light and bright, and Manet is concerned with showing a naturalistic background encompassing the luminosity and play of natural light. Even so, Manet's love of white and its different tonal values is still clear, and his "punctuating" use of color is still evident in the flash of red flowers.

As usual, the figures are the focus of Manet's composition—a young couple sit together, comfortably it seems, on a dock. But, even here, the interplay of emotions between the figures is unclear. The man seeks a connection with his companion; meanwhile she sits placidly, half-smiling, hands in lap, upright, looking ahead, formal, almost unaware of his presence. The man is Rodolphe Leenhof, Manet's brother-in-law; the girl is unidentified.

Boats in the foreground on either side of the couple face in opposite directions and are cut off on all sides—a "snapshot" device suggested by photography and much used by Degas. Although there is no documentary evidence, it seems likely that this painting was executed, at least in part, out of doors—an unusual departure for Manet and one of the first times he would have tried it.

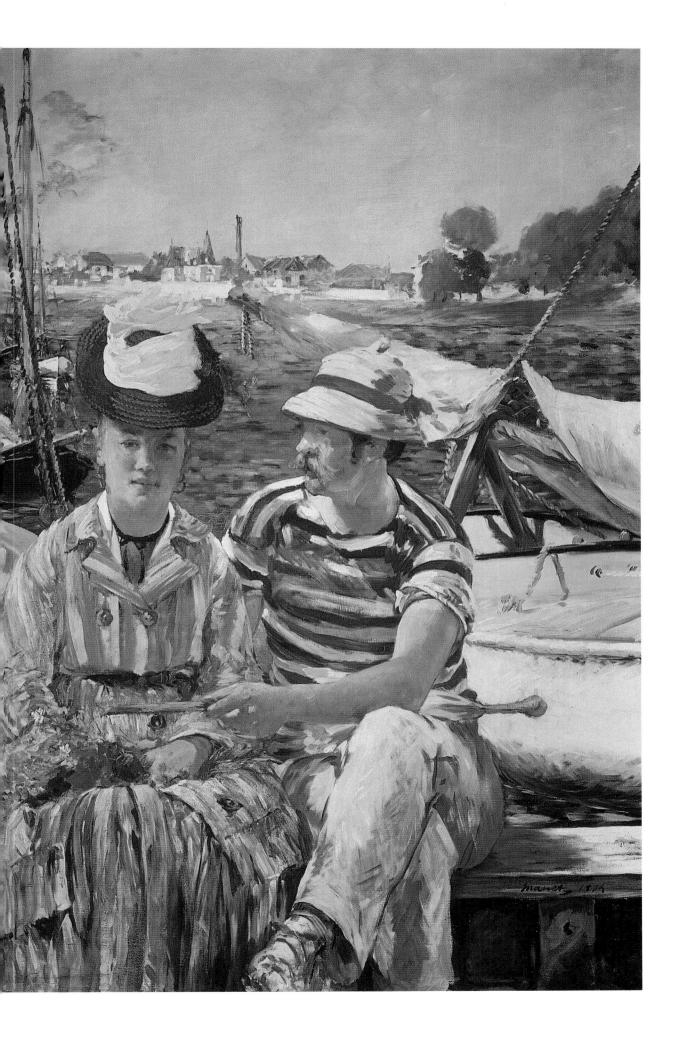

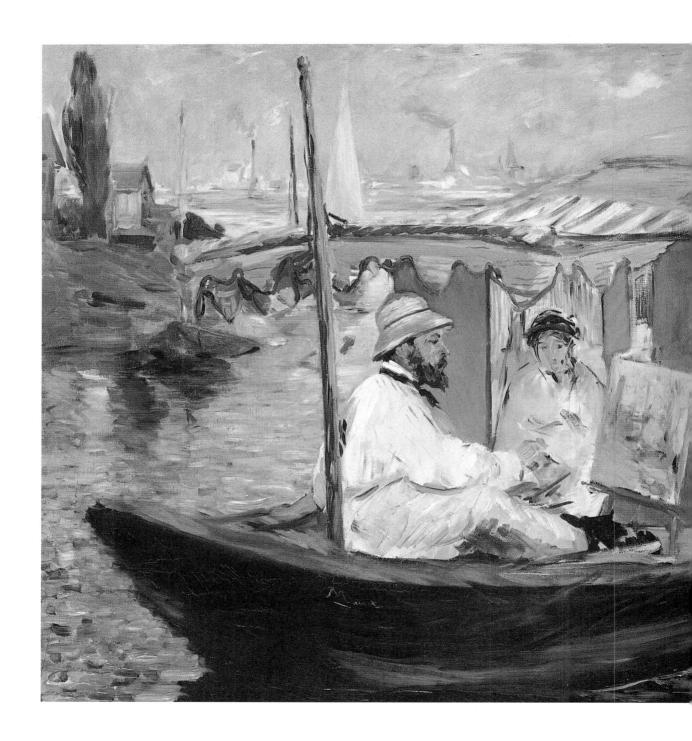

ÉDOUARD MANET The Barge, 1874

Neue Pinakothek, Munich. Celimage.sa/Scala Archives

ANET first met the Impressionists in 1866, although they had admired his work since 1863. They used to meet him on Thursday evenings at the Café Guerbois but it was not until 1874, the year that they first exhibited independently of the Salon, that Manet experimented with their style of painting.

The Barge, which is unfinished because of the long sessions Manet needed to complete it, shows the painter Claude Monet on his floating studio on the river Seine at Argenteuil. In 1874, Manet spent the summer with his family on the opposite bank at Gennevilliers and painted alongside Monet and Pierre-Auguste Renoir (1841–1919). Under their influence, Manet discarded the dark tones and clear outlines of his earlier works and began to work in a more typical "impressionist" style. But even here, Manet cannot quite give up his dark palette totally, as seen in the somber treatment of the boat.

Moreover, true to form, the subject and focus of Manet's work are the people—in this case Monet and his wife Camille. Unlike Monet, Manet never painted a landscape just for itself. It was always part of a preconceived composition in the same way that the flat, dark backgrounds of some of his earlier works were conceived to work in harmony with his figures and were never just an absence of detail.

ÉDOUARD MANET The Grand Canal, Venice, 1875

Shelburne Museum, Vermont. Celimage.sa/Lessing Archive

HIS beautiful depiction of a Venetian canal introduces us to a private scene, which we approach from water level. We are guided through several pairs of blue and white needles, toward a dark boat, which rests lightly on the surface. The man steering its course is almost completely camouflaged by the colors of the background buildings.

The style of painting used for the buildings can best be described as linear, as the paintbrush has been used loosely to outline them. The same effect is used for the man standing on his boat, giving an overall watery effect to the image, as it appears as though the colors of the buildings and the man are merging into one another. The vertical structure of the needles and the treatment of the water combine to contribute to the overall candid feel of the painting.

This work is an example of Manet's impressionistic style, which is seen here in the lack of detail on the buildings and the man's face, as well as in the hasty, shorter brushstrokes used for the water. Typically, for Manet, the blue-gray tones of the water are not repeated elsewhere in the buildings or the boat, and this provides a stark contrast in the piece.

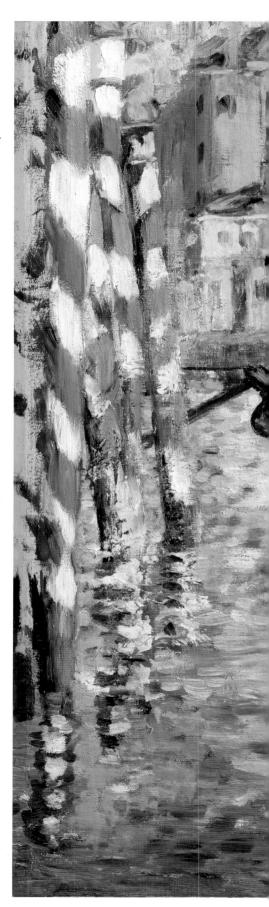

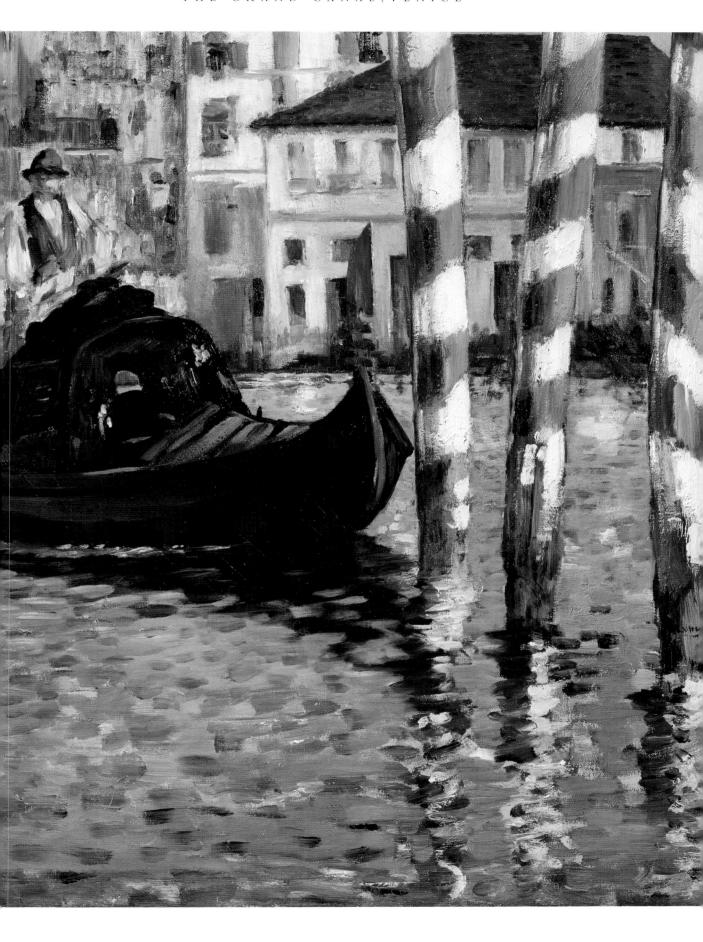

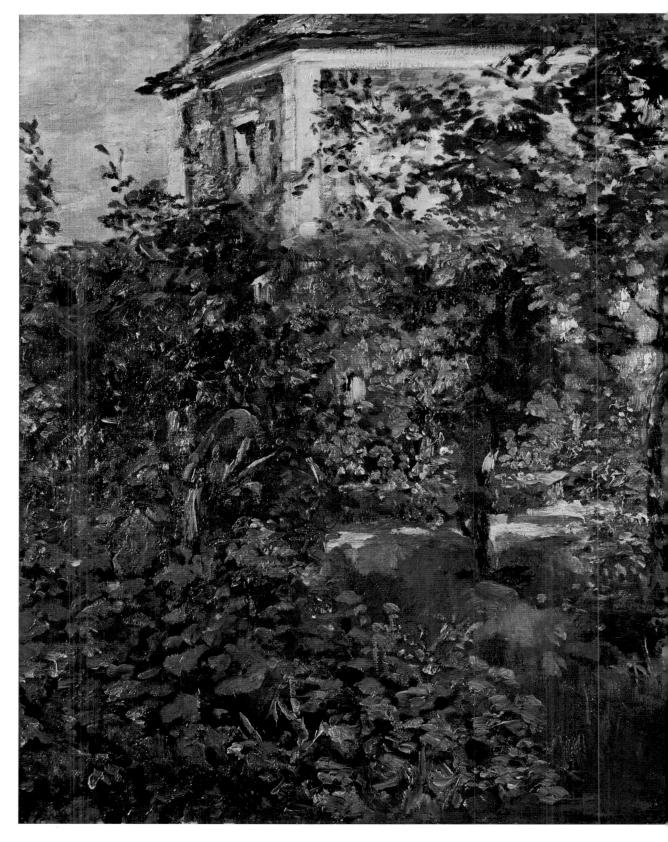

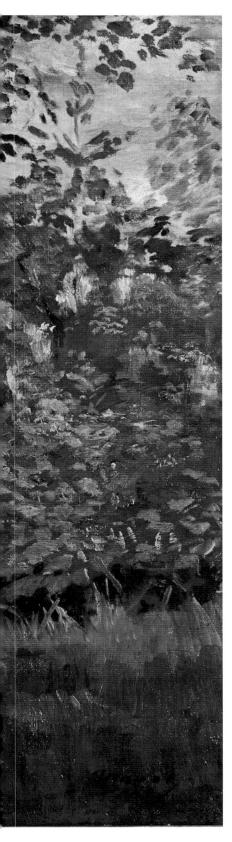

ÉDOUARD MANET The Bellevue Garden, 1880

Private Collection, Paris. Celimage.sa/Lessing Archive

HE Bellevue Garden is a splendid example of an Impressionist artwork, and one in which Manet captures the light, tone, and composition of this one scene at a single instance in time.

The artist spent the last few summers of his life outside Paris in Bellevue, Rueil, and Versailles, and it is from this latter part of his career that we can observe a truly refined artistic style and method, as evidenced in paintings such as this.

The Bellevue Garden does not have the sense of intrinsic light and warmth found in many of Claude Monet's Impressionist paintings. Instead, Manet's works are largely dominated by a darker palette, which often serves to obscure areas of natural light, creating an unlit, somewhat still depiction of a scene. In The Bellevue Garden the flower bushes in the foreground provide a point of focus for our view, and we become lost in their shade. Our eyes do not dart across a plethora of hasty and frequent brushstrokes, but rather become hypnotized by a rich display of dense color and shade, as Manet successfully manages to combine his unique impressionistic technique with a striking, realistic quality.

ÉDOUARD MANET Blonde Woman with Bare Breasts, 1878

Musée d'Orsay, Paris. Celimage.sa/Lessing Archive

HIS is an unusual painting for Manet and bears a strong resemblance to Renoir's *Nude in the Sunlight* (1876), although the light falling on this figure is uniform and she is not outdoors. The palette is typically impressionistic, with none of the white, black, and gray tones so typical of much of Manet's work. The woman is in a state of undress. The hint of a dress falls from her arms and she wears a hat on her head. Her pink skin and the green, flat background complement one another and are full of light, an effect partially created by the varying thickness of the green paint, which allows the color of the canvas to help illuminate the painting. The top, left-hand, unpainted corner of the canvas contributes to this effect and reflects the golden straw of the hat. The red flowers contrast with the green.

Leaving areas of the canvas unpainted was not uncommon in Impressionist circles. Prepared canvases came in a range of pale to midtones and from the 1870s, with their bright palette and desire to represent natural light, it became logical to use the paler, primed canvases and to exploit the ground to play a role in the overall effect of color and light.

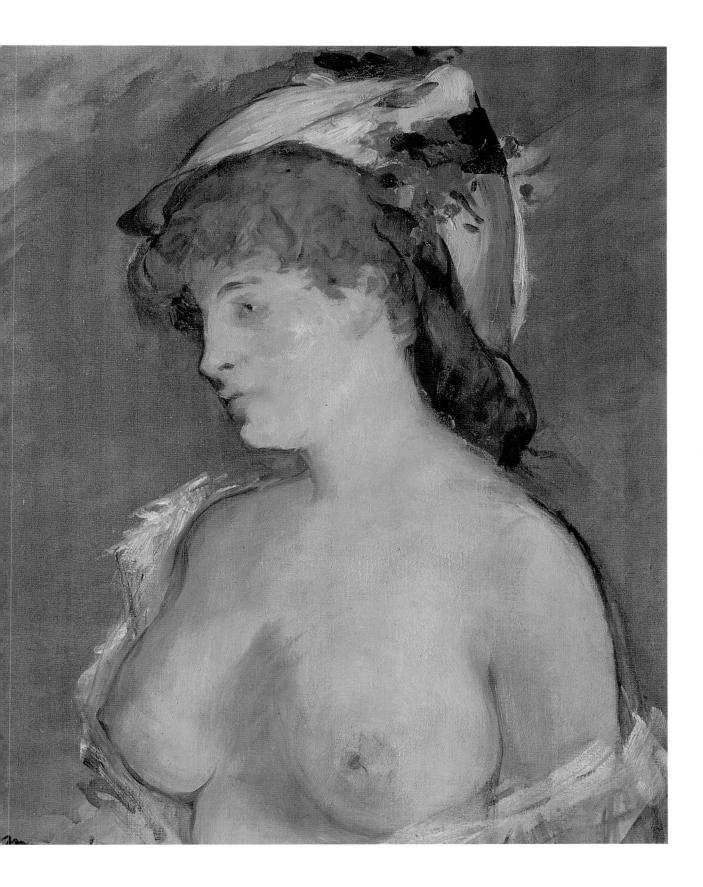

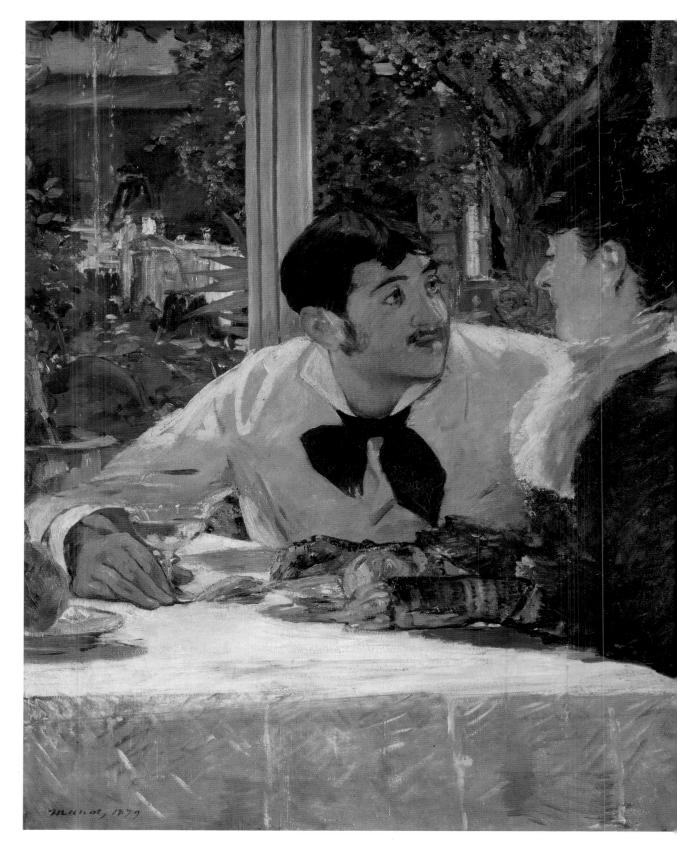

ÉDOUARD MANET At Père Lathuille's, Outside, 1879

Musée des Beaux Arts, Tournai. Celimage.sa/Lessing Archive

HAT invites us into this scene is the powerful expression on the man's face as he leans forward and looks toward the woman sitting at his side. His look of wonder or affection dominates our view as we are drawn toward this single table in the café. We are intrigued by the exactness of his features and clothing, as such attention to detail is not applied to the surroundings. The woman faces away from us, and the waiter standing in the distance is represented as a mere sketchy outline, with poorly defined facial features.

This painting is an unexpected artistic departure for Manet, who has worked with a lighter and softer palette than usual. The soft cream of the tablecloth and the mid-yellow tones of the man's shirt are reflected in the woman's scarf, the walls, across the floor, and on the waiter's apron. This gives a sense of balance to the composition.

The brushstroke used on the woman's dress is traditional for the artist, although the way in which he has painted the floor in these varying tones of yellow, is reminiscent of the impressionistic style. Once again, this intriguing piece combines the techniques of Realism and Impressionism.

ÉDOUARD MANET Woman in a Black Hat (Portrait of a Viennese, Irma Brunner), 1883

Musée du Louvre, Paris. Celimage.sa/Scala Archives

ANET painted many portraits throughout his life and did numerous half-length pastels of women during his last two years. The use of pastel in these works may show the influence of Degas.

One of his last pastels was of Irma Brunner, whom Manet met through his friend Mary Laurent. It epitomizes the elegance and beauty of society Paris—a subject popular with Renoir. The soft treatment, so typical of pastel work, creates a misty quality; the pinks, grays, whites, and shades of black harmonize gently; the only sharp definition is in the whiteness of the woman's profile against her black hat; the only sudden flash of color is her scarlet lips.

The flat gray background is a perfect backdrop to the profile placed in the center of the canvas to such effect. Any background detail would detract from the perfection of the colors and the form. This is a visual technique that Manet used throughout his career, but only if he thought it suitable for the work in hand. Théodore Duret (1838–1927), whose portrait he painted in 1868, describes how Manet added background details to his portrait when he was not happy with the effect of the plain background: " ... missed the colors that might satisfy his eye, and not having put them in at first, he added them in the manner of still-life."

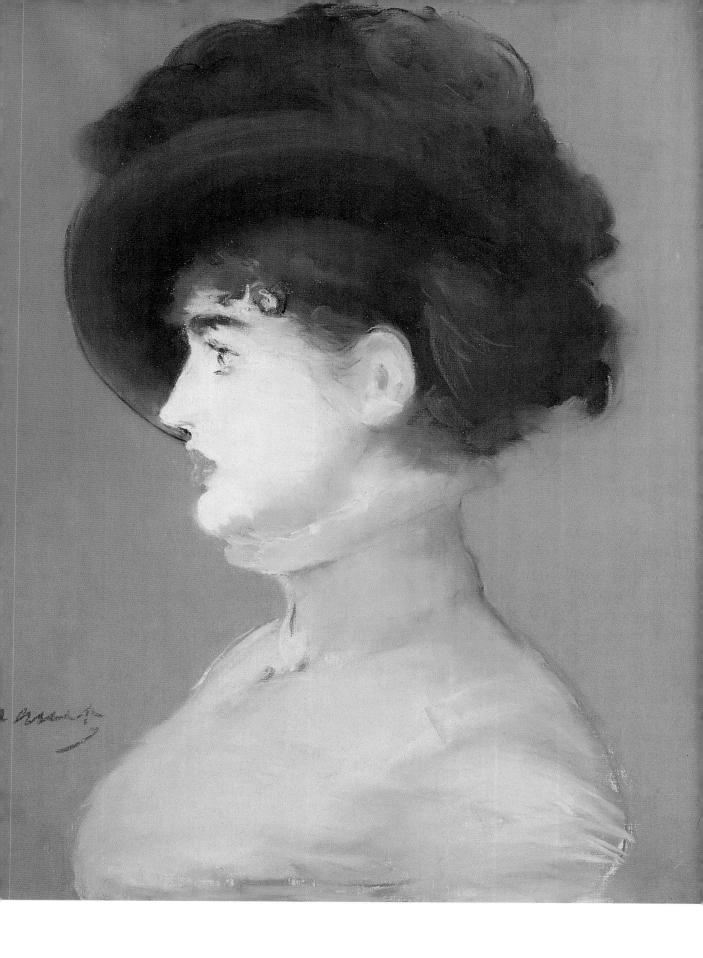

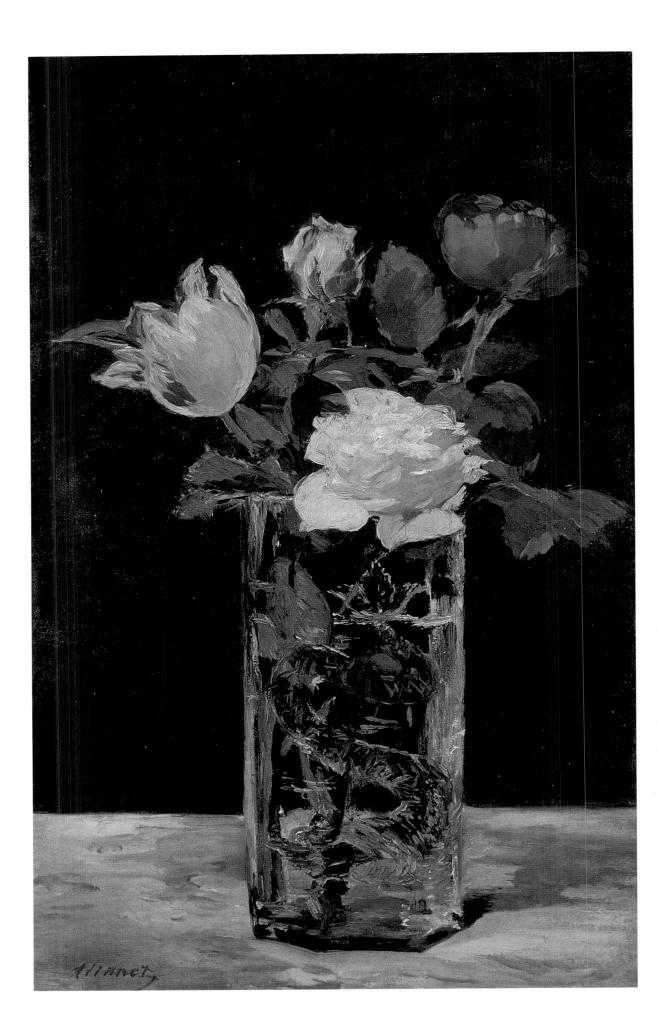

ÉDOUARD MANET Rose and Tulip, 1883

Private Collection, Zurich. Celimage.sa/Lessing Archive

HIS painting, probably executed in February 1883, is one of Manet's last. He died on 30 April 1883 from locomotor ataxia, a nervous disease resulting from undiagnosed syphilis, probably contracted as early as 1848.

Over the last two years of his life, Manet's movements were increasingly circumscribed and he often worked on small-scale still lifes such as this one, and garden views in the houses outside Paris where he spent the summer months on his doctor's advice.

This is one of 16 flower studies that he completed in the last year of his life—the last, *Roses in a Glass*, was executed on 1 March 1883. The flowers were probably brought to him by friends. "There were always flowers in Manet's studio but never so many as there were in Rue d'Amsterdam in the early spring of 1883," wrote Adolphe Tabarant, "... with what joy the patient welcomed these messengers of a springtime that he awaited with so much trust! He wanted to paint all of them; at least he painted some of them." When he died, Degas said regretfully: "He was greater than we thought." Manet was buried in his beloved Paris; Monet was a pallbearer and a year later a retrospective of his work was held at the Académie des Beaux–Arts.

FRÉDÉRIC BAZILLE (1841–70) Family Reunion, 1867

Musée d'Orsay, Paris. Celimage.sa/Lessing Archive

RÉDÉRIC Bazille, a medical student, studied at the studio of the artist Gleyre (1808–74) in 1862 alongside Monet, Renoir, and Sisley (1839–99). They became friends and used to go on trips outside Paris to paint in the open air. In 1863, Bazille wrote to his mother that he had spent "eight days ... near the Forest of Fontainebleau ... with my friend Monet from Le Havre, who is rather good at landscapes. He gave me some tips that have helped me a lot."

This painting shows members of Bazille's family. Bazille is standing on the far left. It bears comparison with Monet's *Women in the Garden*, which was painted later the same year. Both show bourgeois figures in a garden, and have been composed asymmetrically to create a snapshot effect. Both are concerned with the effects of sunlight and shadows on the ground and on the folds of the women's clothing. Bazille even goes so far as to paint the reflected light on the skirt of the girl in the center in turquoise, which must have been just as astonishing at the time as the shadows in Monet's work. The emphasis of the two paintings, however, is different. Bazille's work is static, showing a ponderous, semi-formal grouping rather than a spontaneous moment, and shows a shaded scene in which the light sneaks in through the leaves. Monet's, on the other hand, is a lively sunlit scene, interrupted by shade. However, Bazille's painting was accepted at the Salon of 1868, while Monet's was not.

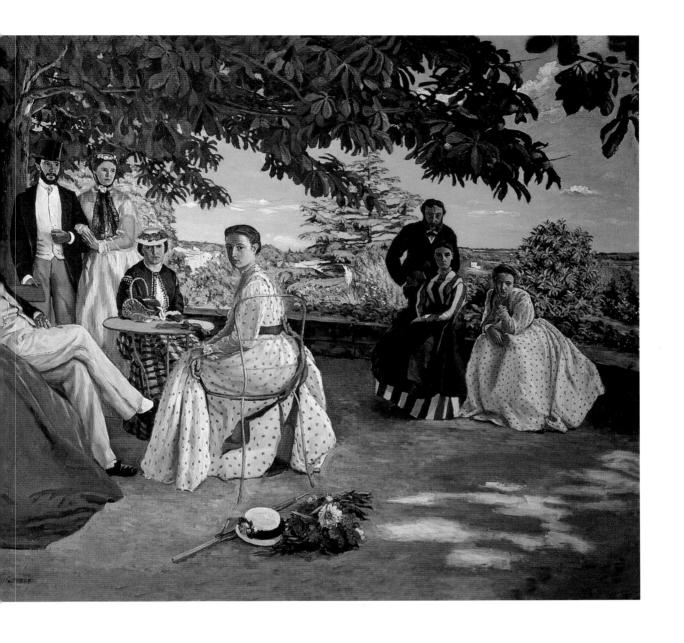

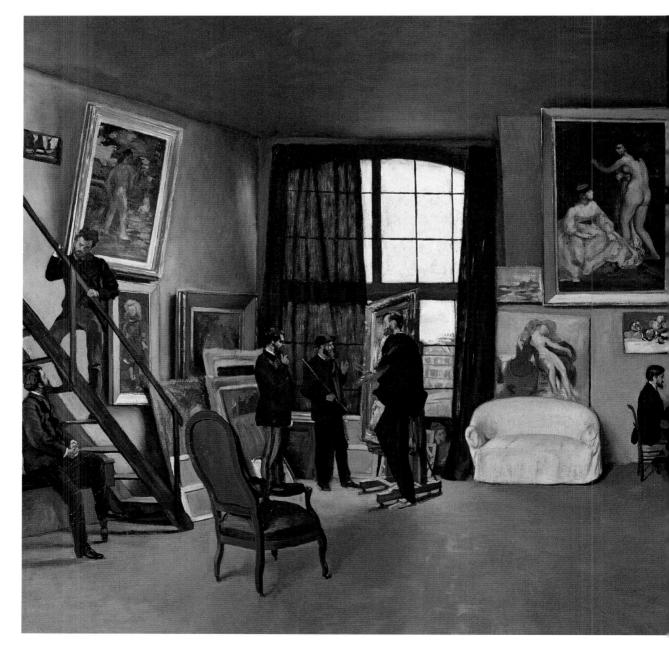

FRÉDÉRIC BAZILLE Bazille's Studio, 1870

Musée d'Orsay, Paris. Celimage.sa/Lessing Archive

HIS painting shows Bazille's studio on the Rue de la Condamine, not far from the Café Guerbois where the group used to meet. Zola leans over the stairs, talking to Renoir; Manet inspects the canvas with Monet. The tall figure of Bazille, painted in afterward (and out of proportion) stands by Manet holding the brush and palette. The pictures on the walls are by his friends, among them a still life above the piano that Bazille, much better off than most of the group, bought from the impecunious Monet.

It is an unusual composition, cut off on both sides and with a large, empty space on the right—a Japanese device much employed by Degas, in particular. The chair and the stove on either side channel the eye to the empty white sofa and the painting and wall behind it. On the right, Bazille's friend Maître (1840–98) plays the piano, separate from the crowd. The stove, the wall and the folded table also lead the eye toward this single figure. The left side of the painting is full and busy, showing an informal scene and the rapport between the friends.

Manet's influence is clear in the colors of the palette, although Bazille's is much lightened. The white sofa, the reds in the furniture, and the golds of the picture frames provide bright accents of color in an otherwise rather gray scene. Sadly, Bazille died the year that he painted this picture, killed fighting in the Franco-Prussian War.

CLAUDE MONET (1840–1926) Women in the Garden, 1867

Musée d'Orsay, Paris. Celimage.sa/Lessing Archive

HEN Monet painted this picture, he had already begun to paint outside, acting upon the advice of Boudin, whom he had met in 1858, and the Dutch painter Johan Jongkind (1819–91), to whom he said he owed "the final development of my painter's eye." Women in the Garden is a forerunner of the Impressionist style. It was painted en plein air and shows a fascination with the effects of natural light. The composition is cut off at the edges, trying to preserve in a big work the spontaneity of a sketch. However, the brushwork is still fairly traditional, the figures show an underlying draftsmanship, and Monet is concerned with details that in later years would disappear completely.

Monet had to have a trench dug in order to reach the top of this 3-m (9-ft 9-in) canvas. On one occasion the landscapist Gustave Courbet (1819–77) visited. Monet was not working and when he asked why not, Monet replied that he was "waiting for the sun." The older painter suggested that he paint in the background while he waited but Monet was adamant that everything had to be painted in the same light.

Refused by the Salon in 1867, Zola alone defended this *tour de force*, describing the then-extraordinary effects of light and shade cutting across the path and the women as "Nothing stranger as an effect."

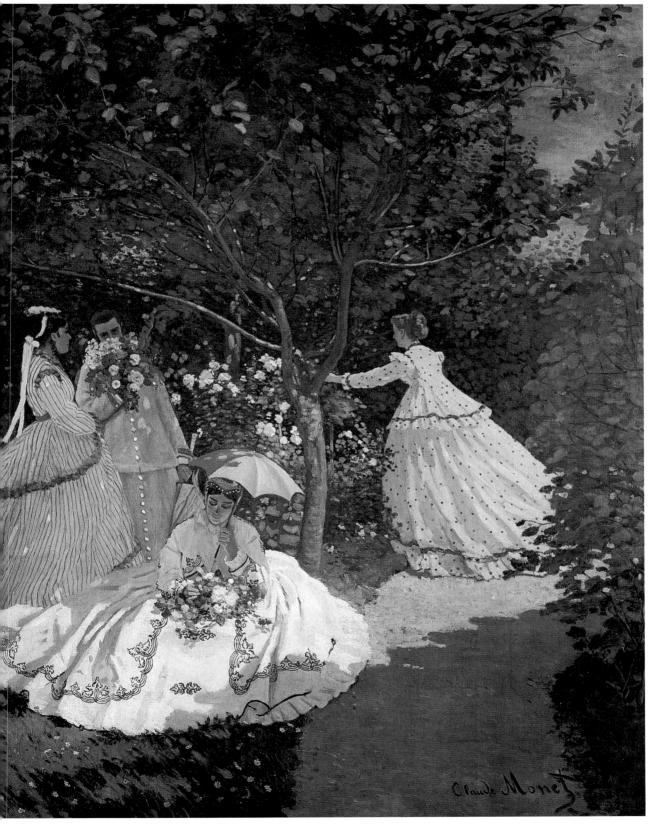

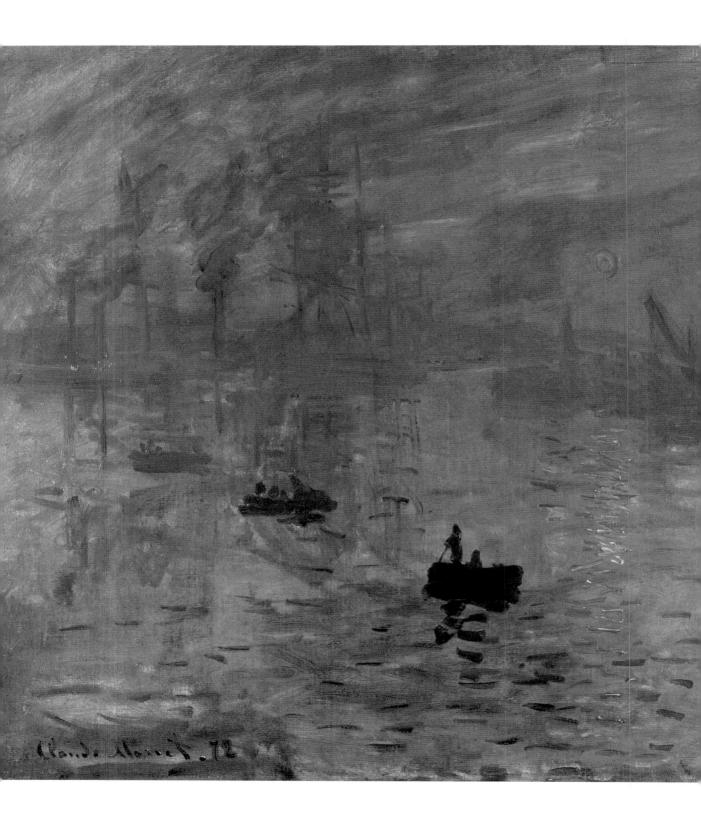

CLAUDE MONET Impression: Sunrise, 1872

Musée Marmottan, Paris. Celimage.sa/Lessing Archive

N 1874 a group of artists led by Monet and his friends, dissatisfied with their dependence upon the selection of the official Salon for success, set up an exhibition to show their own work. The exhibition, at which 30 painters exhibited, including Boudin, Cézanne, Degas, Guillaumin (1841–1927), Morisot (1841–95), Pissarro (1830–1903), Renoir, and Sisley, showed works that were considered typical of the new art's approach. But critics lashed out at the new aesthetic. They were horrified at the modern subject-matter, the unfinished quality of the pictures painted out in the open, the lack of draftsmanship, and the bright, pure color that was used to depict the passing effects of light.

Impression: Sunrise, sketched early one morning at the docks in Le Havre, is the work that gave rise to "Impressionism," a term first used in a satirical magazine in which the critic claimed to have seen the exhibition with a pupil of Ingres (renowned for his draftsmanship). Confronted with these works, he cried out: "Eheu, I am an impression on legs, the avenging palette knife."

This was followed by another article that singled out Monet, Degas, Renoir, Sisley, Morisot, and Pissarro, carefully differentiating their different styles and calling them Impressionists, "in the sense that they do not produce a landscape but rather convey the sensation produced by the landscape." But the name stuck and was used to describe all the artists of the new aesthetic regardless of their individual styles, subject-matter, and techniques.

CLAUDE MONET Poppy Field at Argenteuil, 1873

Musée d'Orsay, Paris. Celimage.sa/Lessing Archive

N 1872 Monet settled with his wife Camille and son Jean at Argenteuil, having spent the years of the Franco-Prussian War of 1870–71 in London. Argenteuil provided him with plenty of idyllic subject matter. *Poppy Field at Argenteuil* is one of his most famous works and was shown at the first Impressionist exhibition in 1874. The small dabs of brilliant color evoke the heat and vibrant atmosphere of a summer's day.

In this painting, in which the figures (Camille and Jean) seem so much part of the landscape, Monet creates an effect of time—not just of a fleeting moment, but of that moment within a broader time frame—in this case, a walk among the poppies. Beneath a broad sky, the poppy bank descends from the left in a swathe of vibrant color. Two pairs of figures (almost like two frames of a moving film) come out into the sunlight—the tree on the far left echoing the upright female figure, implying the distance that they have come. The spontaneity of the scene is created not only by the sketch-like, faintly blurred effect of the paint, but by the figures in the foreground—the child with the flowers he has picked, his mother, with her arm swinging forward as she walks, and her parasol swung casually over her shoulder.

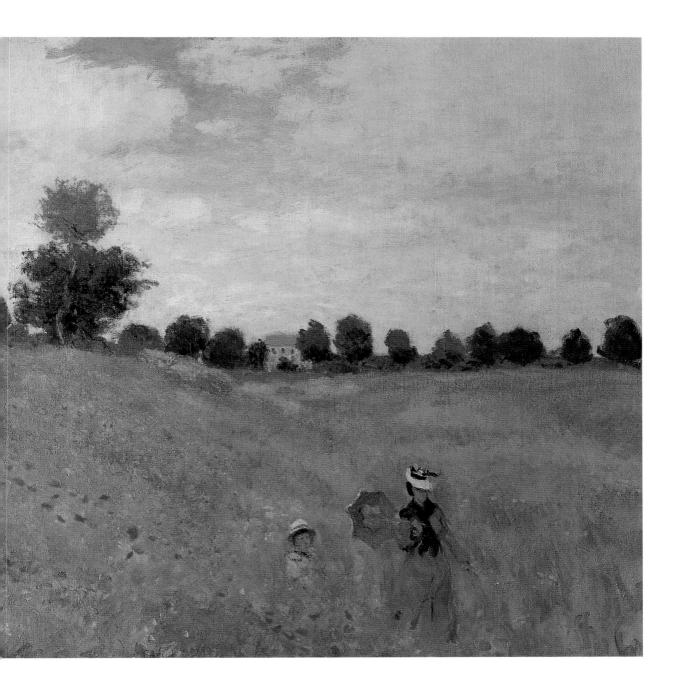

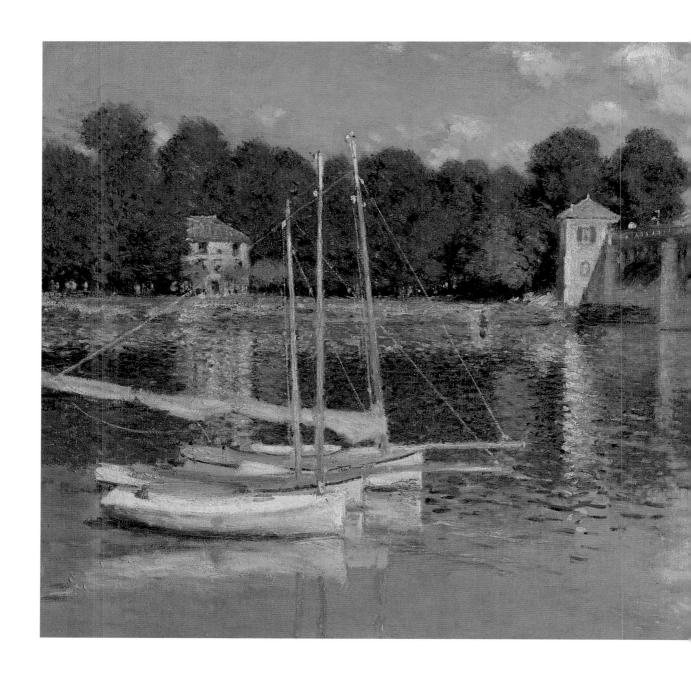

CLAUDE MONET The Bridge at Argenteuil, 1874

Musée d'Orsay, Paris. Celimage.sa/Lessing Archive

ONET presents us with an idyllic sunlit scene—although this painting would typically have been shown within the confines of suburban Paris. He uses pure color to create the effects of light and the reflections in and of water—note the walls reflected back on themselves inside the arches of the bridge. The warm colors—blues, golds, pinks, and whites—repeat, echoing each other from one side of the painting to the other and, above all, in the reflections in the water. But the water is not just a large mirror (interestingly, mirror effects play a part in the works of other artists such as Degas), it ripples and sparkles, an effect created by applying the paint in short and long strokes or in flat patches of color.

The composition, which is so natural, does not lack structure and shows an informed balancing of the strong verticals of the trees, the mast, and the piers of the bridge (and their reflections), with the strong horizontals of the boat, bank, sky, and river.

Modern eyes hardly question the Impressionist style but even this painting was not easily acceptable at the time. Taken out of context, the broken dabs of color would not clearly represent anything at all—their power is in their relation to everything else and the effect that is seen at a distance.

CLAUDE MONET Turkeys, 1876

Musée d'Orsay, Paris. Celimage.sa/Lessing Archive

URKEYS was part of one of four decorative panels that Monet painted for the Château de Rottembourg at Montgeron for his patron Ernest Hoschedé (1838–90), who owned a textile business. Here, he returned to a large format and created a daring, innovative design influenced by the unusual viewpoints found in Japanese prints. Viewed from below, the turkeys loom tall, with the trees and the château in the distance. They are separated by size, color, and the evening sunlight highlighting their feathers and contours in bright yellow. The turkey cut off from the chest downward at the bottom of the canvas increases the immediacy of the scene and positions the viewer who is lying silently in the grass, so close to the birds, looking up a slope. As usual, Monet's palette is confined to blues, yellows, whites, and reds, which are used, particularly in the "white" turkeys, to great effect.

Monet returned from this commission to Argenteuil. He had many money worries and feared he would have to leave "this nice little house ... where I have worked so well." The family did eventually leave in January 1878 and returned to Paris where Monet had also worked over the last few years on scenes of Paris parks and stations.

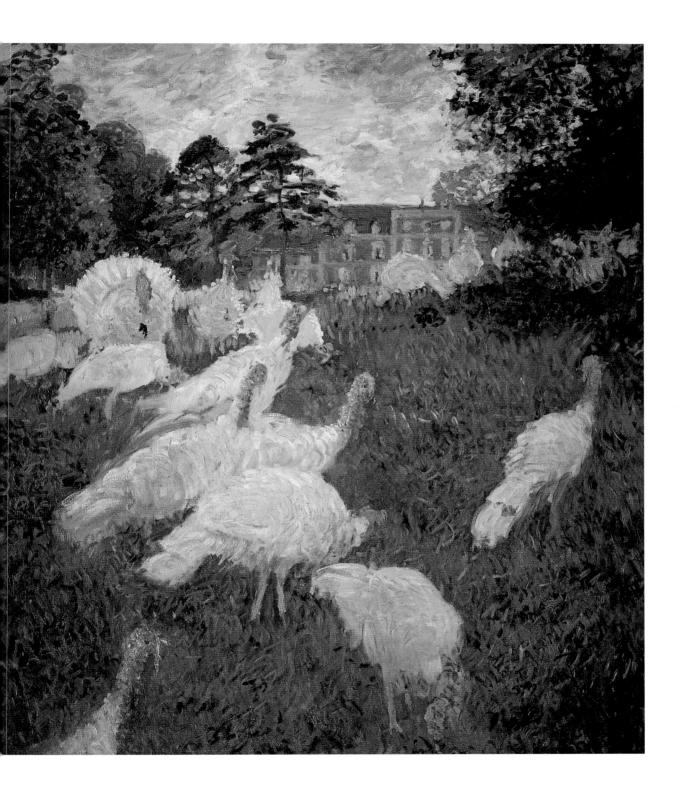

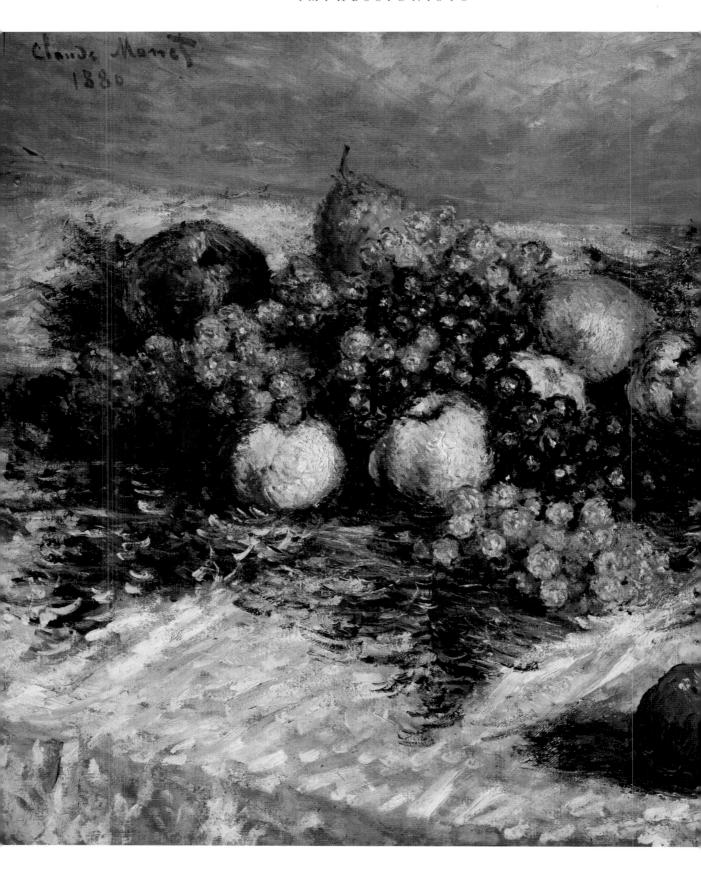

CLAUDE MONET Still Life with Fruit, 1880

Kunsthalle, Hamburg. Celimage.sa/Lessing Archive

TILL Life with Fruit provides a rare opportunity to glimpse one of the few still life paintings that Monet produced. This piece is rich in aesthetic value. Monet realistically and skillfully depicts the different fruits in their natural, rich colors, whilst retaining an emphasis on their form and composition within the arrangement as a whole. Thus, we can see how Monet treated his still lifes in a similar way to his landscapes. In Still Life with Fruit he deliberately places objects of complementary and contrasting color together, in order to convey the intense blend that we see in many of his waterscapes from Giverny. The objects are also carefully organized to provide a balance to the entire artwork.

This wealth and strength of tone and light used to construct the grapes in this piece gives them a striking authenticity. They trail across the rest of the fruit, leading our eyes across to the pears and apples, which they adorn. Compositionally, they also provide a spine to the still life, a quite dramatic focal point.

A secondary focus is established by the two bright red apples, set aside from the main assortment, near to the front of the tablecloth. Set against the green plants, these apples demand our attention.

The tablecloth and background are neutral in color and have been painted with a regular brushstroke, and they therefore do not

intrude on the observer. However, they provide a backdrop that highlights the composition and increases its striking effect.

CLAUDE MONET River Bend, undated

Musée d'Unterlinden, Colmar. Celimage.sa/Lessing Archive

LAUDE Monet was always at the forefront of artistic development. Through observing his brushstroke, the contrast of the colors he used, and the consistency with which he exploited his medium (which he went on to develop and elaborate throughout the long course of his artistic career), we can map out how Monet achieved a central role in the Impressionist movement. In *River Bend* we can see yet another combination of these elements, which shows an artistic method and technique handled with confidence, together with an extravagant use of color.

One of the first things we notice in this painting is the golden, burning red and orange sky, crowning the swirling contours in the distance and almost blinding us to the landscape. Just above the rim of the hills a bright, shimmering yellow outlines the meeting of earth and sky. The hills themselves are woven through with shades of green, red, brown, and pink, in a style that can be likened to that found in the landscapes of Vincent van Gogh (1853–90).

There is an air of mystery to this piece, as we are confronted with a body of water that stretches behind the hills to an unknown source. Fragments of color from the water are introduced into the hills and a reflection of the sky is placed on the water's surface, providing a subconscious unity.

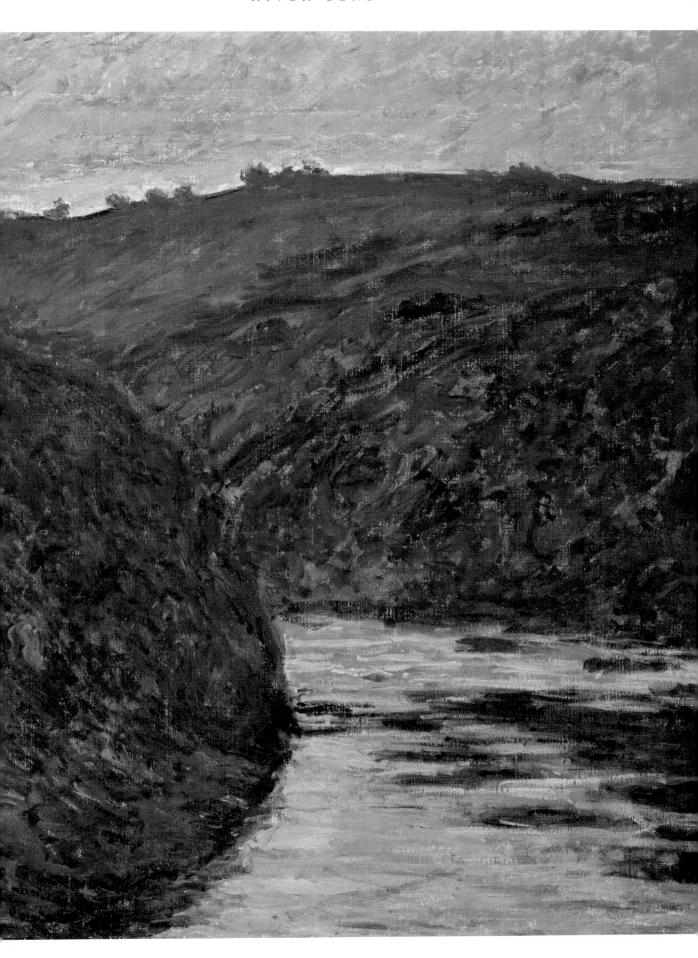

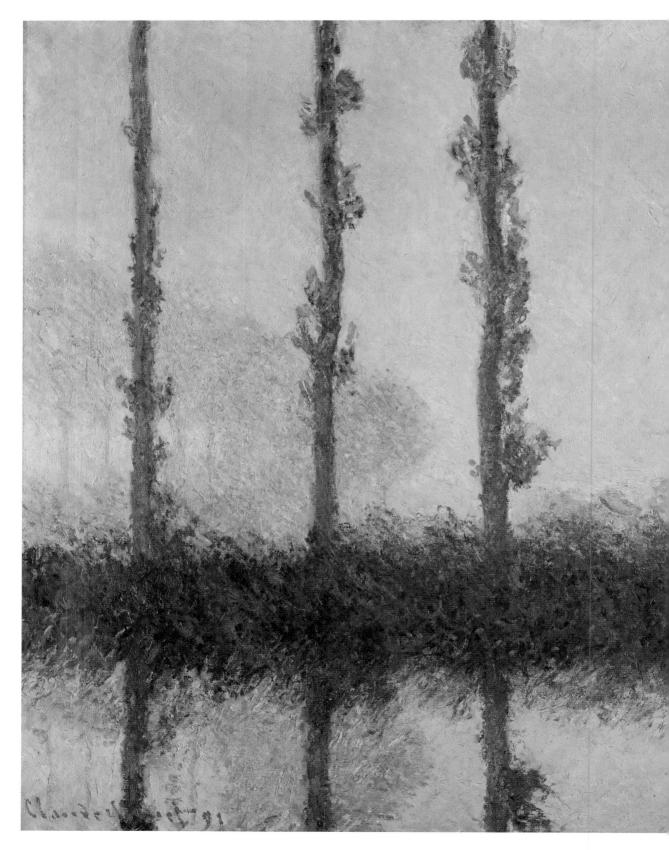

CLAUDE MONET Poplars, or the Four Trees, 1891

Metropolitan Museum of Modern Art, New York. Celimage.sa/Lessing Archive

OPLARS, or the Four Trees is one of a series of 24 pictures, showing poplars on the bank of the River Epte, that Monet painted from the spring to the fall of 1891. This painting is minimalist in terms of its content, and yet has an intrinsic beauty, produced by its cool, limited palette and delicate execution.

From the haze of glowing color in the far distance, to the blues of the trees in the foreground, it seems as though we are standing in the shade of the trees and their reflection. This contrasts with the situation across the horizon, where a thick layer of shrubbery is set alight by a fire of soft red and yellow.

Compositionally the piece is simple, yet effective. The trees immediately in front of us are evenly distributed across the width of the canvas, creating a very balanced feel. The trees themselves are equal in terms of their width, and all stretch upward off the top of the canvas. They reflect almost perfect and undistorted mirror images in the completely still water, as though the reflections are just as real as the trees.

The color scheme of this painting it is limited to a soft palette of blues, browns, greens, yellows, and reds. The reds and yellows, set against the pale blue, allow the painting to have depth and contrast, whereas the blue of the water is repeated across the sky, giving the painting a definite sense of continuity and additional balance.

CLAUDE MONET Rouen Cathedral, The Portal, Morning Sun, Blue Harmony, 1893

Musée d'Orsay, Paris. Celimage.sa/Lessing Archive

ONET traveled less and less during the 1890s but in 1892 and 1893 he went to Rouen to work on a systematic series of paintings of the west façade of Rouen Cathedral at different times of day. These he finished in his studio at Giverny. The effect was startling—over 30 paintings from three slightly different angles, ranging through shades of blue, purple, pink, and yellow. Monet wrote to Alice, whom he had married in 1892, "I am broken ... I had a night filled with bad dreams ... the Cathedral was collapsing on me, it seemed to be blue or pink or yellow."

This image, Morning Sun, Blue Harmony, recalls the colors in Monet's The Road to Vétheuil (1880), but here he is not really interested in the object upon which the light is falling. The stonework is only interesting in providing a vehicle for his research into the effects of light and atmosphere. The details dissolve under the light blue, pink, and dark gold by turns, depending on how much they are in the light or shade.

Monet's series paintings were recognized as ground-breaking. In 1913, the German abstract painter Wassily Kandinsky (1866–1944) wrote that seeing Monet's haystacks in 1897 "set the seal on my entire life ... suddenly, for the first time, I saw a painting ... one thing was quite clear: the undreamt of power of the palette ... But also, unconsciously, the idea that an object is an indispensable element of any painting had been discredited."

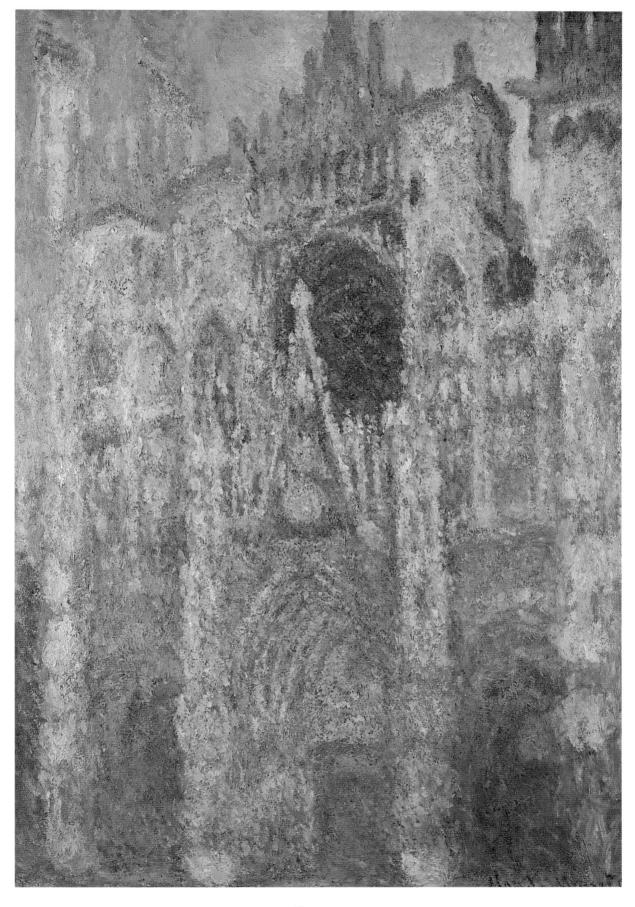

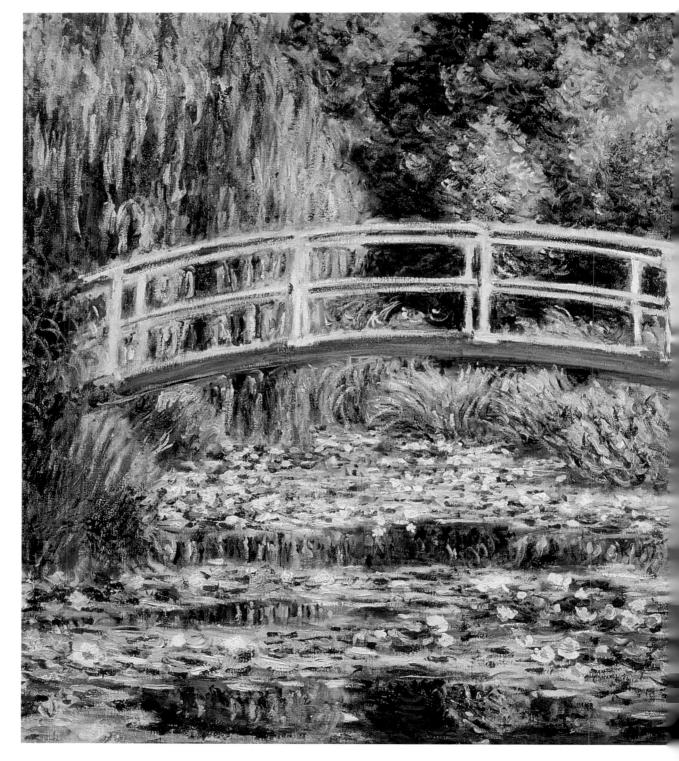

CLAUDE MONET White Water Lilies, 1899

Pushkin Museum, Moscow. Celimage.sa/Scala Archives

ONET had moved to Giverny with Alice Hoschedé and all their children in 1883. Here, he painted the garden that was the culmination of his lifelong passion for horticulture. "My most beautiful work of art," he said, "is my garden."

Monet and many of the other Impressionists had painted gardens throughout their careers but these paintings of the 1890s are no longer full of people. They become beautiful landscapes of color and reflection rather than spaces that people inhabit.

This is one of 18 views of the lily pond that Monet painted in 1899—the motif that, apart from a trip to London and one to Venice, was to dominate the last 20 years of his work. He called them his "water landscapes."

Painted in an almost square format, the sunlit bridge arches across the canvas, cutting it in two slightly above the midpoint. Below, the water, covered with lilies, recedes into the distance. Above, the sunlit trees on each side guide us into the leafy darkness beyond. Trees and rushes rise up, only to be reflected down in the water below, creating verticals that run straight through the mirror surface of the water, suggesting the depths below.

CLAUDE MONET Water Lilies, 1907

Musée Marmottan, Paris. Celimage.sa/Lessing Archive

ONET'S water garden was to become his most important motif in later life, and he explored this theme until his death in 1926. The colors in his palette were changing as his eyesight deteriorated; in later works in the series, as we see here, he moved again to hues of purple and lilac. As in the Poplar series of the 1890s, there are some things that we see only from their reflection in the water.

Based on the complementary shades of green and orange, this vivid work is, nonetheless, peaceful. The composition is verging on the abstract and works in several directions. Looking straight down, as if from the bridge, we see the two lily pads in the left-hand foreground. At water level, we look across the pond and see the lilies receding in the middle- and background. But we also perceive the reflections of the willows to be plunging into the pond, which gives an indication of depth and, by association, height. This is reinforced by the realization that the glorious golden water is a reflection of the ephemeral effects of the sky above.

This interplay of horizontal and vertical planes is further complicated by the flat surface of the canvas, which is emphasized by the vigorous textural brushwork over most of the painting.

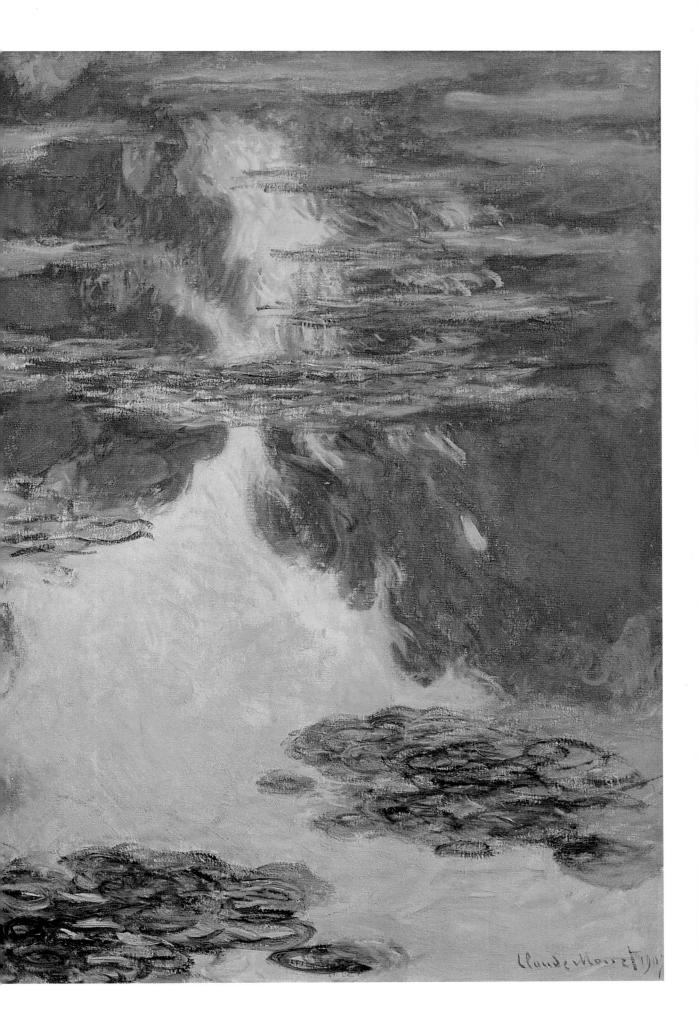

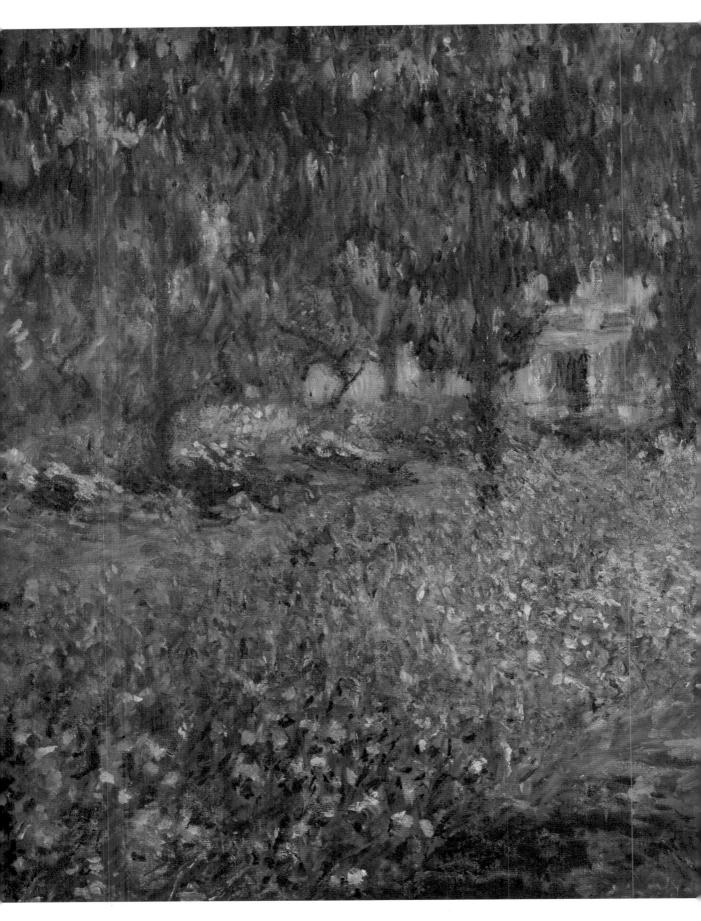

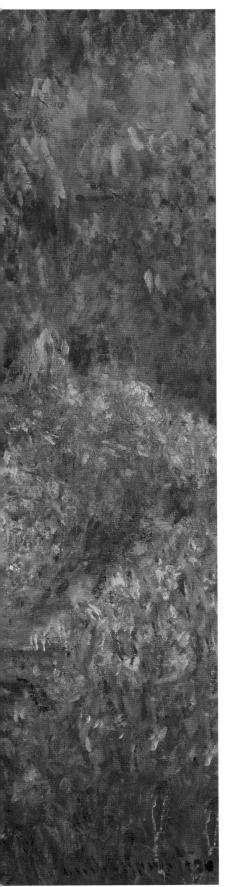

CLAUDE MONET The Garden at Giverny, undated

Musée d'Orsay, Paris. Celimage.sa/Lessing Archive

HIS painting is dominated by a sea of purple color. Our view starts at the bottom of a small, narrow path, which divides two thick blankets of purple flowers. The downward brushstrokes used for the trees mimic rainfall, which provides an interesting contrast with the more clearly defined flowers that stretch across the floor. Two shades prevail in this painting: green and purple.

A house peers at us from behind the dense layer of trees, although the two flowerbeds remain the focus of our view. There is no sky to dilute the strength of their presence, as in Monet's Field of Yellow Irises at Giverny (1887). In The Garden at Giverny, Monet is conveying the essence of the plants. Another difference between the two works is that The Garden at Giverny does not have an obvious linear design, lacking the horizontal banding found in so many of Monet's other paintings.

The tone of this piece is fairly dark, with the green trees overshadowing the plants and the house. Relief is provided by the little specks of yellow that are dotted around the trees and flowers to represent a source of light in the distance.

Monet knew the effects of all his plants, arranging them, said his stepson Jean Hoschedé-Monet, "with foreknowledge of what role they would play . . . rather as he painted a picture. . . ."

CLAUDE MONET Irises by a Pond, undated

The Chicago Art Institute, Chicago. Celimage.sa/Lessing Archive

E are drawn into a mass of flowers and foliage, which dominates almost the entire canvas. There is a vast collection of flowers of different colors, which clash together to increase the overall dramatic effect of the painting. Even as a close-up of a collection of plants, there is a striking lack of detail, and the canvas becomes a splash of color. The different colors appear to be finding different directions across the canvas, so it seems as though we are being drawn into the true, raw essence of this natural setting. Nature becomes a strong force in *Irises by a Pond* and we can see this emphasis in its composition.

The deep, cloudy red at the top left-hand corner of the picture stands out in strong contrast to the cool blue-purple flowers and the green-yellow leaves. *Irises by a Pond* gives a taste of Monet's frequent use of red in his later garden landscapes of Giverny.

The only measure of detail is on the leaves at the bottom right of the canvas, which are accentuated by a fine line of blue shade running beneath them, suggesting their prominence. An almost granular effect is achieved in the top righthand corner, giving a sketchy quality to the painting.

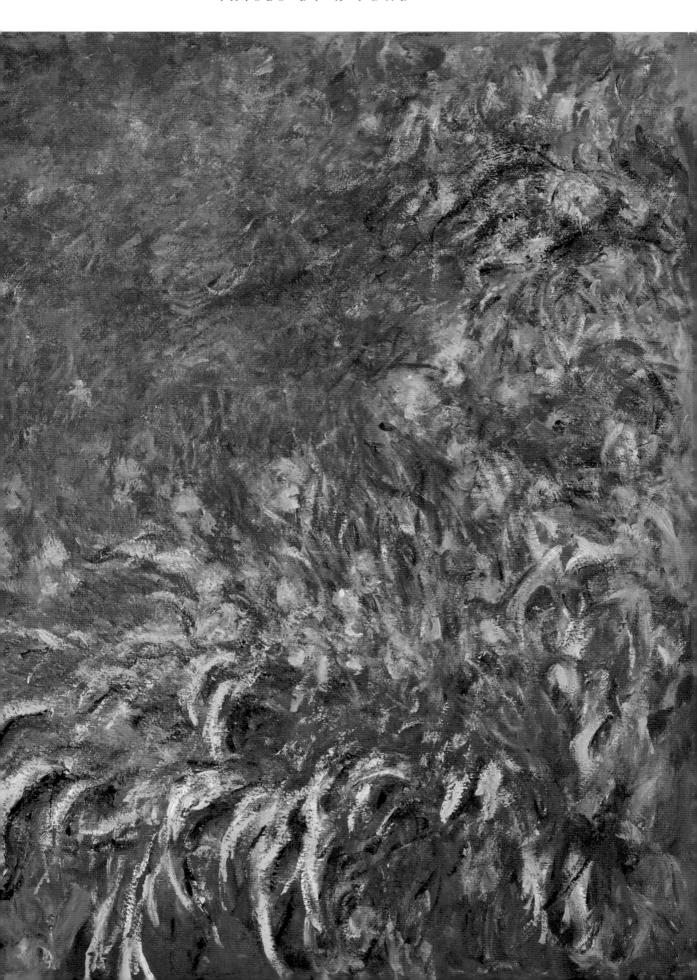

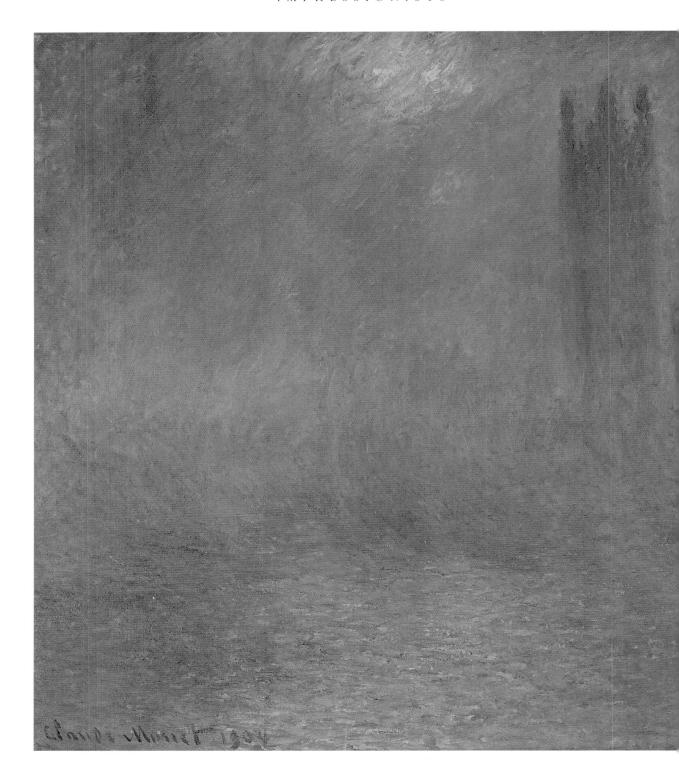

CLAUDE MONET London, Parliament, 1904

Musée d'Orsay, Paris. Celimage.sa/Lessing Archive

N 1904, Monet revisited London, where he had spent the years of the Franco-Prussian war. From a suite of rooms at the Savoy—he was now very comfortably off—he painted many views of the Thames, with the Parliament building as here, or Charing Cross and Waterloo bridge.

The style of his work has moved away from the dab-like brushmarks of his typical Impressionist manner, as it did for a while in the 1890s when he painted views of the Seine. Here, the brushstrokes seem to fuse, shining through or obscuring one another—as the sun sets through the pall of the London fog.

These Parliament pictures, along with the Rouen Cathedral series, are Monet's only paintings of architectural monuments. As with the Rouen series, the building is an excuse for effects of light and color, and in this case, shape, which Monet has simplified dramatically —a green and purple spiky shadow between two flaming orange and gold patches of light and reflection. The light struggling through the mist creates a stunning, focused effect.

Of his paintings at this time, Monet said: "I want to paint the air in which the bridge, the house, and the boat lie, the beauty in which they are, and that's nothing other than impossible." The air in which the Parliament "lies" here, pervades the entire scene.

CLAUDE MONET Water Lilies, undated

Musée de l'Orangerie, Paris. Celimage.sa/Lessing Archive

FTER 1900 Monet became increasingly focused on painting his lovely garden at Giverny. Most if not all of his canvases were consumed with the swathes of color, the water lilies, and the Japanese bridges that would become the most celebrated subjects of his long and prolific career.

This piece is aesthetically stunning but at the same time calming, with its predominant crystal bluepurple water, which embraces the lilies that float randomly across its surface. There is no perspective, but we become completely lost and transfixed by the sheer size and depth of color of the painting. It exemplifies what it is that we celebrate about the artist: his ability to stun his viewers with the breathtaking beauty and inherent harmony of his canvases.

Looking closely at the painting
we can observe the subtle detail of the ripples generated by the slow
motion of the lilies. In some areas Monet has applied a fine line of color
to emphasize the direction of the water's movement. The color of the
green plant hanging into the water is repeated in its reflection and the
random spots of pink and yellow are like little lights or fires that stand
out against the placid blue liquid.

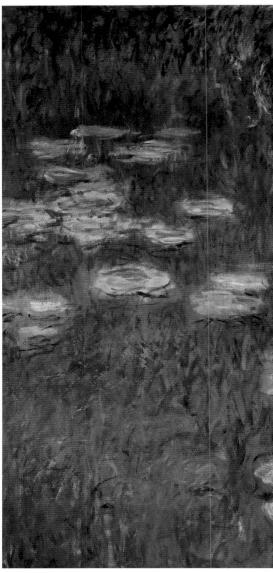

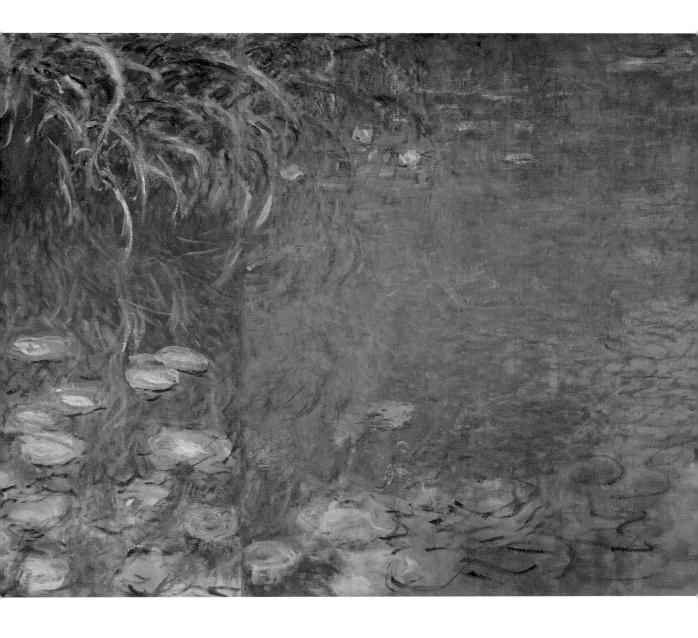

CLAUDE MONET Water Lilies, 1915–26

Musée de l'Orangerie, Paris. Celimage.sa/Lessing Archive

ETWEEN 1911, when his wife Alice died, and 1914 Monet hardly painted at all. In 1912 Monet was diagnosed with cataracts and his son Jean had a stroke—he subsequently died in February 1914.

In April 1914, Monet began to work again—predominantly on large-scale decorative panels, 2 m (6 ft 6 in) square. In 1915 he built a larger studio to accommodate them and larger ones, measuring 3 x 6 m (9 ft 9 in x 19 ft 6 in), followed. In 1918 he offered two of these *Grandes Décorations* to the State in celebration of France's victory in

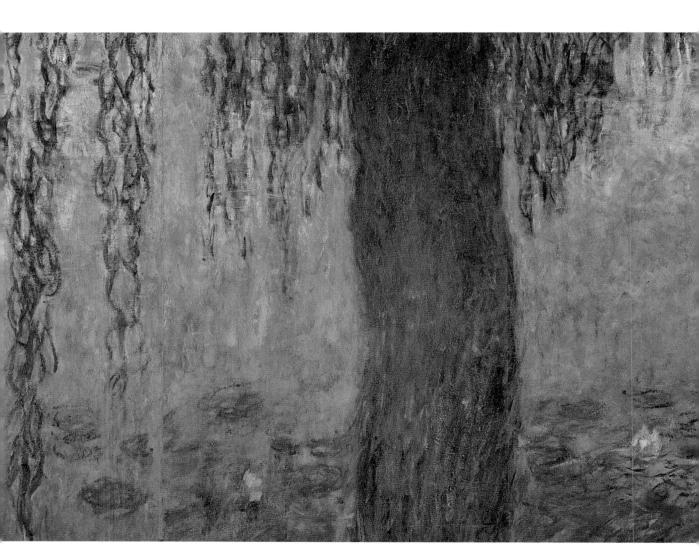

the First World War. In 1922, it was agreed that eight panels would be hung, after Monet's death, in the Orangerie at the Tuileries Gardens. By this time he was 82 and, with the exception of the critic Geffroy and Armand Guillaumin, was the last survivor of the original Impressionist group. Monet found much of this work frustrating and he destroyed many panels. In 1923, he had his cataracts operated upon and his vision improved and cleared of the red and yellow cast that is particularly evident in some of his canvases from about 1918.

He died in December 1926, aged 86, still an artistic rebel and an inspiration for the abstract movement and the work and ideas of artists of the new avant-garde.

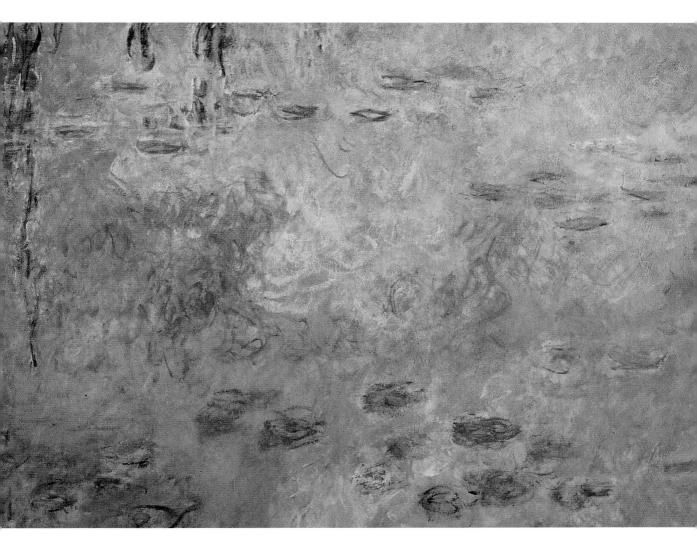

ALFRED SISLEY (1839–99) View of the St Martin Canal, Paris, 1870

Musée d'Orsay, Paris. Celimage.sa/Lessing Archive

LFRED Sisley, born in Paris but the son of wealthy English parents, is the English Impressionist. He intended to make a career in business but in 1857 began to draw. In 1862 he entered the studio of the artist Gleyre, where he met Monet, Bazille, and Renoir—the latter painted his picture in 1868. With them, he painted in the woods near Barbizon, an area popular with landscape artists.

Sisley was a committed landscape artist and his art generally focused on the riverside villages to the west of Paris where he lived. He had little interest in the human figure or the modern urban scenes that fascinated his colleagues.

This picture shows a view of the Saint Martin Canal, almost the only site that Sisley ever painted in Paris itself. It shows a traditional composition receding to a central vanishing point on the horizon—something he tended to maintain throughout his work.

As in many of his paintings, Sisley favors a big sky. "Not only does it give the picture depth through its successive planes, it also gives movement," he once said. Much like Monet, he shows a love of water and sky and their relationship with each other—a mutual source of light and reflection, here enhanced by the darkness of the buildings and trees on either side.

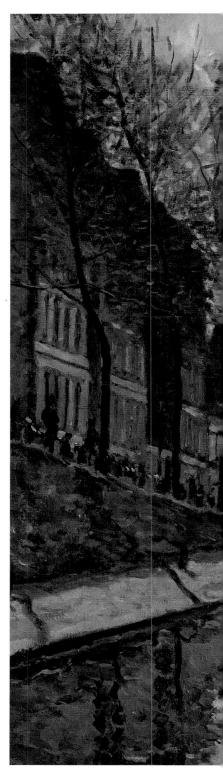

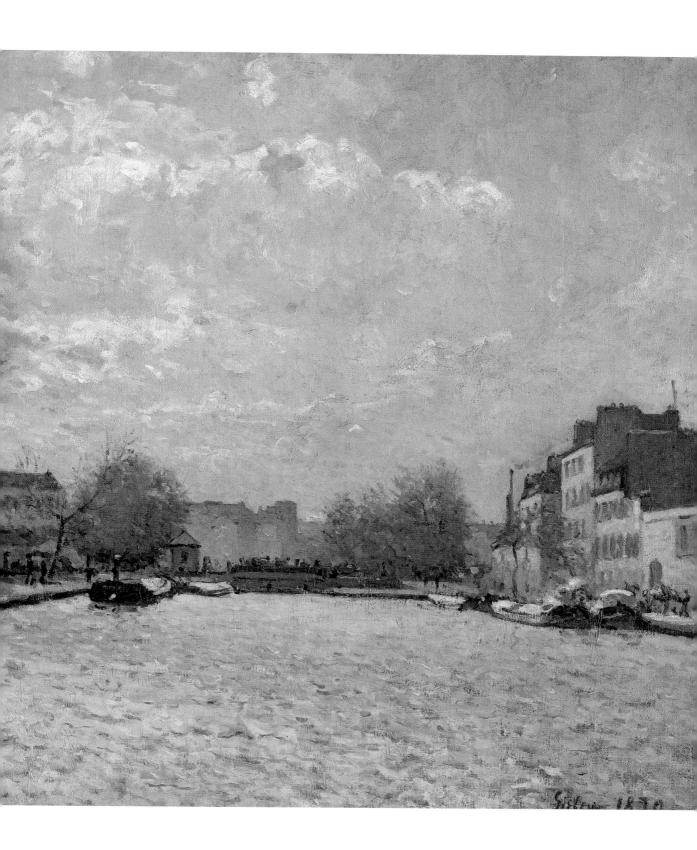

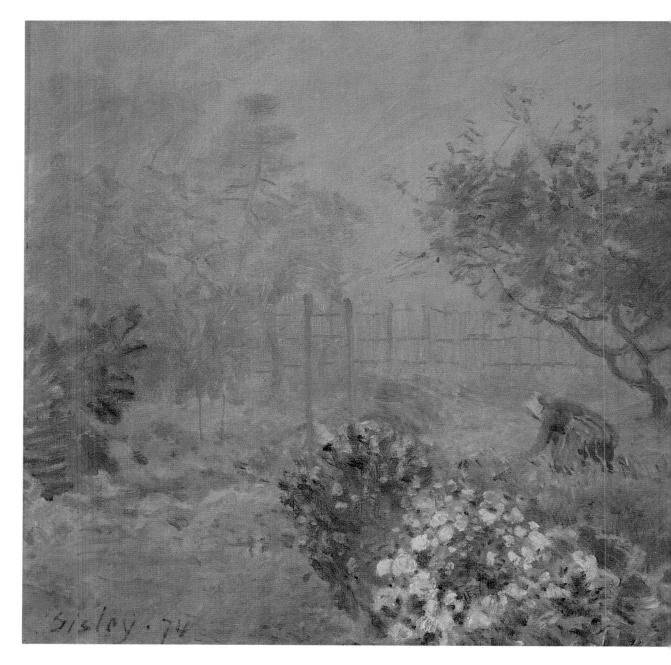

Alfred Sisley Misty Morning, 1874

Musée d'Orsay, Paris. Celimage.sa/Lessing Archive

HIS was painted the year of the first Impressionist exhibition in 1874. By this time Sisley had lost his family fortune as his father's business went bankrupt during the Franco-Prussian War. But he was managing to sell some pictures to the dealer Durand-Ruel, although his prices were never as high as Monet's, whose work his own reflects. Of all the Impressionists, Sisley experimented the least, painting in the Impressionist style throughout his entire career.

Even so, this is an unusual picture, showing as it does, the muffling of light and vision by the mist. Sisley presents delicate harmony of colors—pinks, blues, and greens. The trees are a soft blue, as is the fence that defines the limit of what we can see before the soft mantle of fog takes over. The softness of the treatment contrasts with some of the more vigorous brushwork in other paintings such as *View of the St Martin Canal* (1870).

The flowers in the foreground and the woman bending over in the middle ground are more clearly defined, but are still softened and enveloped in the mist. The informal brushwork varies, according to Sisley's belief that there should be a variety of treatment, even in a single painting, corresponding to the needs of the subject matter and the effect being sought. This is one of the reasons that Impressionist paintings in general create such a feeling of vitality.

ALFRED SISLEY Snow at Louveciennes, 1878

Musée d'Orsay, Paris. Celimage.sa/Lessing Archive

N 1876 and 1877, Sisley exhibited at the second and third Impressionist exhibitions and moved to Sèvres. But his finances were not good and he was being supported by the collector Eugène Murer (1845–1906), who was a hotelier and friend of Armand Guillaumin, and also by Georges Charpentier (1846–1905), another collector who was a patron, in particular of Renoir. The years 1878 and 1879 were very lean for Sisley, with few purchases of his paintings.

This snow scene of Louveciennes, where both Pissarro and Cézanne lived, shows a muteness of color and a solitary figure that perhaps reflect Sisley's anxiety in those difficult years. The effect is bleak. A leaden yellowish-gray sky lowers over a country lane. Thick, white snow covers the ground, the fences, the trees, the tops of the wall, and the church roof in the distance. But there is no sunshine to make the snow glisten and sparkle, or create pink or blue shadows and reflections. There is no warmth. A subtle use of black predominates.

The vertical format has an elongating effect and increases the sense of emptiness, as there are no trees to connect the upper and lower edges of the painting. The large triangle of sky holds our attention as much as the triangle of snow that comes to meet it in the figure of the lone, dark woman heading toward a dead end.

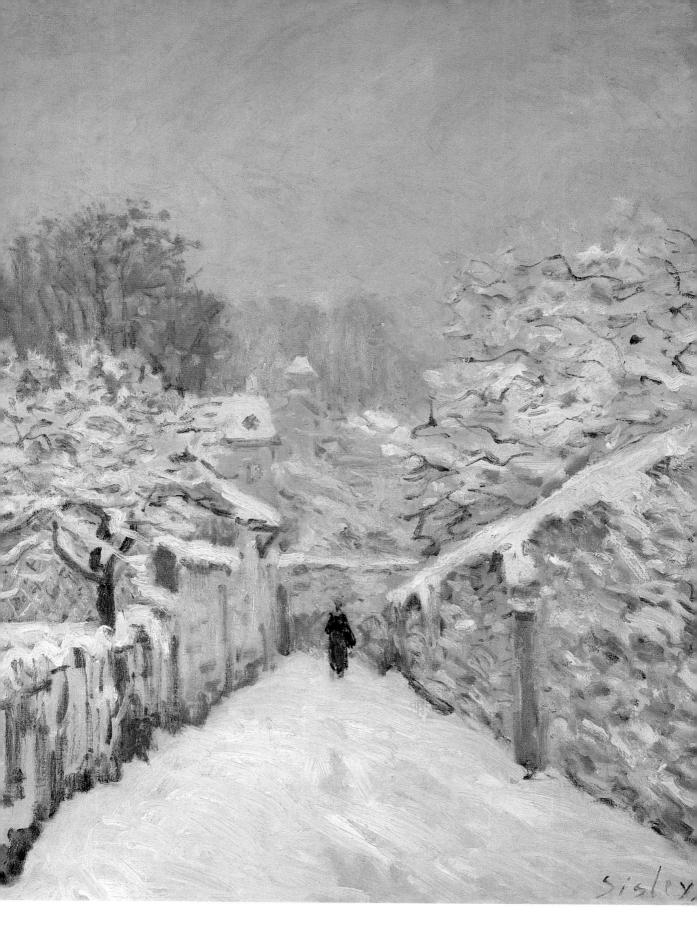

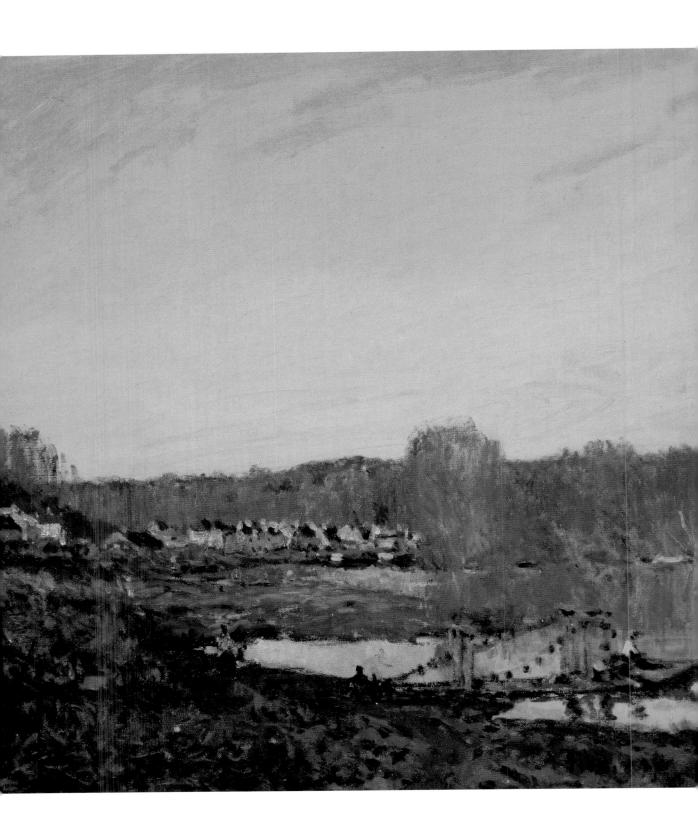

ALFRED SISLEY Autumn: Banks of the Seine near Bougival, undated

The Montreal Museum of Fine Arts, Montreal. Celimage.sa/Lessing Archive

NUSUALLY, the sky dominates this still and serene river scene, its prevailing presence underlined by the reflection of its color in the water. The trees on the far bank cast their golden, hazy reflection on the water, and give out a warm, rosy glow across the horizon. Their fiery red and orange colors contrast with the pale, cold blue of the water and the sky, and they form an assertive band between the two. The effect of the sun through the trees reaches right across to the other side of the water, and reflections of the colors play along the green foliage and the walls of the houses. Even the sky is infused with a glow that reflects the light of the trees. Their treatment is reminiscent of paintings by the English painter, Turner (1775-1851), whose works Sisley would have seen on his visit to London in 1874.

The palette used is a blend of warm yellows, oranges, and reds, which work in juxtaposition to the cool greens and blues. A mild balance is struck through the repetition of the warm colors in the sky and along the ground, providing a subtle unity to the painting.

ALFRED SISLEY Villeneuve-la-Garenne, undated

Pushkin Museum, Moscow. Celimage.sa/Lessing Archive

HIS view is typical of most of Sisley's work, since his method changed little during the course of his career. Sisley differed from his contemporaries in this sense, and although he remained loyal to Impressionist values, he sustained his interest in his subject and its faithful recording.

The heavy and threatening shadows cast by the trees in the foreground recall the works of Camille Pissarro (1830-1903). The branches frame our view of the river and the houses along the bank, creating a dark, almost foreboding atmosphere.

Aesthetically, this painting has many interesting aspects, some more obvious than others. The water has been executed with a fine and detailed realism, which is evident even from behind the restraint of the trees. However, closer to us, in the near foreground, brightly-colored leaves are scattered across the surface of the grass and soil. These also are executed with a notable exactness, despite their position in the shade.

This work is composed asymmetrically and is cut off on both sides so that we are aware that the world continues to the left and right of our view.

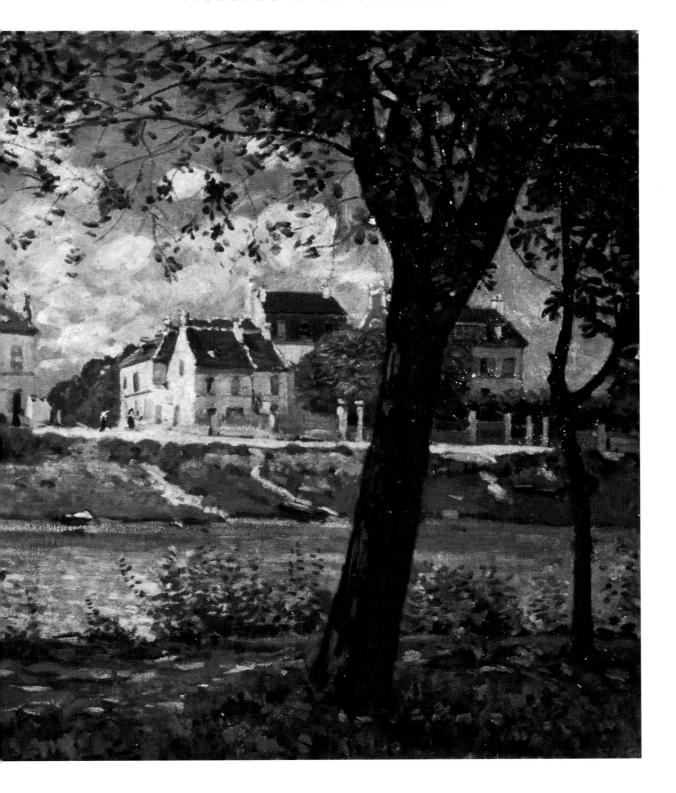

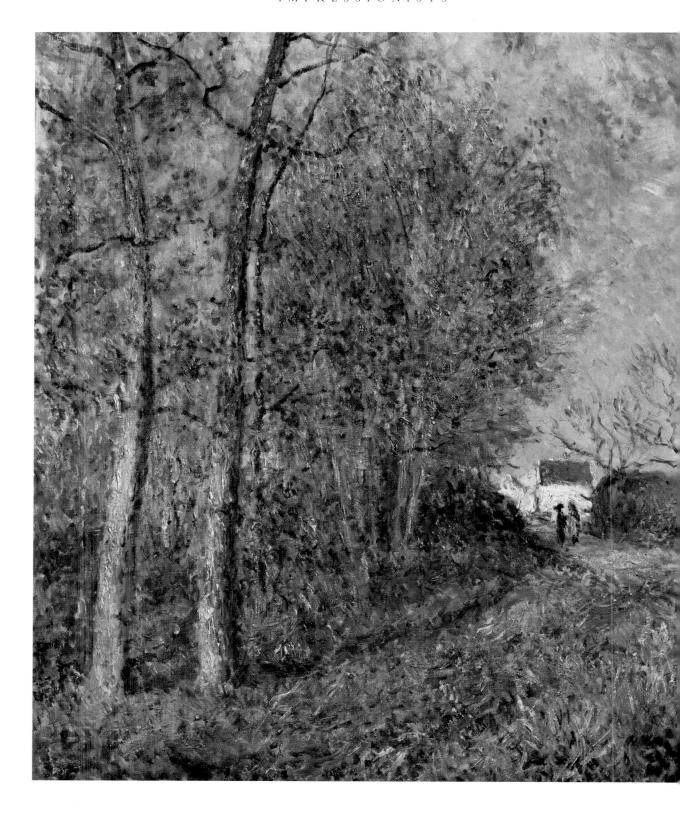

ALFRED SISLEY Road at the Forest Fringe of Fontainebleau, near Moret-sur-Loing, 1883

Musée d'Orsay, Paris. Celimage.sa/Lessing Archive

HIS is painted in a typically free impressionistic style, the colors and brushstrokes imbuing the work with vivacity and joyfulness. The brightness of the sky and the tender use of red in the leaves more than compensates for the bare tree in the distance and the cold white of the house, resulting in quite a warm image of a cold fall day.

The paint has been applied in the same way throughout the foliage of the trees and across the sky, with small, frequent brushstrokes. Perspective is defined as the brushstrokes become smaller toward the distance, so that the house at the end of the path looks as though it has been composed of a series of very small white-cream dots. The leaves on the ground closest to us are painted slightly larger and longer, signifying their close proximity. Sisley used this technique more overtly in other works, such as *Spring in Moret-sur-Loing* (c. 1888), to suggest areas of varying light across the painting.

A similar composition is also adopted in both artworks. The location and color of the houses act to direct our focus toward the sky. In *Road at the Forest Fringe of Fontainebleau*, *near Moret-sur-Loing*, a differentiation between the ground and sky is also created by the use of a contrasting palette of reds, set against a cool blue and stark white.

CAMILLE PISSARRO (1830–1903) Pissarro, Self-Portrait, 1873

Musée d'Orsay, Paris. Celimage.sa/Lessing Archive

AMILLE Pissarro was the oldest member of the Impressionist group, two years older than Edouard Manet. He began drawing in 1855, and first painted under the influence of the landscapist Gustave Courbet (1819-77), whose work he first came across and admired at the World Fair in Paris in 1855.

Pissarro met Paul Cézanne and Armand Guillaumin, who considered him their mentor, in 1862 at the Académie Suisse. Like many of his fellow Impressionists, Pissarro exhibited at the Salon des Refusés in 1863. Between 1864 and 1868 he ran into financial difficulties and spent part of 1868 producing shop signs with Guillaumin in order to earn more money.

Pissarro, Self-Portrait was completed in 1873. In the painting, the artist's gaze seems ambiguous, as it is difficult to tell whether he is looking directly at us, or whether his eyes are looking slightly to our left. The overall image is subdued by a dark, misty layer of brownyellow, which stains Pissarro's beard and skin. His stature is quite strong, with his shoulders expanding to fill almost the entire width of the canvas. In the background, a couple of paintings, probably by the artist himself, are hanging on the wall. In contrast to the detail of Pissarro himself, these are very roughly drawn in. The artist is definitely our main focus. The lucidity and pale palette of the backdrop provides a compelling depth and is a strong contrast with Pissarro's precise features and the bold color of his cloak.

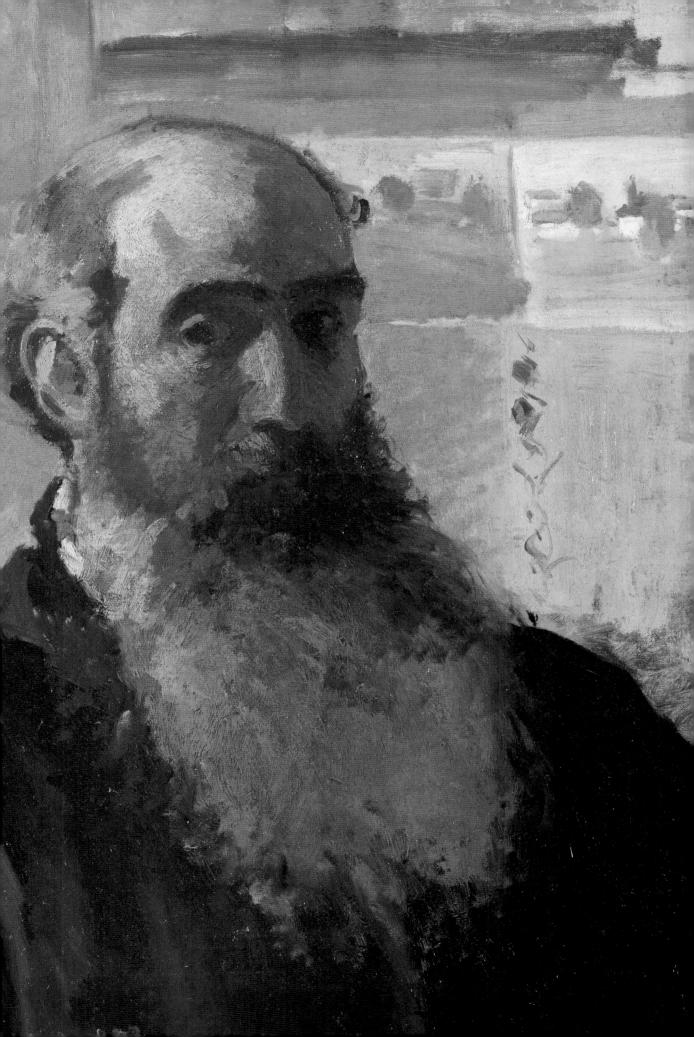

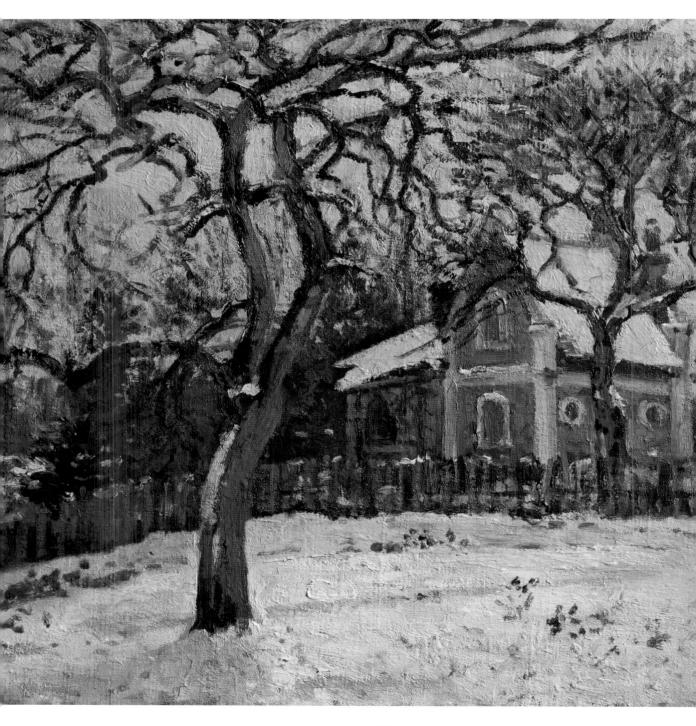

CAMILLE PISSARRO Chestnut Trees at Louveciennes, c.1872

Musée d'Orsay, Paris. Celimage.sa/Lessing Archive

FTER the Franco-Prussian War and at around the time this work was produced, Pissarro returned to Louveciennes. Cézanne also moved close by, and the two worked in conjunction with each other in the same region for the next ten years. It was at Louveciennes that Pissarro fully developed his own distinctive style of Impressionism.

This cool, wintry image provides a total contrast to the bright colors of some of Pissarro's other landscapes. The leafless trees and snow-capped roofs of the buildings contribute to the painting's effect of icy stillness. The angular position of the trees also gives the image an eerie or perhaps surreal effect.

The picture here is cut off on each side, creating a sense of immediacy, and we view the scene from a slight height, as if we are descending a slope to this place, looking from left to right. The only element that suggests that this may have been a staged composition is the appearance of the woman and child in the foreground, who look as though they are directly facing the artist. The composition of the painting is also well balanced, with the trees on either side making way for us to see the building behind the fence. The tones of the sky are also reflected in the snow on the ground, as is the red of the girl's dress and the brick of the building.

Camille Pissarro Hoar Frost, 1873

Musée du Louvre, Paris. Celimage.sa/Lessing Archive

HIS painting of a field at Louveciennes aroused much vitriolic comment at the first independent Impressionist exhibition of 1874. "What?" spluttered the critics. "Are those furrows? Is that meant to be frost ... they are just scratchings of paint placed in strips on a dirty canvas. It's got neither a head nor a tail, a high nor a low, a front nor a back...."

Not only were the critics distressed at the technique but also at the lack of subject matter. They did not understand or appreciate Pissarro's desire to convey reflections of morning light on a tilled field with the frost still on the ground in a complementary harmony of golden and blue tones.

Pissarro has put together a composition in which horizontal and diagonal lines dominate, emphasizing the breadth and depth of the scene. The geometry is immediately obvious in the strips of light and shade that run as far as the horizon from right to left and the broader edges of the fields that run the other way, drawing the viewer's gaze in opposite directions. The central point is marked by the sunlit bushes in the middle ground, where four triangles roughly intersect below the trees placed centrally on the horizon.

The brushwork is typical and lends itself to the texture of the rough clods of tilled earth. Although a lot of white is used, which creates a fresh tonality, there is an overall contrast of cool "blue" colors and warmer reds and yellows. In this shimmering atmosphere, the wood gatherer stands out, finely contoured and suggestive of the hard work involved in country living as he toils along the road.

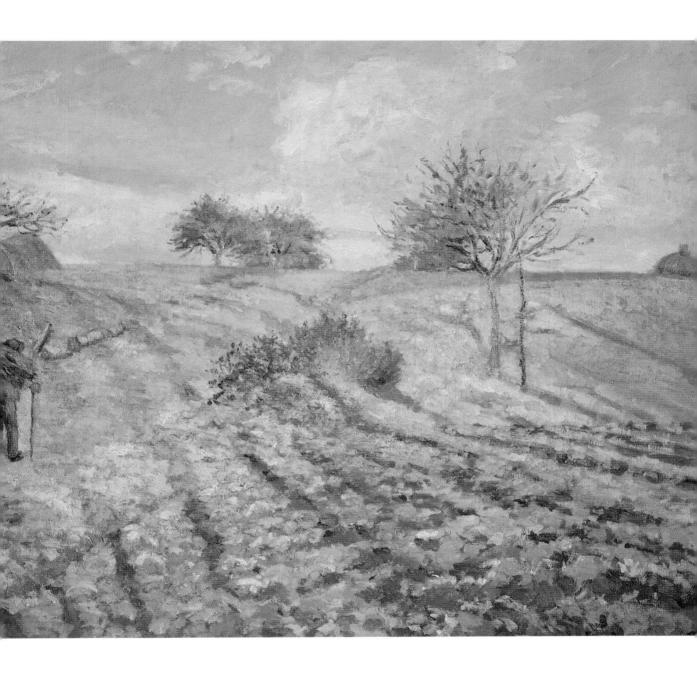

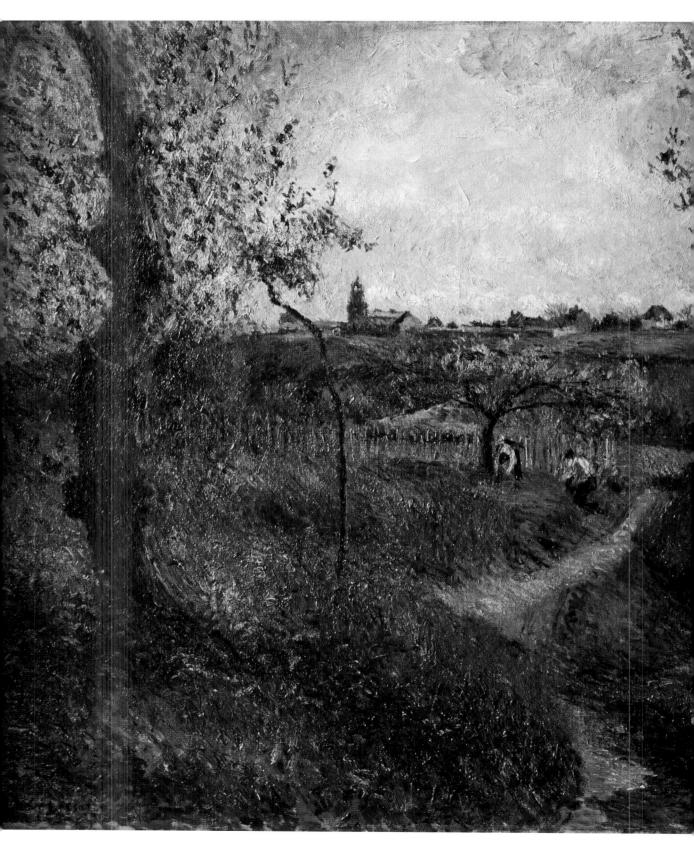

CAMILLE PISSARRO

A Path Through the Fields (Pontoise), undated

Musée d'Orsay, Paris. Celimage.sa/Lessing Archive

E can see how Pissarro had begun using the smaller, fleeting, directional brushstrokes for which he was to become known. Black has been almost completely ousted from his palette as he limits his colors to the primaries and their derivatives.

It seems as though each color featuring in this scene has been tinged with red-brown to produce this earthy image of a landscape. Such a technique can be liked to that used by Camille Corot (1797–1875). A similar effect has been used by Pissarro in *Village near Pontoise* (1873).

Pissarro was always concerned with the structure of his canvases, and in this piece we are led through the different layers of the landscape, via a meandering path, which directs us to the different aspects of the painting. The artist also explores the contrast between the verticality of the nearby trees, which stretch far beyond the height of the canvas, and the horizontal planes spreading beyond our view. The effect gives a definite perspective to the painting. The winding of the path provides a further element of contrast, as it contradicts the straight line of the trees and the breadth of the hills.

Here, nature certainly predominates, since the buildings and houses in the distance are so small that they almost vanish behind the contour of the distant hill.

CAMILLE PISSARRO The Cabbage Garden near Pontoise, 1878

Musée de la Chartreuse, Douai. Celimage.sa/Lessing Archive

HIS beautiful, warm and golden display of color parades through the canvas, constituting another fine example of one of Pissarro's bright and peaceful landscapes. It is as though we can divide his paintings into two different categories, other than simply landscapes and portraits. In some of his works, Pissarro uses a mild, warm and golden palette, whereas in some of his winter paintings, the icy grays, blacks, and stark whites create a totally different effect.

In The Cabbage Garden near Pontoise the sun glazes the landscape and the two people, inviting us to observe the scene. Traditionally for the artist, the figures are immersed in a blend of color that is similar to that of their natural surroundings, a technique also used by Claude Monet. Pissarro, like Monet, repeated colors in different parts of a painting to emphasize the internal unity between its different aspects. In this piece, Pissarro also achieves this through a harmony of colors, and a rhythm of line and shape across the canvas. The way in which the medium has been applied to the surface of the canvas suggests the influence of Cézanne, who built up shapes in his paintings through a series of mosaic-like brushstrokes.

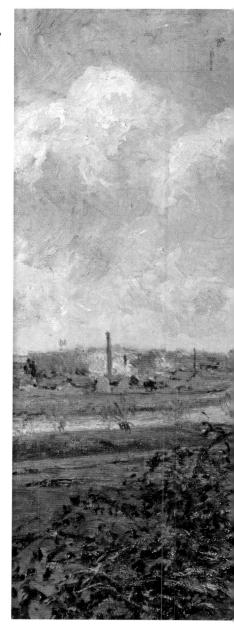

The arrangement of this piece is not very balanced, as the flatness of the landscape to the left of the picture meets with the sudden slant in the hill on the right. In addition, the people are not as integrated with their surroundings as they usually are in Pissarro's landscapes.

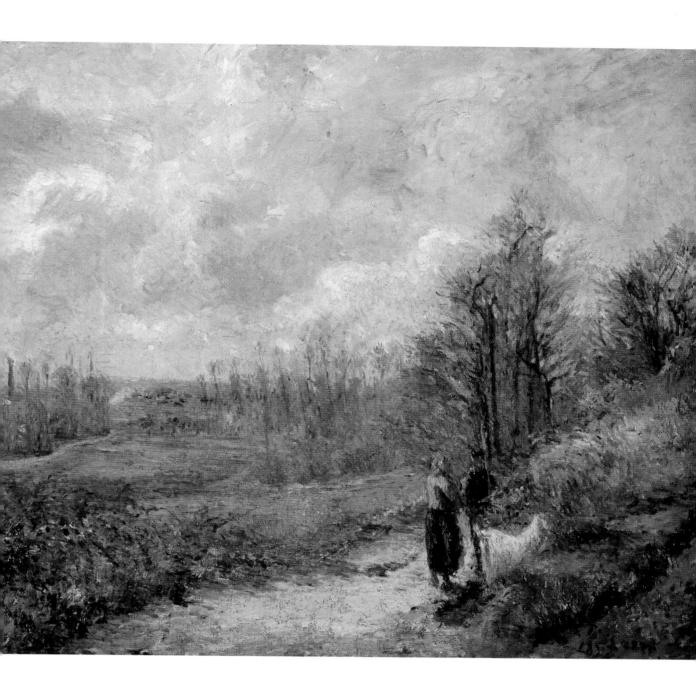

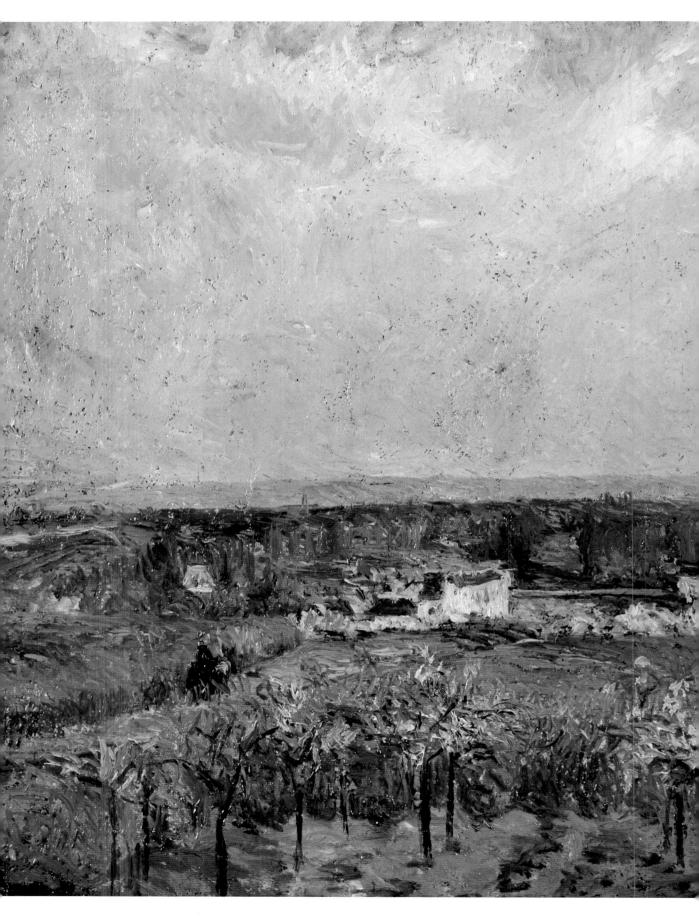

CAMILLE PISSARRO (1830-1903) Landscape at Pontoise, 1877

Musée du Petit Palais, Paris. Celimage.sa/Lessing Archive

O the left of the canvas we suddenly spy the little figure that we expect in Pissarro's work. With the aid of a few simple brushstrokes he has created a figure standing amidst the green of the field. Another recognizable trait of a piece by this artist is the small cluster of houses standing out from the landscape.

Although at first it seems as though the blue and green shades of the sky and ground contrast with one another, there is an intrinsic gentleness to the canvas, achieved through the soft curve of the hills across the horizon. These become subtly absorbed in the sky, forming a darker blue band as the green and blue colors merge into one another.

At the front of the canvas, we are faced by a group of trees, all individually defined. Each one is crested with dabs of white paint to signify the brightness of the light shining on its leaves. This technique is often utilized by Pissarro. The houses appear somewhere between these trees and the distant hills, almost totally encumbered by the green that surrounds them, and camouflaged by the white of the leaves, which is repeated in their structures.

Once again, the landscape is dwarfed by the sky, a measure that forces us to look more closely to identify the features of the painting.

CAMILLE PISSARRO Red Roofs, Corner of a Village, 1877

Musée d'Orsay, Paris. Celimage.sa/Lessing Archive

HIS is another scene from around Pissarro's home village of Pontoise and reminiscent of the pretty, but unstartling view depicted in Louveciennes (1872). In style, it bears comparison with Cézanne's House of Dr Gachet (1872), but by 1877 the latter was beginning to develop an idiom of his own that solidified nature into a timeless, geometric weight. Pissarro's work is firmly in the Impressionist style and shows the light effects on a particular afternoon.

In 1867, the critic Zola described a work of art as "a corner of creation seen through a temperament." Much of Pissarro's work, including this one, reflects this statement quite literally. As here, he often chooses enclosed views, surrounded by trees that do not stun by their majesty and grandeur. The scene is rendered extraordinary by Pissarro's treatment of it.

The green and brown earth, littered with sinuous young saplings, recedes to the white buildings with blue doors and red roofs, which are lit by the golden light that suffuses the whole canvas. The red, yellow, and green slope, farmed in strips, rises to a high diagonal blue horizon, which is fragmented by the delicate tracery of the trees in the foreground. The complicated relationships are devised solely through the use of color, which is not localized but repeated in different areas of the painting to create an overall harmony of color and design.

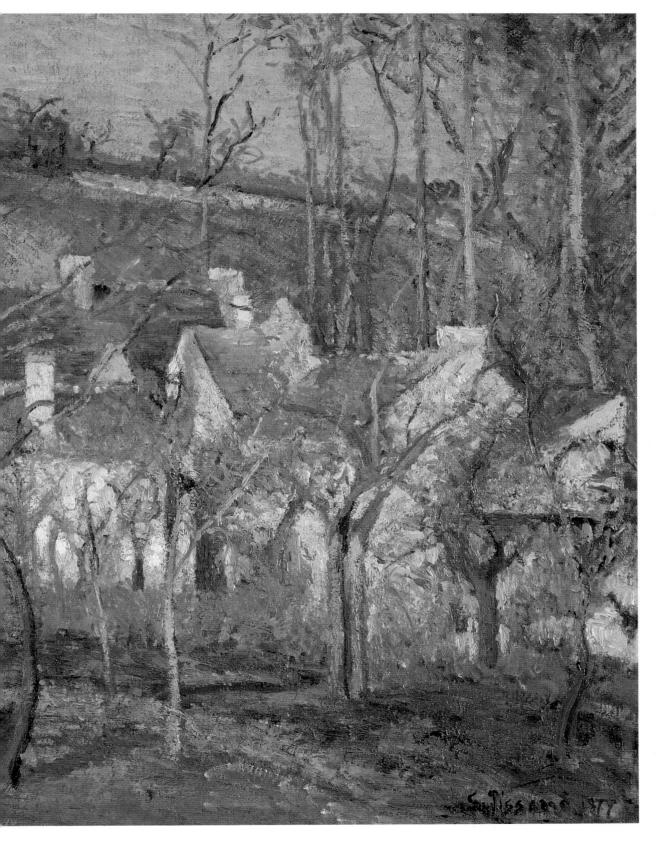

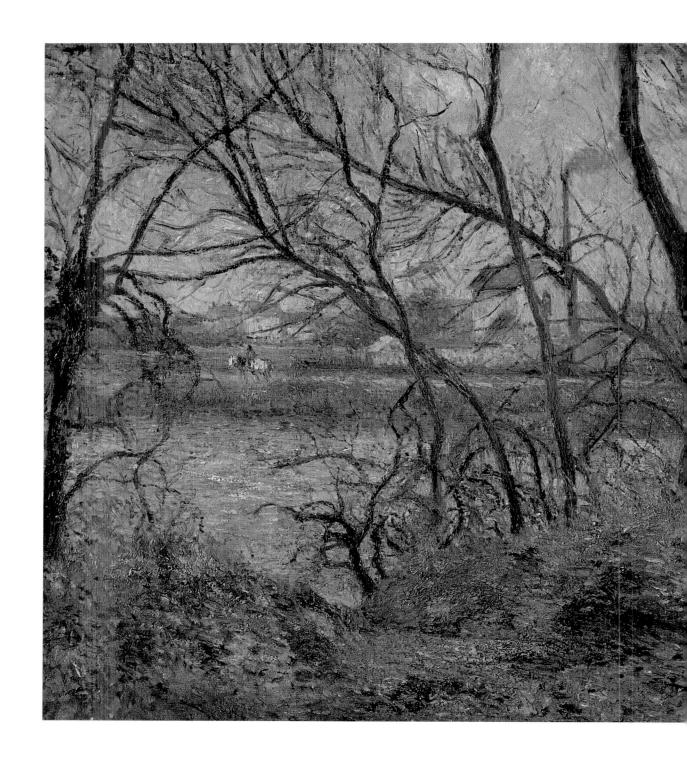

CAMILLE PISSARRO Bank of the River Oise, 1878

Musée du Louvre, Paris. Celimage.sa/Lessing Archive

N a gray day by the river Oise, Pissarro takes a view across the water to the opposite bank where a man rides a white horse. The viewer is led straight into this scene on the left by the structural composition of the foreground in which the bending, leafless trees create a kind of viewfinder focused on the scene beyond. The effect is tiny and delicate, with the trees providing a fragile framework in the painting.

Pissarro's artistic skill causes the viewer to look to the right, where in the foreground we see the sturdy trunks of larger trees through which we see a house, or possibly a factory, with a tall smoking chimney. Only at the last moment do we see the figure gathering wood, part of the diagonal created by the bending tree behind him and barely highlighted by a dab of light on his shoulder. Although Pissarro works in the Impressionist manner, in this painting he is rather more concerned with the absence of bright light, without which the colors subside and do not vibrate and dazzle. The painting recalls the muted colors of some of his earlier works, and Pissarro's longstanding admiration for Corot's gray-toned landscapes is clear. In 1866 Cézanne had written to Pissarro: "you are quite right what you say about gray, it alone prevails in nature, but it is frightfully difficult to capture."

CAMILLE PISSARRO Double Portrait of Gauguin (left) and Pissarro (right), undated

Louvre, Dpt. des Arts Graphiques, Paris. Celimage.sa/Lessing Archive

874 saw Gauguin visiting his first Impressionist exhibition, which confirmed his desire to become a painter. He developed a close relationship with Pissarro, who took a keen interest in Gauguin and his attempts at painting. In 1876, Gauguin had his first landscape painting, in the style of Pissarro, accepted by the Salon. Pissarro also introduced his new friend to Cézanne, and all three worked together at Pontoise for some time. Here, Pissarro and Gauguin drew several pencil sketches of each other, one of which was this particular *Double Portrait of Gauguin (left)* and *Pissarro (right)*.

This piece was executed in ink on paper, and the effect is quite striking. The ink sketch of Pissarro is simple yet effective, demonstrating the vast difference in style between traditional painting and Impressionism. Here, the artist has described his portrait with a black outline, which he then loosely fills with color to provide a sense of three-dimensionality. Meanwhile, the depiction of Gauguin has been executed with a single black ink

color, which has been used vigorously to outline the detail of his face and features. Both faces are shown from their right profile, yet this does not lessen the strong impression that their features create. The overall effect of both faces on this browned paper surface is quite authentic.

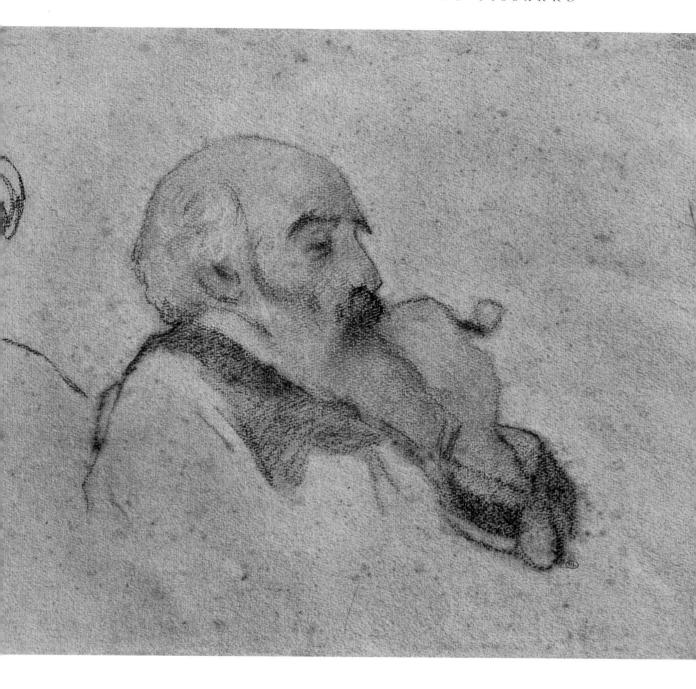

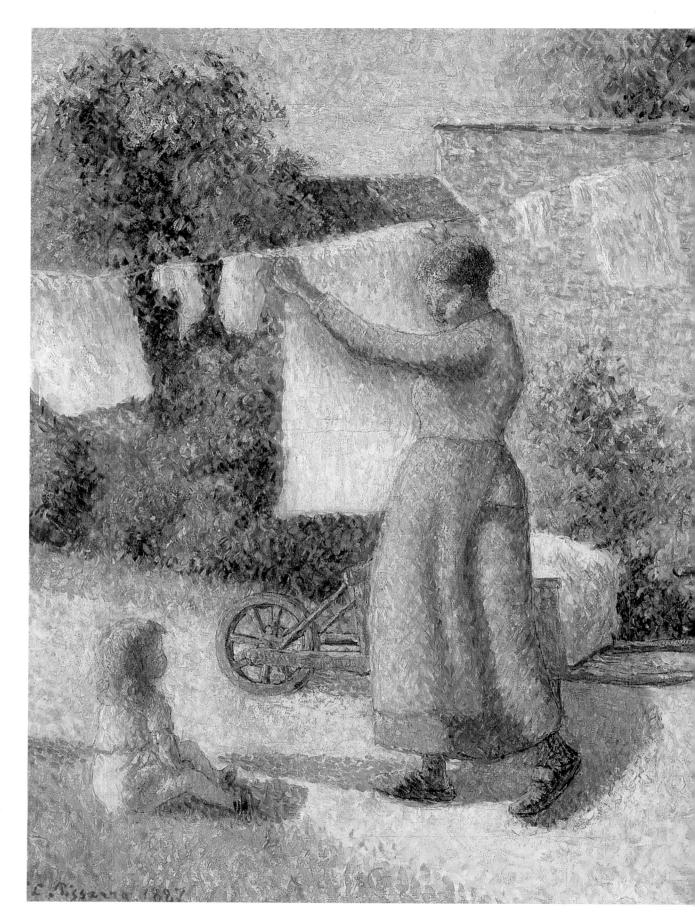

CAMILLE PISSARRO Woman Hanging Out the Washing, 1887

Musée d'Orsay, Paris. Celimage.sa/Lessing Archive

HIS is one of Pissarro's later works in which he focuses on a full-length figure. Although the composition suggests quite a large painting, as with many of the others, the dimensions are not big (16 x 13 in). The portrait formula lends itself to showing a full-length figure because it emphasizes the vertical. For landscapes, particularly with a fairly uninterrupted horizon, such as Hoar Frost (1873), which measures 25.5 x 37 in, he turned the canvases round.

This is another charming picture in which Pissarro uses small dabs of paint in a semi-divisionist manner. The only area where he seems to combine pure color for an optical effect is in the apron, in which blue predominates with a greeny tinge appearing around the folds, where bright yellow has been added.

In spite of the increased formality of the technique, Pissarro creates a feeling of movement as the young woman hangs up the washing and talks to the child. This is created by elements such as the linen on the left blowing in the breeze, the flickering quality of the brushstrokes, and the lines leading from right to left across the canvas out of the picture. Pissarro also expresses a very real tenderness for the child, whom he depicts with a charm akin to the child portraits painted by Renoir.

CAMILLE PISSARRO Woman in an Orchard (Spring Sunshine on the Field at Éragny), 1887

Musée d'Orsay, Paris. Celimage.sa/Lessing Archive

ISSARRO moved to Éragny-sur-Epte, where he painted this picture, in 1884 and stayed there until his death in 1903. It was painted a year after the eighth Impressionist exhibition, which proved to be the last owing to differences in opinion among the group regarding new exhibitors such as Paul Signac (1836–1935), Seurat (1859–91), Gauguin (1848–1903) (who began to exhibit in 1879), and Odilon Redon (1840–1916). Of the original core group, only Pissarro, Morisot, Guillaumin, and Degas took part. Pissarro was the only founder member to have exhibited at all eight shows.

From 1886, Pissarro, who was more open to new ideas than other members of the group, was influenced by the "Divisionist" technique of Georges Seurat in which bright dots of pure color were placed side by side with the intention that the color should be mixed optically by the eye.

Pissarro is partially adopting the technique in this painting, which otherwise shows a fairly typical landscape with a little figure that would almost be overlooked in the dazzling sunlight were it not for her red headscarf. Even though he has apparently taken on this new "scientific" approach, Pissarro is not applying the rules consistently. The green we see, for example, is not a combination of blue and yellow dots on the canvas as, theoretically, it should be. Pissarro was taking no chances and painted his greens green. Deep down, he remained a loyal supporter of the Impressionist ideal.

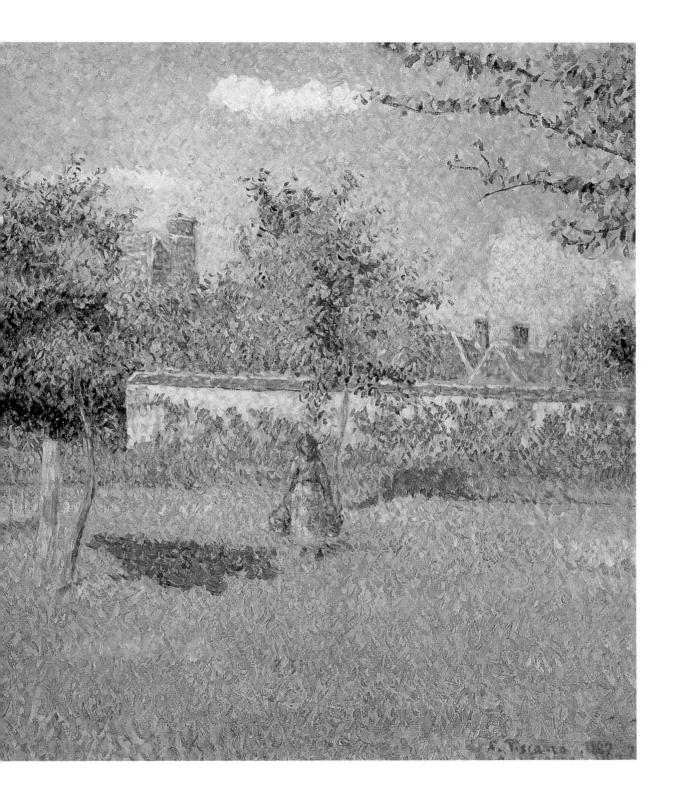

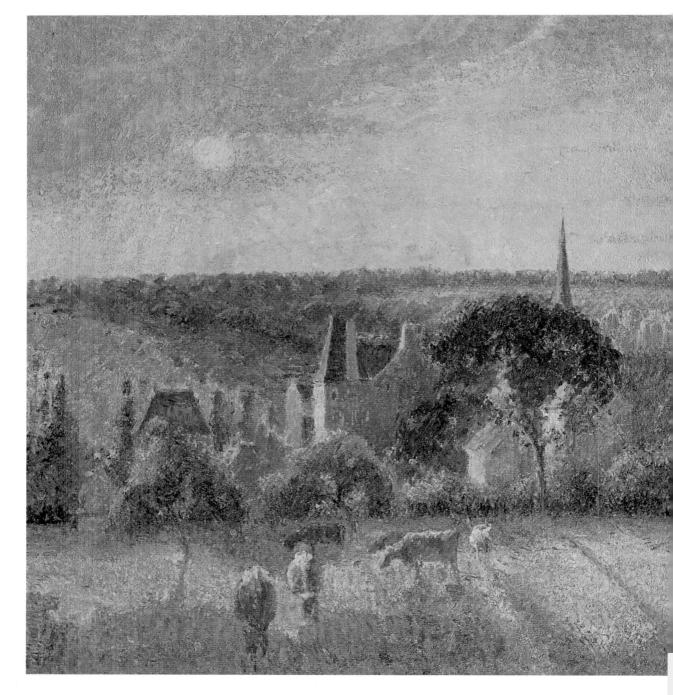

CAMILLE PISSARRO Landscape at Éragny: Church and Farm at Éragny, 1895

Musée d'Orsay, Paris. Celimage.sa/Lessing Archive

HE decade of the 1890s was a fairly active one for Pissarro. He was becoming increasingly well-known, thanks to the dealer Durand-Ruel, and with the other Impressionists had work exhibited at the Century Exhibit at the Paris World Fair in 1889. From 1890 he also made several visits to his son in London and in 1894 he fled to Belgium to escape political persecution as an anarchist.

After 1890, Pissarro stopped painting in the Divisionist style and later regretted that he had spent so long working in that way, which he felt denied his emotions and restricted movement. Here, the calm and tranquillity that we have come to expect is to the fore. The pastoral scene is peaceful, the composition is balanced in three bands, and the colors harmonize.

Pissarro's work, particularly that which depicted peasants, was often compared to the work of Jean-François Millet (1814–75), which had religious or biblical overtones. Pissarro, who was Jewish but had no religious beliefs, had become an anarchist in 1885 and felt that religion hindered social reform and objected to these comparisons. However, this landscape, with the luminous sky and the lengthening shadows, not to mention the church steeple in the town, creates an atmosphere that could almost be deemed to be religious. It seems to suggest a peacefulness after the drama of his flight in 1894.

CAMILLE PISSARRO Place du Théâtre Français, 1898

St Petersburg State Hermitage. Celimage.sa/Scala Archives

N 1888 Pissarro had begun to suffer from eye problems. This meant that, increasingly, he avoided painting in the open air, where he was disturbed by the wind. Instead he painted through open windows and from 1896 he began to concentrate on views of city life. In the same way that he had often taken a raised view-point on the landscapes of Pontoise and éragny, he now painted bridges, boulevards, and squares in Rouen, Paris, and Le Havre, in scenes that recall paintings by Monet and Manet.

Pissarro painted a number of views of the Place du Théâtre Français from the Hotel du Louvre in the winter and spring of 1898. Here he creates a sunlit, spring scene of people getting on and off the bus in the square below. He now returned to a truly Impressionist way of painting in terms of his aims and the application of paint. He increases the brilliance of the busy scene with marked use of the complementary opposites, red, green, yellow, and blue.

His figures are lively and individual, in spite of being treated so briefly. Each one has a life of its own. Note, for example, the woman leaning over the top of the bus on the left and the people chatting in the open carriage a little farther up as it rolls along.

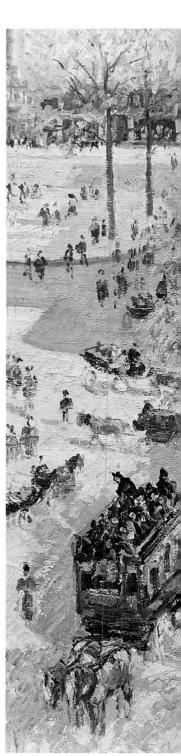

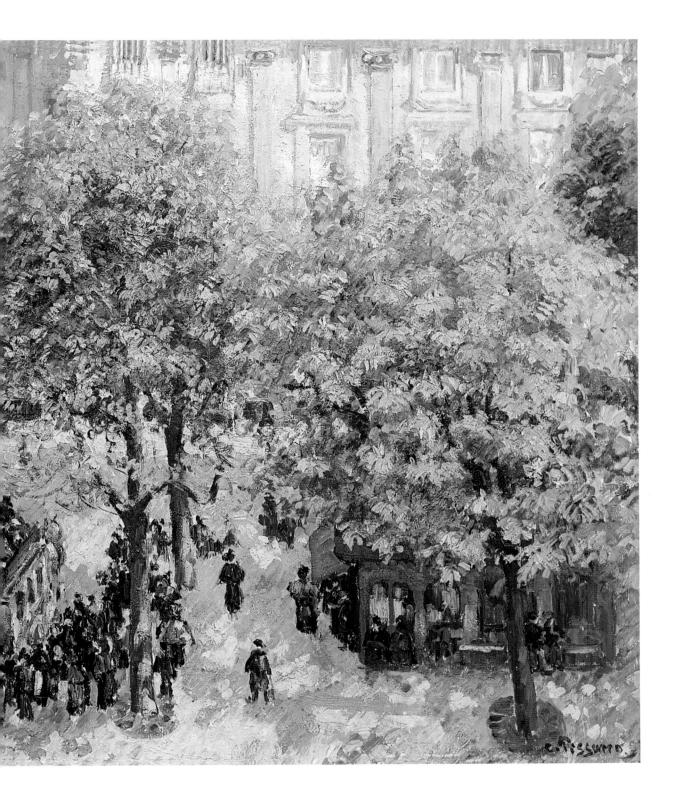

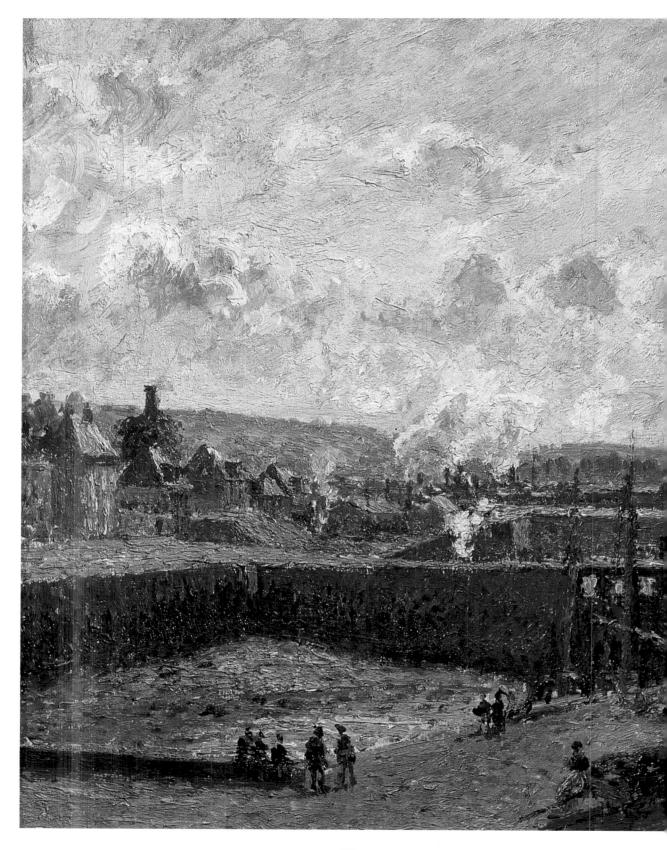

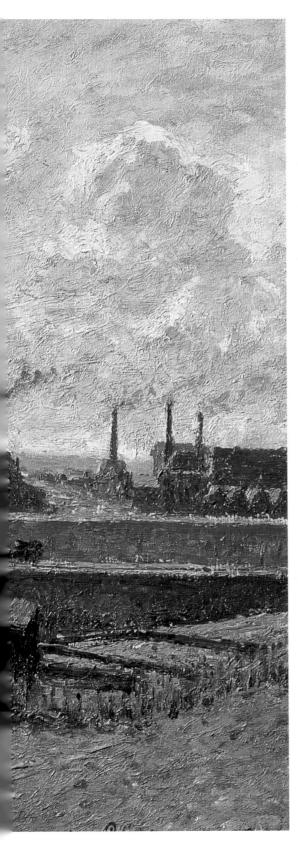

CAMILLE PISSARRO Duquesne Basin, Dieppe, 1902

Musée d'Orsay, Paris. Celimage.sa/Lessing Archive

HIS is one of several paintings of Dieppe harbor and town that Pissarro painted the year before his death. In it, he has returned to his early roots and the muted tones reminiscent of Corot as well as the slightly raised viewpoint from which he paints his subject at a distance. It is a tranquil painting, an effect achieved by the predominantly horizontal composition, the muted colors, and the soft, rounded quality of the clouds, which merge so seamlessly with the smoke from the factory chimneys.

In 1903, Pissarro explained to his son how he painted: "All I see is dabs of color. When I begin a painting, the first thing that I fix is the accord ... The great problem that has to be solved is to bring everything in line with the overall harmony, with that accord I have spoken of."

Pissarro died in Paris on November 12, 1903, while planning a series of paintings at Le Havre.

PIERRE-AUGUSTE RENOIR (1841–1919) Lise with Sunshade, undated

Folkwang-Museum, Essen. Celimage.sa/Lessing Archive

Rivording the Académie des Beaux-Arts in 1862. He was to become one of the leading exponents of the Impressionist movement.

The subject of this portrait was Lise Trehot, Renoir's mistress and favorite model at the time. One of the most noticeable aspects of this painting is the fact that the young woman's face appears cast under a heavy shadow and we have to look quite closely to decipher her features. In such a portrait the artist will usually celebrate the detail of his subject's face by allowing it to be seen in clear light.

Like the other Impressionist artists, Renoir had not yet fully incorporated the *plein-air* Impressionist style into his work, although he would follow it faithfully during the 1870s. The background is flat, and there is little consideration of the natural effects of light. However, this serves to positively emphasize Lise's presence in the painting. Renoir's handling of her figure is firm and the drawing is precise, particularly with regard to the folds of her dress. The palette is strong, with a clear contrast between the black and white of Lise's attire, a technique perhaps used in homage to the Impressionist movement's founding member, Edouard Manet.

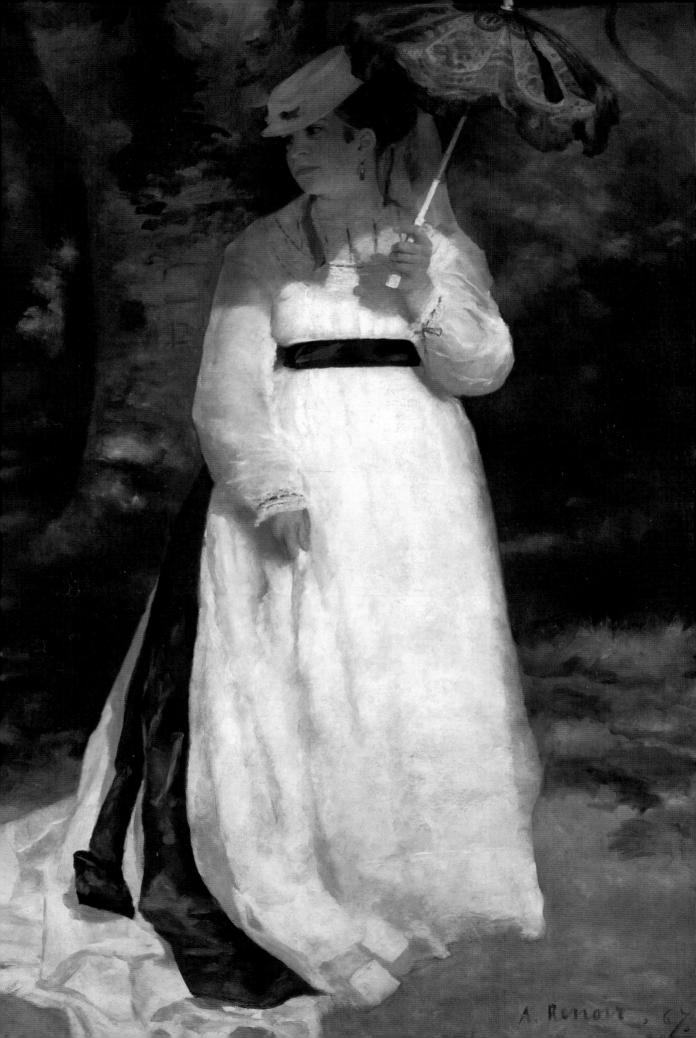

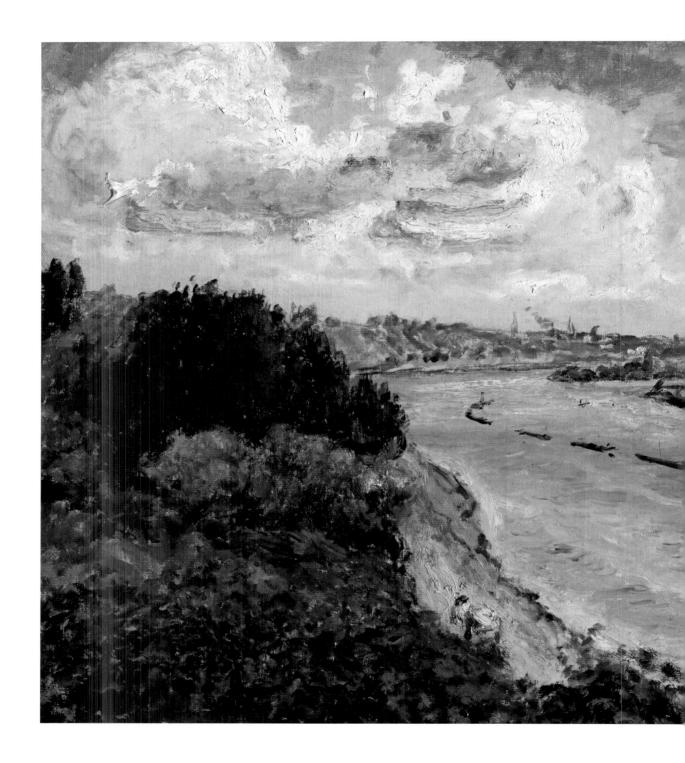

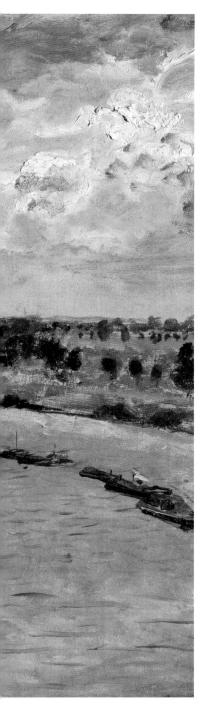

PIERRE-AUGUSTE RENOIR Barges on the Seine, c. 1869

Musée d'Orsay, Paris. Celimage.sa/Lessing Archive

N this early painting we can already see Renoir employing a more exaggerated brushstroke and liberal use of paint to create a scene of barges on the River Seine. There is a particular emphasis on the heavy clouds in the sky, and the dark hedges to the left of the canvas. This early painting shows Monet's increasing influence on Renoir's palette and artistic style. In Barges on the Seine we can see that a quickened pace of brushstroke has been used for the water and clouds. Although quite minimal, Renoir's palette has lightened, and here he begins to explore the different effects of light on the surroundings through his work. A similar technique inspired La Grenouillère (1870–71), where the scene he depicts seems to have dissolved into a light- and shadowfilled haze.

If we look closely at the painting we can see that the bushes and parts of the river have been picked out with specks of white paint, which has either been applied on top of the existing color, or allowed to seep through from the canvas below. This creates a subtle unity between the blue, green, and grey that are the main colors in the landscape. However, the overall impression leaves us feeling that the different areas of the painting are quite separate in their composition.

PIERRE-AUGUSTE RENOIR Mademoiselle Sicot, 1873

Chester Dale Collection, National Gallery, Washington, D.C. Celimage.sa/Lessing Archive

ADEMOISELLE Sicot's posture is quite conservative and formal, her hands are crossed in her lap, and her head faces away to the side of the onlooker, so that her gaze is unthreatening. She looks deep in thought, even troubled, and the dark cast of the backdrop accentuates this impression. The palette comprises two main shades: purple and black. The only contrast comes from the deep green of the chair in which Mademoiselle Sicot is sitting. Her attire is quite delicately portrayed, although given the heavy Japanese influence on French artists at this time, *Mademoiselle Sicot* is singularly unadorned. This can be compared to Renoir's slightly earlier *Portrait of Rapha* (1870–71), where the Japanese inspiration seeps through the detail of the canvas.

This painting is very symmetrical, and Renoir provides a precise portrayal of Mademoiselle Sicot's dress and features, including her earrings and the detail of the black lace garment resting in her lap. This is not a typical Impressionist portrait, and was planned and considered in terms of its form and structure. Renoir simply demonstrates his versatility as an artist who, although regarded as an Impressionist, was also able to display great realism in his work.

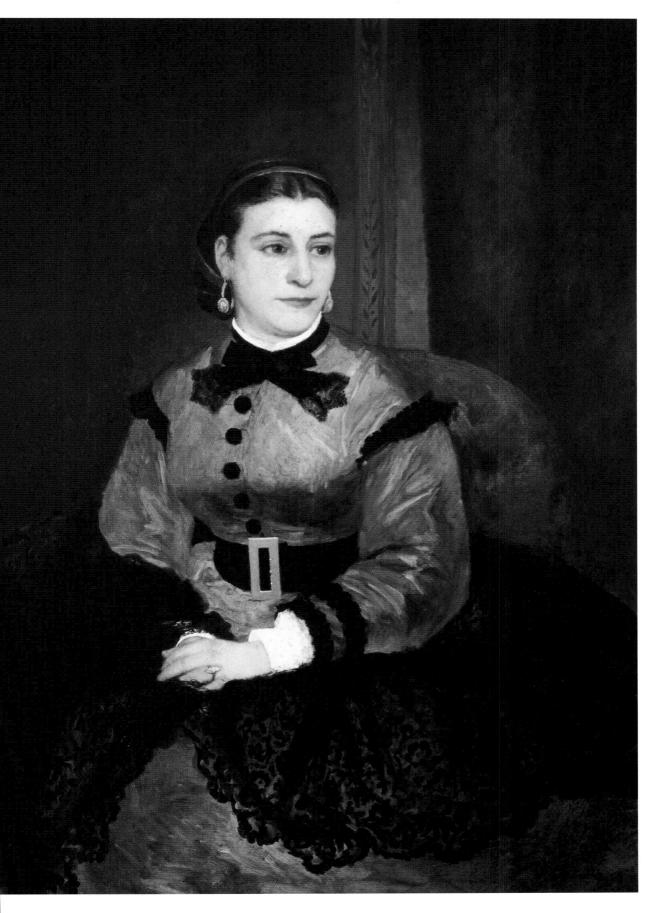

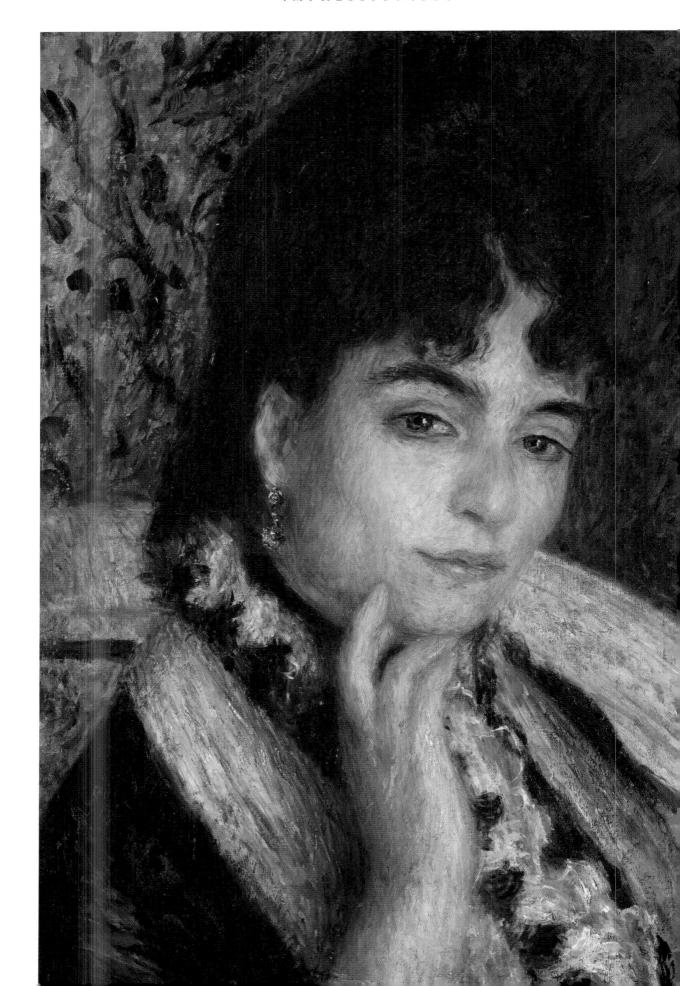

PIERRE-AUGUSTE RENOIR Mme. Alphonse Daudet, née Julie Allard (1844–1940), wife of the poet, 1876

Musée d'Orsay, Paris. Celimage.sa/Lessing Archive

HIS portrait is the diametrical opposite of the reserved, traditionally conservative portrait of *Mademoiselle Sicot* (1873). We are forced to confront the woman in the painting, and are not permitted to get lost in the background detail. Her expression is somewhat sexually suggestive, her eyes gazing seductively at the viewer and her hand resting beside her chin in a gesture that sems to be encouraging the observer to come closer to her. Her head is tilted in a similarly suggestive attitude, providing a further element of ambiguity to the piece.

There is a symmetry in the blue color of the background, reflected in the left-hand corner of the canvas, on Alphonse's dress, and in the pattern on the wall-covering, which is mirrored almost exactly in the fabric covering the chair in which she is sitting.

PIERRE-AUGUSTE RENOIR Moulin de la Galette, 1876

Musée d'Orsay, Paris. Celimage.sa/Lessing Archive

Rivière, it was painted on the spot.

ENOIR painted several scenes of Parisians enjoying themselves, and this is the first. It was exhibited at the third Impressionist exhibition (1877) and was well-received.

According to Renoir's friend and biographer Georges Rivière, it was painted on the spot.

It is painted in a typically Impressionist manner, although the soft, caressing quality of the brushstrokes is a hallmark of Renoir's very specific style. He delights in the effect of the sunshine filtering through the trees, dappling the revelers with light. Pink and blue predominate—true to the Impressionist ideals even black is not shown as black but as a color (or lack of color) that changes when light falls on it. The light dissolves the shapes and contours and, in the left corner, even flattens the distance between the little girl and her mother and the area where people are dancing.

As ever, Renoir is fascinated by the people in his paintings and has created a lively scene with plenty of stories being played out. Cut off on all sides like a photograph, the painting shows a Japanese influence in an innovative composition, which divides the canvas almost diagonally from top right to bottom left with the foreground animation in the bottom half and the background details in the top half. The two sides are linked by the head of the standing girl but there is no loss of depth—the figures in the background rapidly diminish in size, drawing the eye in to the canvas.

MOULIN DE LA GALETTE

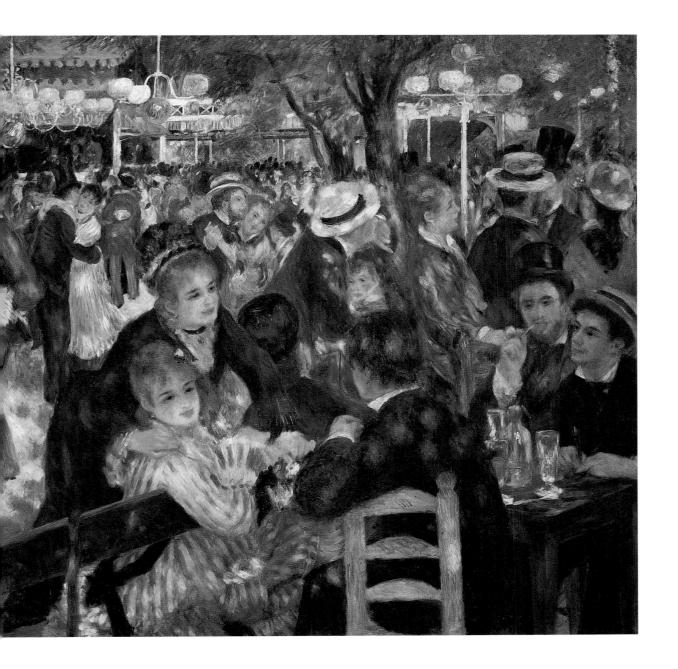

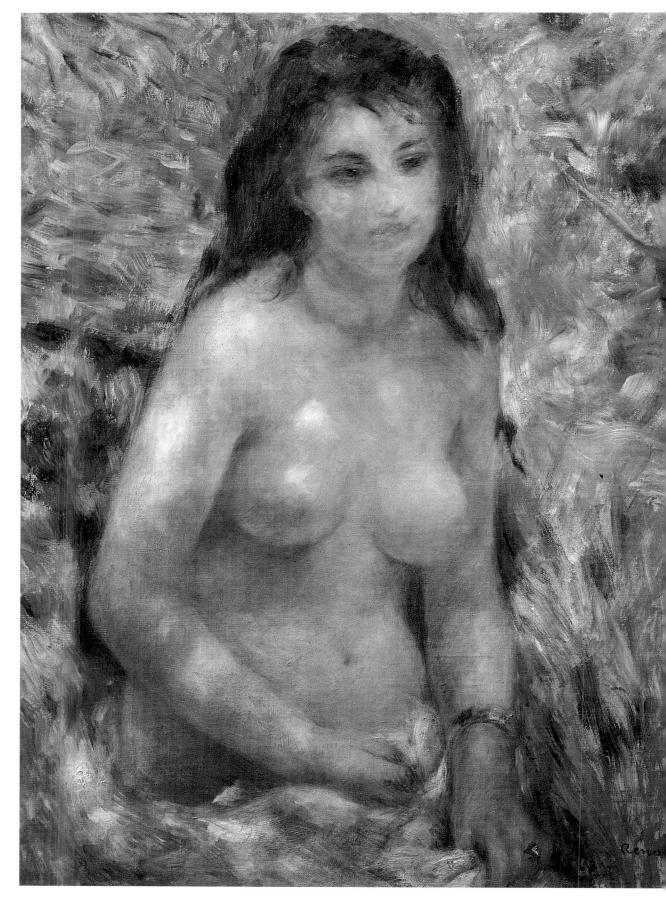

PIERRE-AUGUSTE RENOIR Nude in the Sunlight, 1876

Musée d'Orsay, Paris. Celimage.sa/Lessing Archive

HIS delightful study of a nude was shown at the second Impressionist exhibition of 1876. A few critics liked it, calling it a "superbly colored study," "well posed and well-lit", and the critic Armand Sylvestre wrote of "[the] delightful pink flesh tone ... the work of a great colorist." But Albert Wolff, critic for the French daily newspaper, *Le Figaro*, savaged it: "Try to explain to M. Renoir that a woman's torso is not a mass of flesh in the process of decomposition with the green and purplish blotches which denote the state of complete putrefaction of a corpse ...!"

In exhibiting a study, Renoir was challenging the critics. The composition is daring: the nude is slightly off-center, the brushwork loose (something for which Renoir had already been criticized) and the background abstract, with parts of the canvas bare. The light, filtered through leaves above that we cannot see, falls on the girl's body, dappling it with light and blue shadows. Her face blurs under the diffusing qualities of the light. Except for the bracelet and the ring that indicate her modern status, she is a timeless nymph. The change in style since *Portrait of Rapha* (1870–71), for example, is clear.

The model may be a girl called Anna who died, aged 23, in February 1879. Renoir wrote to his friend Dr Gachet (1828–1909) asking him to go and see her.

PIERRE-AUGUSTE RENOIR Path Climbing Up Through the Tall Grass, c. 1876–77

Musée d'Orsay, Paris. Celimage.sa/Lessing Archive

HIS lovely painting shows Impressionism in true Monet style and bears a resemblance to his paintings of poppy fields of 1873. Four patchy figures descend a path toward the viewer, a little girl in front, a woman with a red parasol behind her followed, at a distance, by two figures side by side and deep in conversation—a theme Renoir treated in closer proximity on several occasions in paintings such as *The Moulin de la Galette* (1876), for example.

Only the trees betray a darker effect than one might expect—bearing little relation, for example, to the bright trees of *The Boulevards* (1875), painted the same year. These, in their dark delicacy, recall the influence of the landscapist Corot, whom Renoir admired. The contrast between the trees and the hillside is enhanced by the wet-on-wet technique that Renoir uses to paint the soft, light-filled blurry background of the hillside. In the foreground and middleground, where the light falls, he has used a thick impasto. As is often the case in these green, blue, white, and yellow canvases, Renoir uses tiny dabs of red to create a stronger contrast and make the colors resonate. In this case, it also leads the eye toward the apex of a triangle—the woman's red parasol.

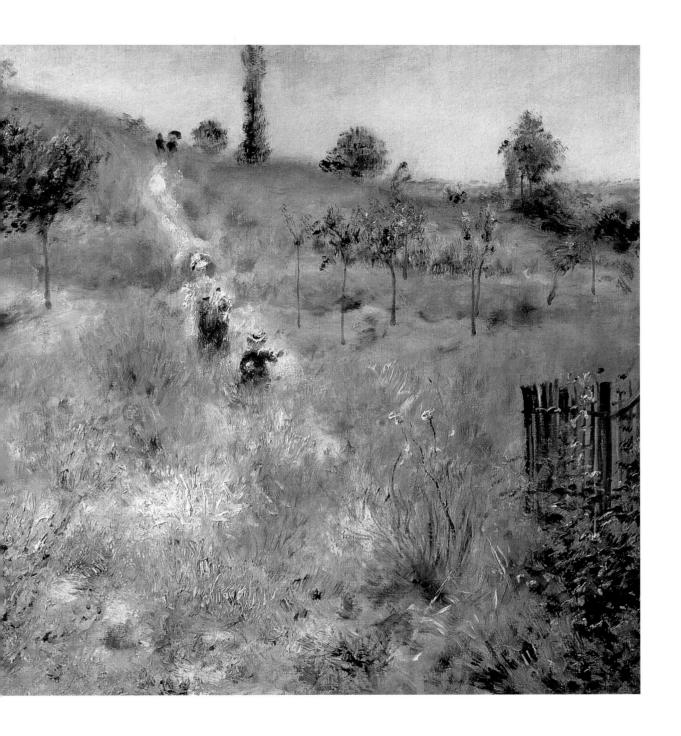

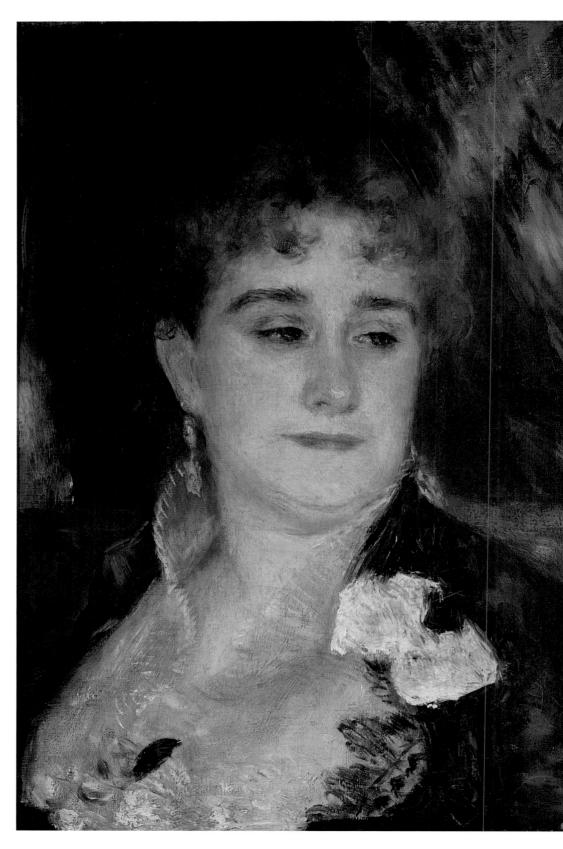

PIERRE-AUGUSTE RENOIR Madame Georges Charpentier, 1876–78

Musée d'Orsay, Paris. Celimage.sa/Lessing Archive

ADAME Georges Charpentier (1848–1905) was the wife of the publisher Georges Charpentier, one of Renoir's early patrons. Married in 1872, Madame Charpentier's salon soon became a famous literary and left-wing meeting place. Her guests included Renoir and Manet.

Charpentier first bought three of Renoir's paintings in 1875. Through him, Renoir received several commissions that kept him solvent. In 1879, he had a great success at the Salon with a landscape portrait of *Madame Charpentier and her Two Children* (1878). In 1880, the art dealer Durand-Ruel began to buy Renoir's work regularly, after which Renoir was never financially insecure again.

This portrait is fairly conventional in style—as was necessary in order to attract commissions—but the Impressionistic patchy, loose brushwork, seen in Renoir's works as soft, feathery brushstrokes, is clear and especially flattering to female sitters. Renoir continued in this style until the early to mid-1880s. But until then he was painting contemporary Parisian scenes and portraits—especially of children, whom he portrayed in all their childlike softness and gentle innocence. Renoir did not exhibit at the fourth, fifth, and sixth Impressionist exhibitions in 1879, 1880, and 1881. By 1880, the dynamics of the group were changing, with severe internal disagreements.

PIERRE-AUGUSTE RENOIR Dance in the Country, 1883

Musée d'Orsay, Paris. Celimage.sa/Lessing Archive

HIS is one of Renoir's many scenes of contemporary life in which people are shown enjoying themselves. A young couple dance energetically, the man's hat having already fallen off, enjoying the closeness that social dancing allows. The scene is firmly placed at a specific moment, with the remnants of a meal to the right and, to the left, people continuing their meals.

It was designed as a pendant to *Dance in the City*, one of three almost life-size canvases of dancing couples that Renoir began in spring 1883. They were among the last of his paintings to show contemporary life.

Dance in the Country shows Renoir's incessant joie de vivre, his belief that all paintings should provide a pleasurable experience arousing the senses. Here, the young woman, Renoir's mistress Aline Charigot whom he met in about 1880, smiles at the viewer—a picture of sturdy, rude health so typical of Renoir's models.

The Impressionist palette remains, as does the blurry background and the use of complementary colors to enhance brightness, but the figures have taken on a new clarity. This, coupled with the clean contours of the dancers, reflects the lessons Renoir learnt on a trip to Italy in 1881 where he had discovered Raphael (1483–1520) and concluded that he had never really learnt how to draw or paint. By the mid-1880s he had turned to the severest form of Classicism.

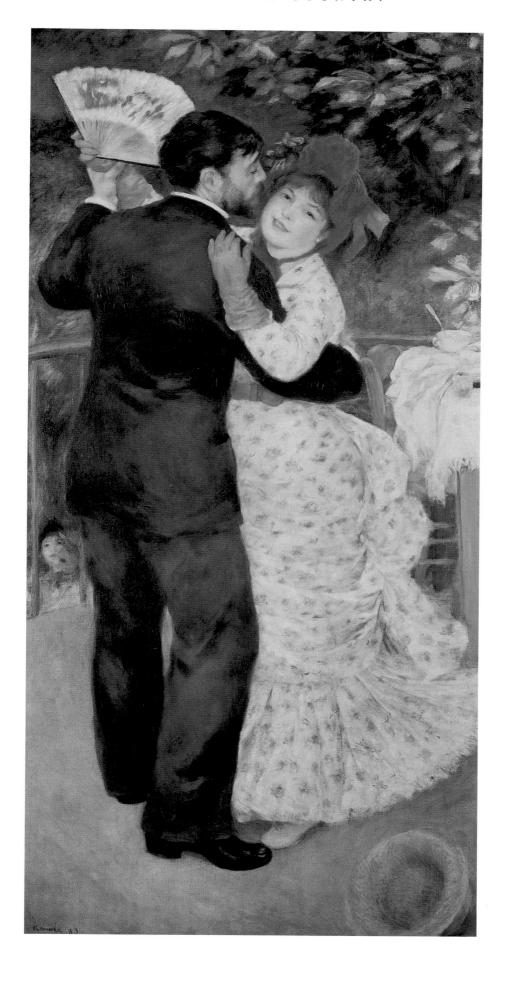

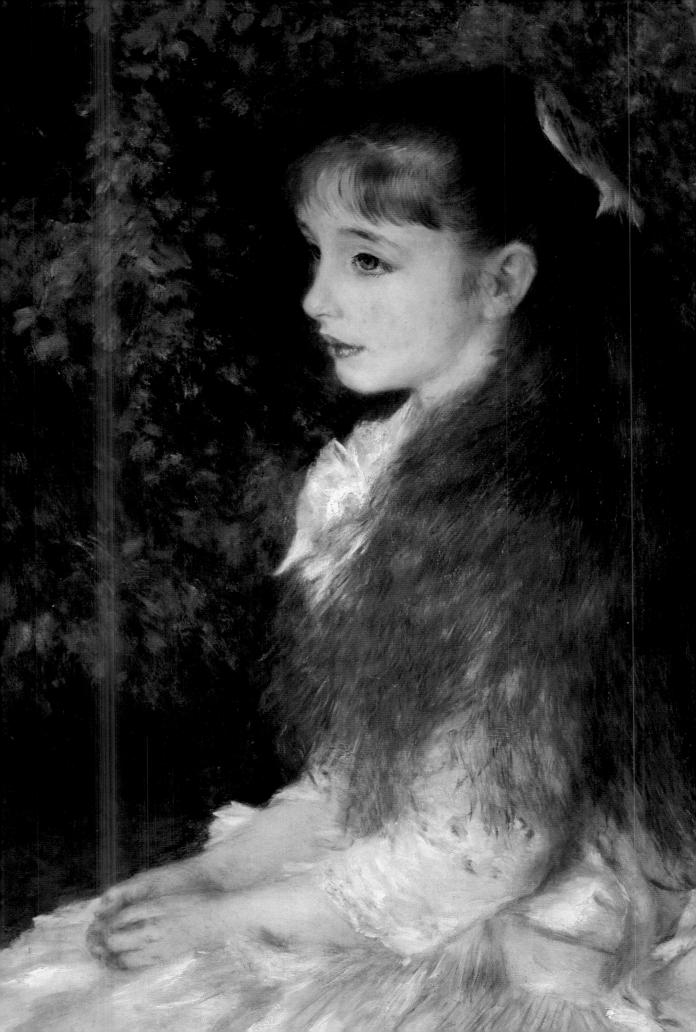

PIERRE-AUGUSTE RENOIR Little Irene (Portrait of the 8-year-old daughter of the Banker Cahen d'Anvers), 1880

Private Collection, Zurich. Celimage.sa/Lessing Archive

HIS painting is quite conservative and conventional in its appearance. This was so that Renoir could please his patron and receive the fee for the portrait. Little Irene has been portrayed in her innocent, childlike manner, an effect achieved through Renoir's gentle use of brushstroke and palette. The soft white of her dress and skin gives the painting an angelic quality, a technique employed by the artist that would prevail in his work well into the 1900s.

Although Renoir's style varied quite significantly throughout the nineteenth century, as a result of his travels abroad to Algiers and Italy, this particular painting exemplifies the style that we most often associate with the artist. The bright palette and suffused background serve to accentuate the appearance of the girl in her youthful naivety. There is an element of continuity to the portrait, seen in the way in which Renoir has painted the green hedges in the background, and the tips of little Irene's hair, with the same soft palette of color and impressionistic method. The golden tones of the child's hair have been repeated in the bush, creating an additional unity in the artwork. Renoir's intention may have been to illustrate the way in which the innocence of nature is akin to that of youth.

Pierre-Auguste Renoir Peaches, undated

Musée de l'Orangerie, Paris. Celimage.sa/Lessing Archive

HE background swirls of color remind us of a landscape painting by Vincent van Gogh. The peaches, in their color and style, are similar to those found in a still life by Paul Cézanne, yet this work has a certain quality that is associated only with Renoir. The softness of the palette and the brushstrokes are typical of this artist and of Impressionism. Renoir had the unrivaled ability to use oils on a canvas to create a rich and intense use of color, yet without overpowering either the image or the viewer.

The composition is simple yet effective, almost like Cézanne's Apples and Biscuits (c.1880). However, what is noteworthy about this and other paintings by Renoir, is that the background is often as significant or as interesting as the subject itself. In Peaches the backdrop color is not neutral, but is rather an assortment of light colors that complement the different, natural tones of the peaches. This differs from Cézanne's Apples and Biscuits, where the fruits are displayed in their natural colored richness against the dark top of a brown table or chest. The pale blue of the wallpaper provides a further contrast with the fruit pieces. In Peaches Renoir uses a method similar to that of some of his portraits, in which the background tones pacify the subject, rather than contrast with it.

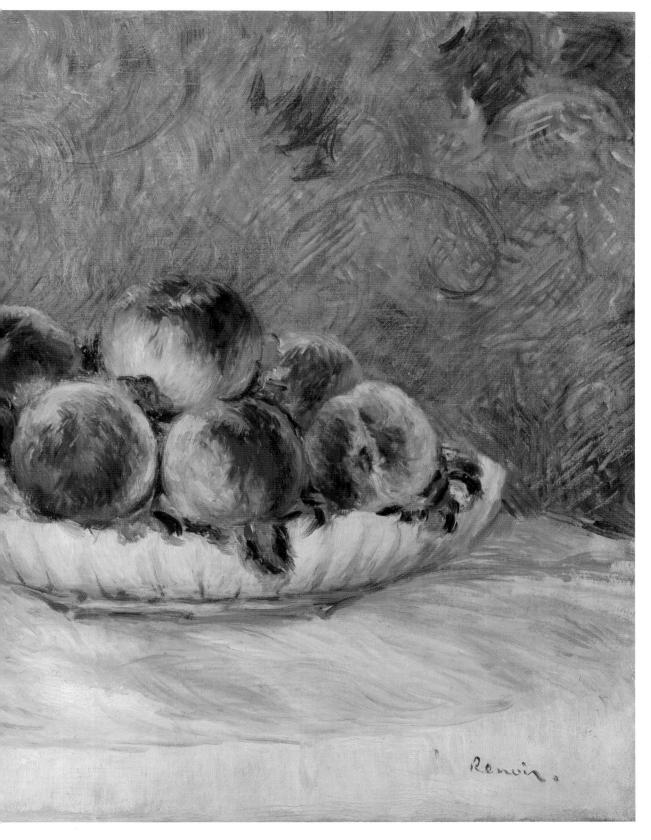

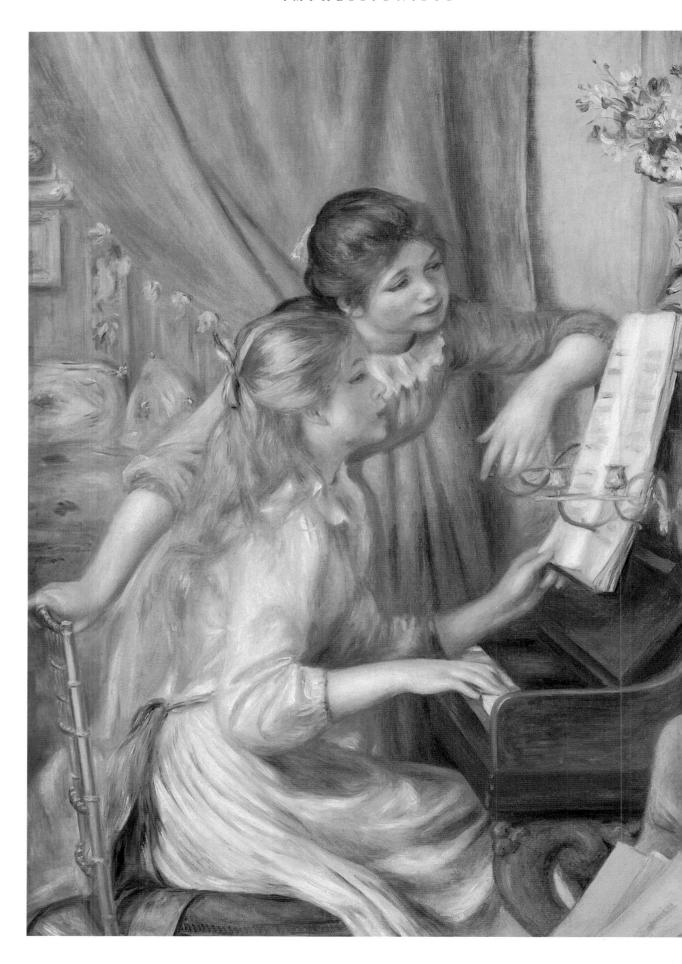

PIERRE-AUGUSTE RENOIR Young Girls at the Piano, 1892

Musée d'Orsay, Paris. Celimage.sa/Lessing Archive

IX versions of this painting exist. The earliest was painted in 1889 and the rest when the French government asked Renoir to paint a new picture for the Musée du Luxembourg, which exhibited the work of France's leading living artists. The commission caused Renoir much worry—hence the many versions, which showed slight variations in the backgrounds and in the poses of the two girls, particularly the arm of the brunette. This is the version that the Luxembourg chose.

The theme is very much in keeping with the overall tenor of Renoir's work in the 1890s—genre scenes depicting natural, harmonious youth, usually young girls walking, talking, gathering flowers or sitting in meadows. The piano theme has clear links with the images painted by the French eighteenth-century artists that Renoir so much admired. The models in all these paintings appear to be the same, and the brunette in pink and the blonde in white with a blue sash (although the dress patterns vary) run throughout.

This picture is not a double portrait; there is no psychological intent. Harmony rules in a timeless world; this is no "passing moment." The soft, supple brushwork so typical of Renoir is still in evidence and the pure, bright palette remains, but there is no doubt that he is no longer working in the Impressionist idiom of the 1870s.

PIERRE-AUGUSTE RENOIR Claude Renoir (Coco), Son of the Artist, 1910

Museum of Fine Arts, Boston. Celimage.sa/Lessing Archive

CCORDING to his son Jean, from about 1900 onward, Renoir seemed to have resolved his insecurities as a painter and, while insisting that it was essential to study and learn from the masters of line, such as Raphael (1483–1520) and Ingres (1780–1867), from 1905 his palette became increasingly warm and he seems to have thrown in his lot with colorists such as Delacroix (1789–1863), Rubens (1577–1640,) and Titian (c. 1480–1576).

In 1907 Renoir and Aline bought a property in Cagnes in the south of France. This move was partly because of Renoir's worsening health; by the time he had painted this portrait in 1910 he was unable to walk and had become so arthritic that it was difficult for him to hold a paintbrush.

Renoir began to concentrate on smaller subjects after 1910, painting many still lifes and landscapes, and this was to be one of his last portraits. Quite romantically, it is of his son, Claude, or Coco, Renoir.

The portrait is rich in terms of its color and technique. The delicate and smooth brushstroke used to outline the boy's body and clothing are distinctly Renoir. His painting of the features of Claude's face is exquisite, and the boy's eyes shine very realistically. Structurally, and in terms of the palette, this piece also has an obvious balance and unity.

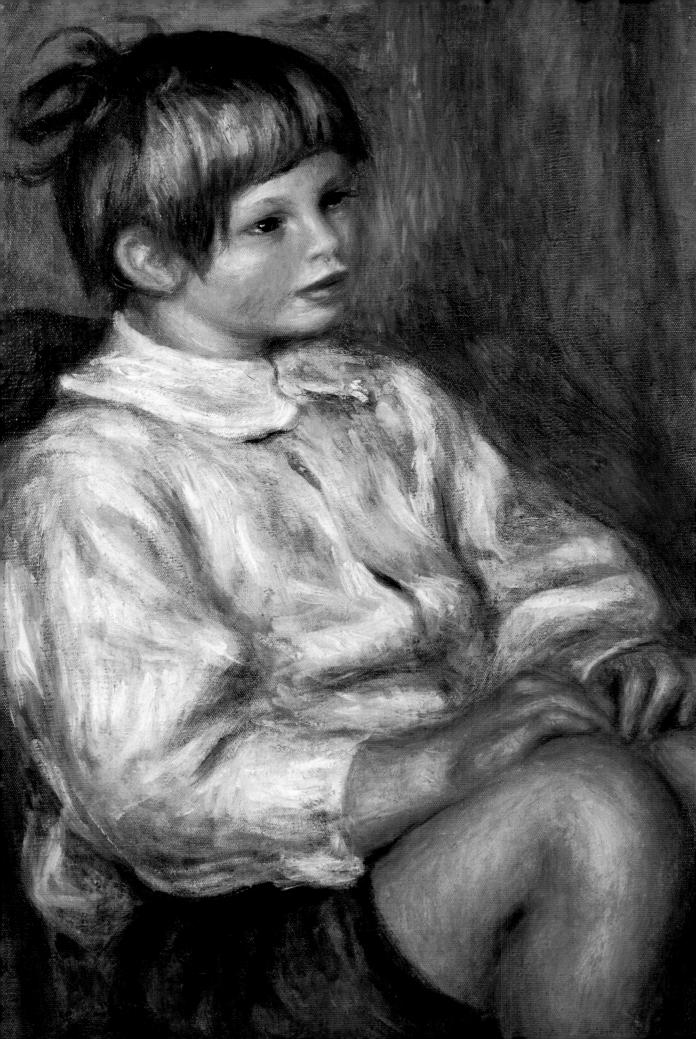

RICHARD GUINO Head of a Woman, 1916

Musée d'Orsay, Paris. Celimage.sa/Lessing Archive

HIS is a bust of Aline Renoir, Renoir's partner and wife of over 35 years, who died in 1915. Renoir was devastated and in 1916 asked the Catalan sculptor Richard Guino (1890–1973) to model a bust of her from a seated study. This is a return to the material of Renoir's early years as a painter of ceramics and a direct connection with the marble busts of the 18th century that he admired so much.

Aline is shown in her youth in a charming hat with roses, a bright smile on her face recalling her image in *Luncheon of the Boating Party* (1880–81) in which, in virtually the same hat, she sits on the left playing with a small dog. Other paintings for which she posed also spring to mind, such as *Maternity* (1886), in which she suckles her baby, and *Dance in the Country* (1883), in which she dances so very cheerfully and gaily.

Renoir, who could not handle clay properly owing to his severe rheumatism, was clearly showing a renewed interest in the medium when he began to teach his son Claude how to make pottery in the autumn of 1916. Unfortunately, when Guino left Cagnes in December, Renoir became disenchanted with his collaboration with him and lost interest in pottery.

Pierre-Auguste Renoir The Bathers, 1918–19

Musée d'Orsay, Paris. Celimage.sa/Lessing Archive

HIS is Renoir's last painting of any size and he intended it as his final pictorial statement. In recognition of this, his sons made a gift of it to the state on his death.

This monumental painting is a summary of one of the most important themes of his career: nudes in a landscape—and a recapitulation of his *Bathers* (1887), which he painted in the 1880s in the same classical style as *Maternity* (1886) and *The Plait* (1884).

His allegiance to color and his large, lushly painted female forms remind us of Titian and Rubens. He merges the figures, their clothes, and the cushions with the vigorous landscape, each a part of the other. In 1918 Renoir told a friend: "My landscape is only an accessory; at the moment I am trying to fuse it with my figures."

Painted on a white primed canvas that increases the luminosity of the pigments, the colors sing, assembled "like a musician who ceaselessly adds new elements to the orchestra." His friend, the critic J. F. Schnerb, described his later works: "M. Renoir loves his canvas being full and sonorous. He loathes empty spaces. Every corner in his landscapes offers a relationship of colors and values with a view to embellishment of the surface." Renoir would not have disagreed. In 1908 he said: "With all modesty, I consider not only that my art descends from a Watteau, a Fragonard ... and also that I am one with them."

Renoir received a medal from the Légion d'Honneur before he died in 1919 in Cagnes, aged 78.

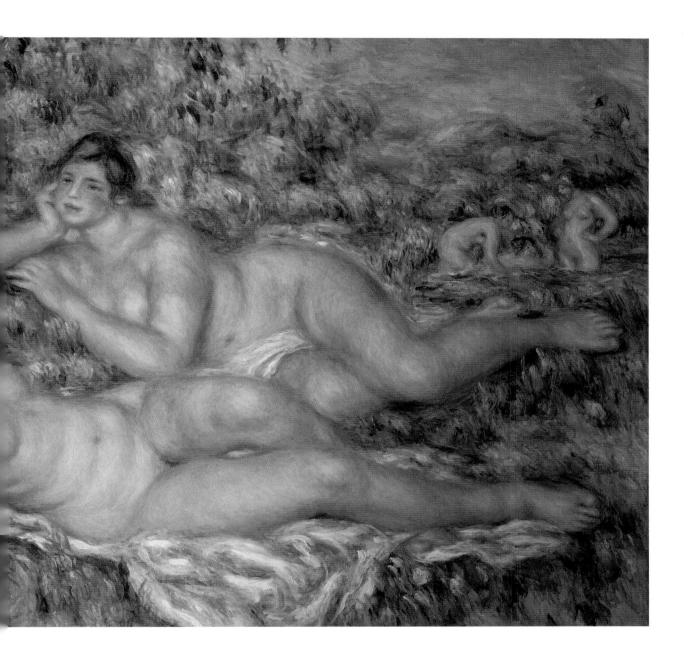

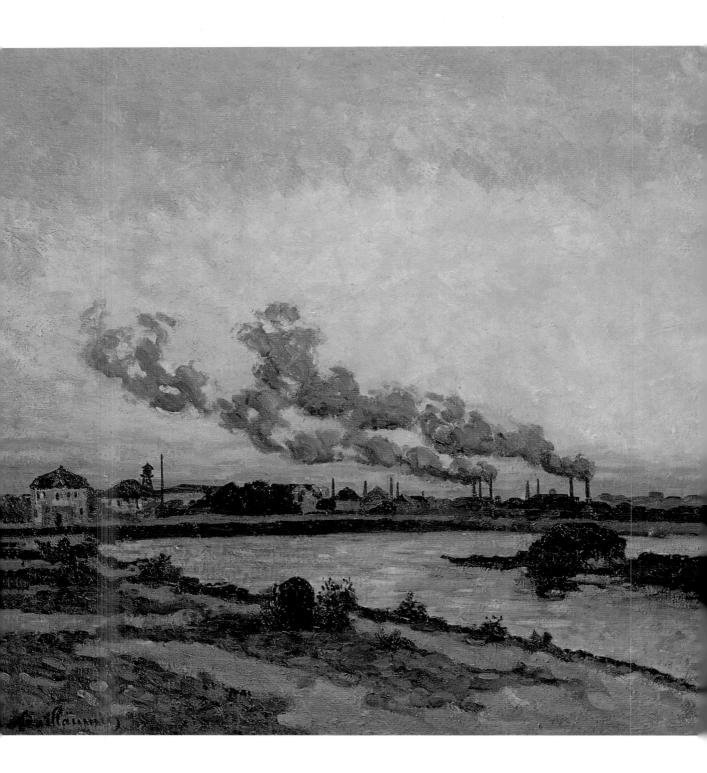

ARMAND GUILLAUMIN (1841–1927) Sunset at Ivry, 1874

Musée d'Orsay, Paris. Celimage.sa/Lessing Archive

RMAND Guillaumin was working in his uncle's shop when he began to attend evening drawing classes at the age of 15. In 1861 he began to make use of the facilities at the Académie Suisse where, for a small fee, artists could paint nude models provided by the atelier. It was here that Guillaumin met Pissarro and Cézanne.

Although he has never been regarded as a major Impressionist painter, Guillaumin was involved from the beginning when, like many of the group, he was rejected at the Salon of 1863 and exhibited at the Salon des Refusés.

Under the influence of Pissarro, Guillaumin, like Cézanne at this time, took up the Impressionist way of painting and often painted out-of-doors—often at Pontoise, where Pissarro lived. The three remained friends and Cézanne once even copied a painting of Guillaumin's which showed workers shovelling sand.

Guillaumin worked night shifts on the railway so that he could paint during the day. He is known for landscapes around Paris and along the Seine. This is a view of Ivry, an industrial suburb of Paris, in which he combines the glorious blue heights of the sky and the sun's golden rays with the factory chimneys' billowing smoke.

ARMAND GUILLAUMIN The Seine at Rouen, undated

Musée de la Chartreuse, Douai. Celimage.sa/Lessing Archive

HE longest-surviving and most faithful member of the Impressionist group, and yet probably the least known artist of his time, Armand Guillaumin exhibited at the Salon des Refusés and at the majority of Impressionist exhibitions held during his lifetime, even though he only worked as a part-time artist until 1895. Although highly regarded by Cézanne and Guillaumin, he failed to win the praise and approbation of Degas and Monet.

The River Seine was a popular choice of subject for many Impressionist painters, and for Guillaumin, up until 1895, it remained a main focus of his work as part of his series of dockland and industrial landscapes. Thereafter, he traveled extensively through France, painting Impressionist motifs. His works are recognized for their vivacious and passionate use of color that, toward the end of his life, brought him close to Henri Matisse (1869–1954) and the Fauves. The Seine at Rouen is dominated by a scene of pinks, greens, blues, and purples, as Guillaumin creates a harmonious and compositionally balanced depiction of Rouen. His brushstroke is hasty and frequent, mimicking the fast pace of industrial development at the time.

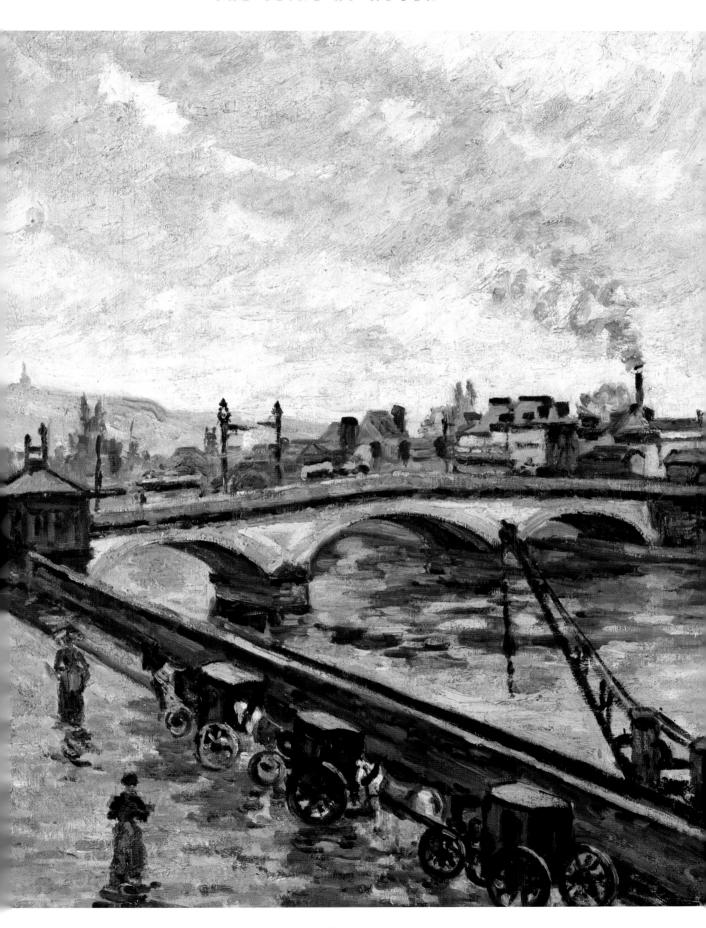

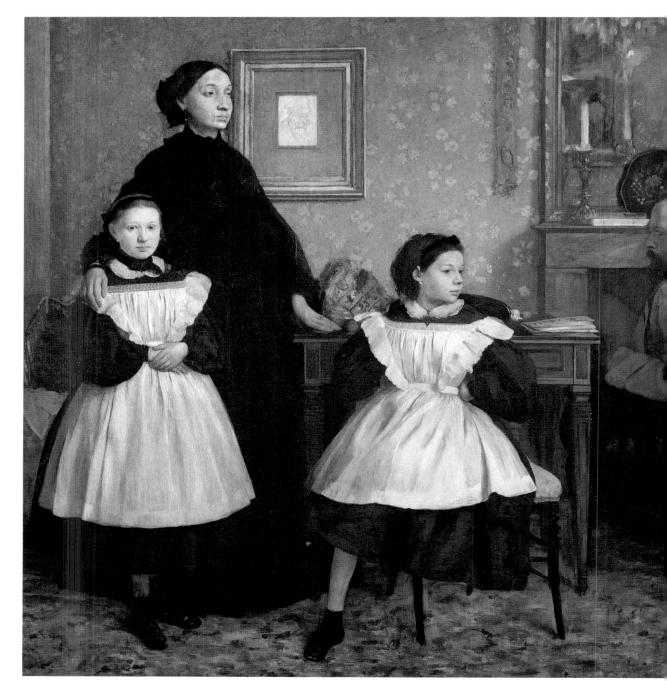

EDGAR DEGAS (1834–1917) The Bellelli Family, 1858

Musée d'Orsay, Paris. Celimage.sa/Lessing Archive

EGAS came from a wealthy background and followed a traditional course of study at the Académie des Beaux-Arts. He also made several trips to Italy. In 1857 he stayed in Florence for several months with his uncle and aunt, the Baron and Madame Bellelli, when he painted this family portrait.

This is Degas' first large work, painted in oil on a non-standard size canvas—something more typical of great, heroic historical works—and therefore unusual. The portrait reveals, even at this early stage in his career, Degas' ability to arrange his compositions in such as way as to suggest the nature of the relationship between the sitters—creating a tension or a rapport between them. Here, the painting and the family are clearly divided in two—the strong triangle of the mother and two daughters in the light with the father separate in the shade on the right, his back to the viewer. The relationship between the baron and his wife is clearly strained. Contrast the black dresses blending together on the left, worn in mourning for Mme Bellelli's recently deceased father, whose portrait is on the wall and forms part of the female group, and the lighter, casual clothes of the father, and the alienation between the two groups is complete.

EDGAR DEGAS Young Spartan Girls Provoking the Boys, 1860

National Gallery, London. Celimage.sa/Lessing Archive

EGAS' early work, of which this is an important example, is in the traditional, historical manner. Like so many artists before him, he copied Old Masters in the Louvre, notably Andrea del Mantegna's *Crucifixion* (1431–1506), and went to Rome to study ancient sculpture. It was his intention to become a history painter—the highest calling for an artist in 19th-century France.

But even here, in *Young Spartan Girls*, despite the apparent Classical subject-matter, the spirit of the work is revolutionary. What is the picture really about? Unlike traditional history painting, this painting has no story based on the writings of the Classical canon and is probably taken from a 17th-century source, *Voyage du Jeune Anacharsis en Grèce*, in which the Abbé Barthélemy describes the warlike upbringing of Spartan girls. This, as in so many of Degas' betterknown, later paintings, is a description of life—the then-modern life of the Spartans—rather than a Classical conquest or mythical story.

Degas' style does not yet reach the heights of color that he was to achieve later, nor is the broken brushwork typical of the Impressionists yet in evidence, but the independence for which he was renowned both as a man and an artist, is here in embryonic form.

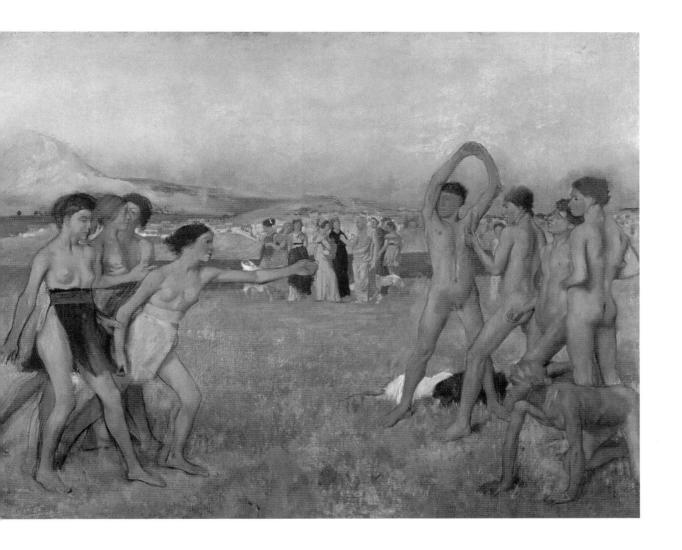

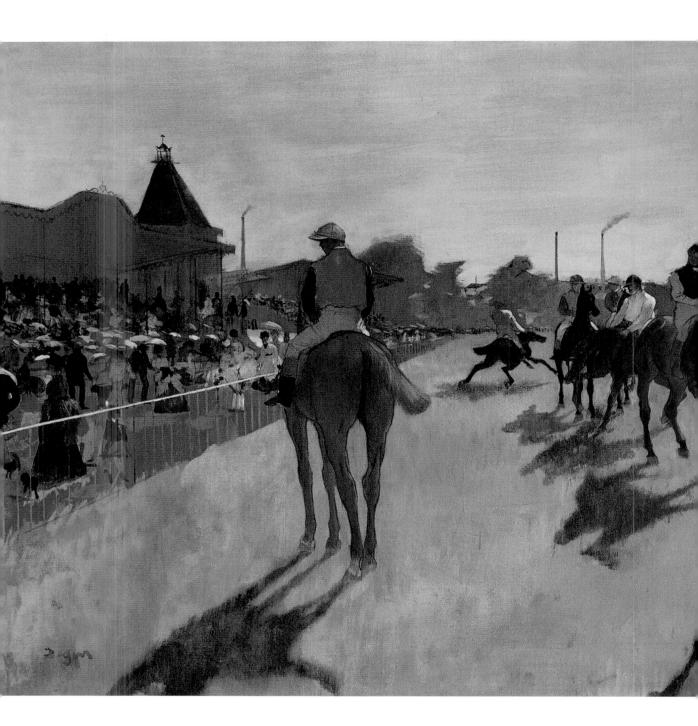

EDGAR DEGAS At the Races, in Front of the Stands, c. 1866–68

Musée d'Orsay, Paris. Celimage.sa/Lessing Archive

EGAS first began to paint racehorses in 1861, but he continued to work on historical subjects as well until 1865, the year he met Monet and Renoir and became a frequent visitor at the Café Guerbois, where the group often gathered. There is some doubt as to the date of this particular painting; it has been suggested that it was painted in 1879.

This is one of many works of horses and jockeys on the racecourse, a theme he treated several times before 1872 (when he went on an extended trip to New Orleans to see his brothers) and one to which he returned in the 1880s.

This painting already shows many of Degas' typical artistic traits. It is cut off on the left to indicate greater space beyond the "viewfinder" of the canvas; has a clearly thought out, almost geometric spatial design; shows an interest in contemporary Parisian life (the racecourse at Longchamps was new and very fashionable); makes an interesting use of color (note the mix of gold, green, and blue in the grass); and, something that was to become increasingly noticeable, it shows Degas' fascination with movement, clearly expressed in the horses and their shadows. Degas' racehorses prefigure his dancers and nude studies. They are also the only pictures that depict outdoor scenes but, contrary to the ideals of the Impressionists, they would have been painted in the studio from numerous notes and sketches.

EDGAR DEGAS The Orchestra at the Opera, 1868

Musée d'Orsay, Paris. Celimage.sa/Lessing Archive

From a low viewpoint across the orchestra we see the skirts and legs of the dancers, lit up by the footlights and cut off at the ankle by the apron of the stage. The foreground, using a dark, Manet-like palette, shows the orchestra. Degas' friend, bassoonist Désiré Dihau, is slightly off-center directly below the dancers. His right hand creates a patch of light amid the blacks and browns. The draftsmanship is fine and the individuality of the faces pays tribute to Degas' portraiture skills—indeed, this is, in effect, a portrait of his friend in his working environment.

Degas' revolutionary compositional style, influenced by photography and the Japanese prints flooding into France at this time, is evident in the interplay of diagonal, horizontal, and vertical lines that link the three pictorial planes and sometimes bind them together as if there were no distance between them at all—note the scroll of the double bass on the right. Nobody else at this time was as daring in compositions as Degas.

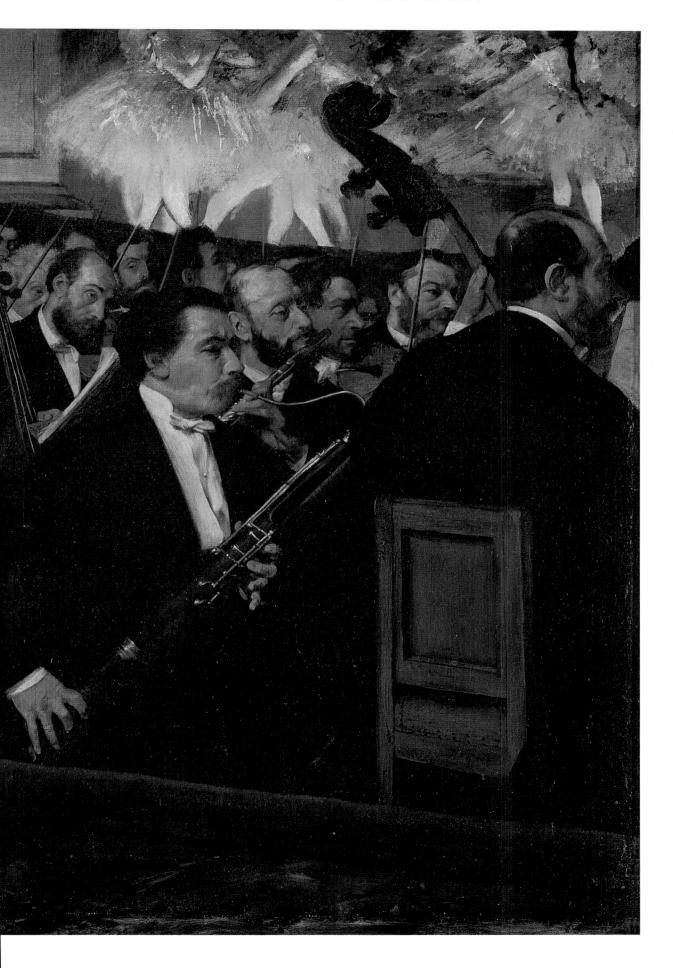

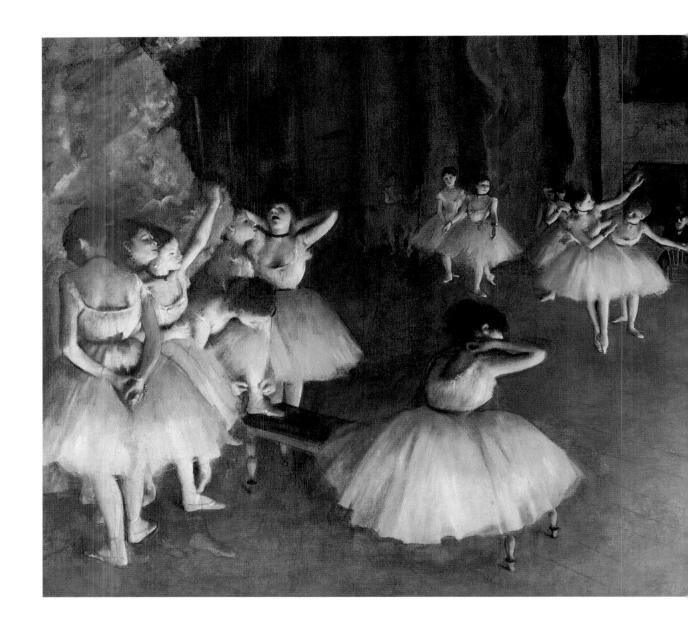

EDGAR DEGAS Ballet Rehearsal on the Stage, 1874

Musée d'Orsay, Paris. Celimage.sa/Lessing Archive

Y 1874, Degas had already begun to paint and draw scenes from the ballet, of which this is one of his most well-known. It is one of three paintings of the same subject painted that year, and was exhibited at the first Impressionist exhibition in 1874.

Degas, never an Impressionist in the same way as Monet, Renoir, or even Manet in the 1870s, was instrumental in organizing this event and exhibited in all eight shows, although he subscribed to few of the group's ideals, including landscape *plein-air* painting. What Degas shared with all these artists was a desire to be independent, to break away from, and be successful in spite of, the Salon—to pursue goals and present art in a way never seen before.

Degas never painted compositions from life. Although he created works that have a stunning immediacy, he built up his compositions using constant notes, sketches, workings, and reworkings of his material—note the ghostly foot on the left side of this painting. As his eyesight began to deteriorate from the 1970s, memory also played a part.

This painting, in sepia tones like that of a photograph, presents an unusual perspective on an unusual scene, with the dancers glowing in the gloom of the stage. The poses often recur in his works and bear comparison with his nudes and women ironing, revealing his fascination with movement.

EDGAR DEGAS The Dance Class, 1873–76

Musée d'Orsay, Paris. Celimage.sa/Lessing Archive

EGUN in 1873, this is Degas' first large canvas of dancers. It was commissioned by the opera singer Jean-Baptiste Fauré. However, Degas could not resolve the composition so, as Fauré was insisting on receiving his canvas, Degas painted a similar work, *The Dance Exam* (1874), for him.

Lit by a large, unseen window on the right, the class is finishing. The dancers are tired and taking little notice of the teacher, Jules Perrot, whom Degas sketched in 1875 and added in his reworking of the composition. The dancers scratch their backs, stretch, and adjust their clothing—a recurrent theme. Note the small details, such as the pink highlight on the calf of the standing dancer in the foreground, the dog, and the watering can.

Painted from a low viewpoint, another Japanese influence, the composition works in several directions. In the middle ground, the eye focuses on Perrot. The empty expanse of floor diagonally to his right is typical of Degas' compositions. Perrot's upright figure is echoed in the standing dancer and strengthened further by the marble pilasters on the wall. A deeper diagonal runs from the two dancers in the foreground, following the floorboards and the wall to the dancer in the far corner—a quasi-mirror image of the girl perched on the piano.

Like Manet, with whom he became friends in 1861, Degas uses a limited, though much lighter palette, with a lot of white interspersed with flashes of pure color.

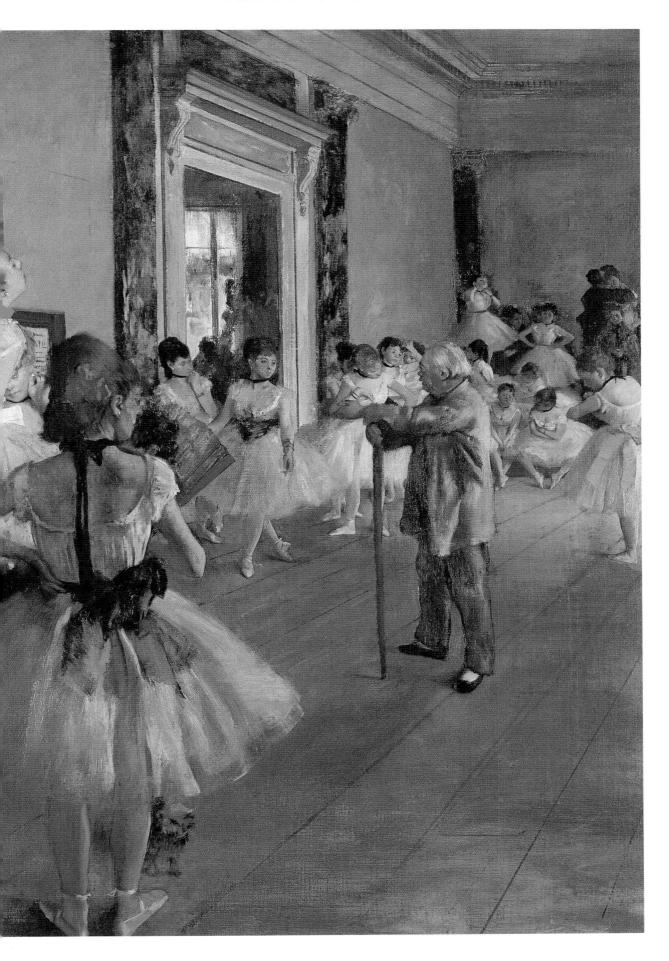

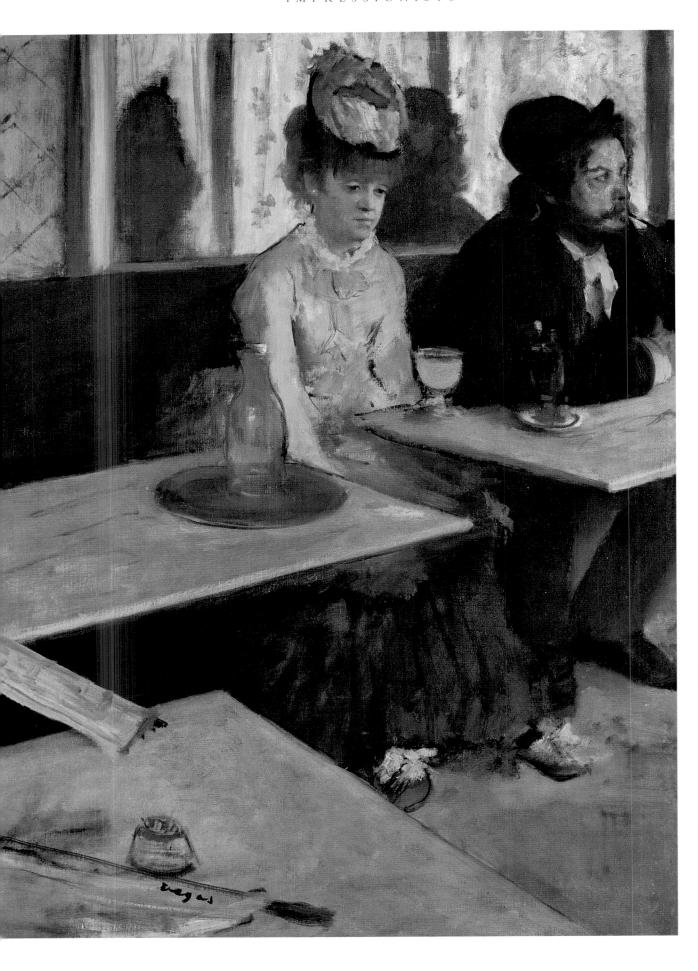

EDGAR DEGAS In the Café (Absinthe), 1875–76

Musée d'Orsay, Paris. Celimage.sa/Scala Archives

N the Café is one of Degas' most depressing works. It shows a melancholic woman and her apparently dissolute male companion in a café on a sunny afternoon sitting side by side but in their own separate worlds. The woman has a glass of absinthe—a notoriously cheap alcoholic drink given to inducing hallucinations.

The models for the painting were Degas' friends the engraver Marcellin Desboutin (1823–1902), (who was teetotal), and the actress Ellen Andrée. The café is the Nouvelle-Athènes, one of the cafés where the Impressionists used to gather in Paris.

The painting caused a scandal in London, where it was sold, and in Paris, where it was shown at the Impressionists' third exhibition in 1877, because it appears to depict a down-at-heel prostitute.

Degas may have been inspired by Émile Zola's recent low-life novel *L'Assommoir* (1877). Both Manet and Degas produced paintings and pastels of prostitutes. Degas even made a series of 50 satirical monotypes depicting brothel scenes—many of these were destroyed by his family on his death in 1917.

As ever, the composition and perspective are innovative. The scene is viewed from a nearby table, allowing a design of table-tops to enclose the figures. Degas makes use of one his favorite devices of placing figures slightly off-center, with a large intervening space in the foreground. Unusually, on this occasion he may have painted from life without preparatory drawings, with a few areas, such as the slight blurring of the woman's face, being touched up afterward.

EDGAR DEGAS The Racecourse, 1877–80

Musée d'Orsay, Paris. Celimage.sa/Lessing Archive

HIS marks Degas' return to painting racehorses in the 1880s. Unusually, it shows a landscape with a town in the background and a steam train rushing in from the left—the smoke from its funnel echoed in the white, cloudy sky above.

Both sides of the painting are cropped—on the left a jockey reins in a galloping horse. A clear comparison is being made between the horse and the train behind it. On the right, a woman in a carriage looks at the jockeys. A man with a cane, cut off on the right, comes into the foreground. Three jockeys on horses overlap in such as way as to suggest a composite animal. This patterning effect shows Japanese influences. The bottom-left quarter of the canvas is empty—another device that was borrowed from the Japanese and used in many of Degas' paintings.

According to critic Paul Valéry, who was a friend of Berthe Morisot's, Degas was "one of the first to study the appearance of the noble animal by means of Major Muybridge's (1830–1904) instantaneous photographs." He began to show the correct position of the running horse's legs after about 1880.

Racecourses appear in the work of both Degas and Manet and they certainly visited the racecourse together at least once. Ironically, despite the speed and the liveliness of the movement, all their works were painted in the studio from drawings.

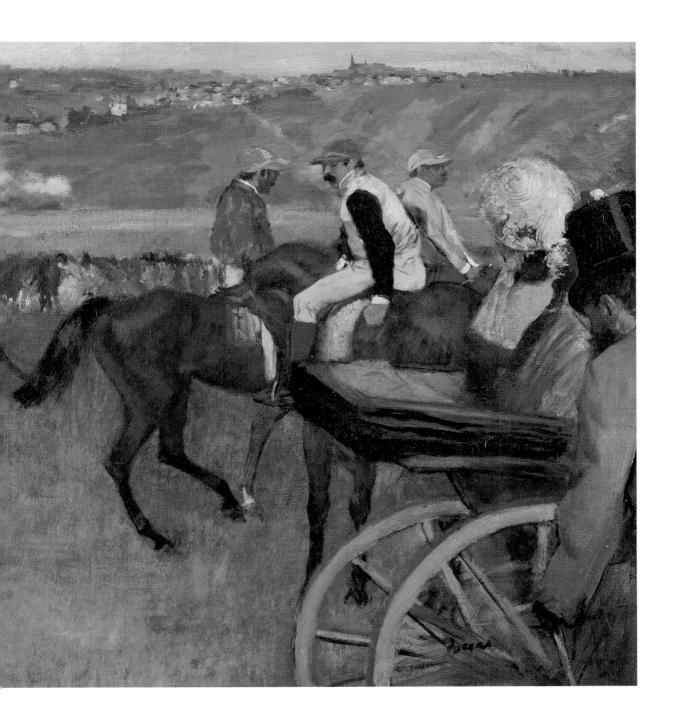

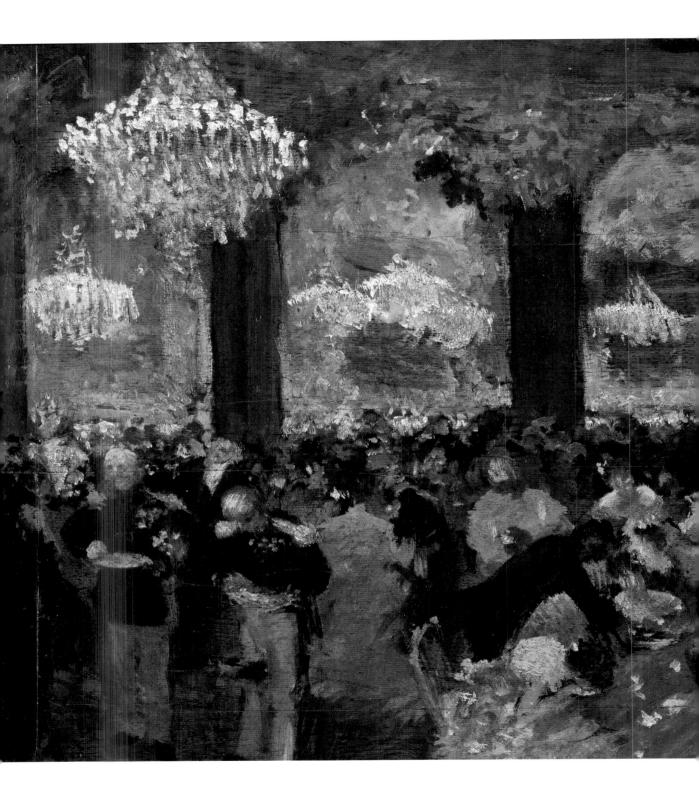

EDGAR DEGAS Dinner at the Ball (after Adolf von Menzel), 1879

Musée d'Orsay, Paris. Celimage.sa/Lessing Archive

ETWEEN 1875 and 1885, Degas experimented prolifically with artistic techniques. Dinner at the Ball is an outstanding example of an Impressionist painting, with the rapid, short brushstrokes filling the canvas to depict the fleeting movement of men and women dancing at a ball. This piece is almost incomparable to some of Degas' dancers or portraits, since here he experiments with the use of bright gold and red, set against the black of the men's suit jackets. The golds and yellows add an element of glamor to the scene.

The features on the people's faces are completely indistinct, and a lack of tonal variation makes the painting appear quite flat. From a distance, the scene appears as a sea of color. It is only at closer quarters that the true nature of the piece can be deciphered. In some places, the paint is applied so thinly that the texture and color of the canvas beneath shows through. Yet this simply adds to the spontaneity of the painting, underlining its truly Impressionist style and demonstrating the versatility of the artist.

EDGAR DEGAS Green Dancers, c. 1880

Thyssen-Bornemisza Collection, Lugano. Celimage.sa/Lessing Archive

HIS an early example of the pastel work that came to dominate Degas' later years. It is notable, above all, for its composition—three dancers in bright green seen from a plunging height as if from a box, cut off on the right and with only one whole dancer, the others simply a combination of legs and skirts. Dancers in orange strike casual poses in the background. In reality, they could not be seen by the audience, but their inclusion gives a sense of both the "real" and the "magical" aspects of the dancers. The customary empty space, in this case the stage, is tilted to an angle of 45 degrees, making the foreground seem yet more vertiginous.

This painting was very much admired and belonged to the English artist Walter Sickert (1860–1942). It shows Degas' lively analytical curiosity, his absolute fascination with how subjects can be ordered and presented in novel ways. Here, as in *In the Café* (1875–76), Degas' love of design comes to the fore—his dancers are almost abstract patterns on a page. The cut-off figures in the foreground also betray Degas' interest in photography; their portrayal is of three frames of the same dancer—something Degas had seen from the photographs of Edward Muybridge showing horses and people in motion.

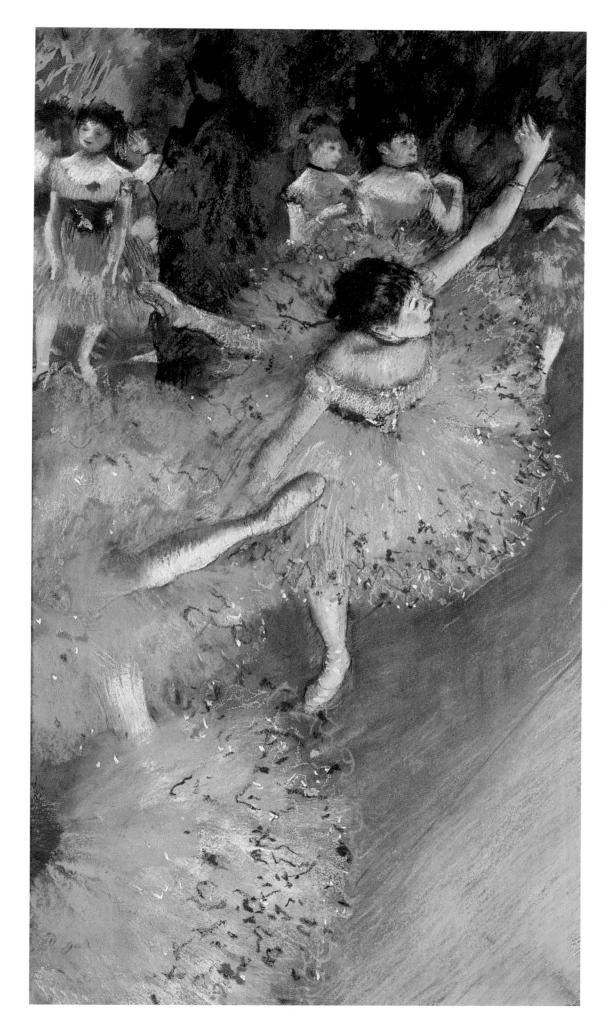

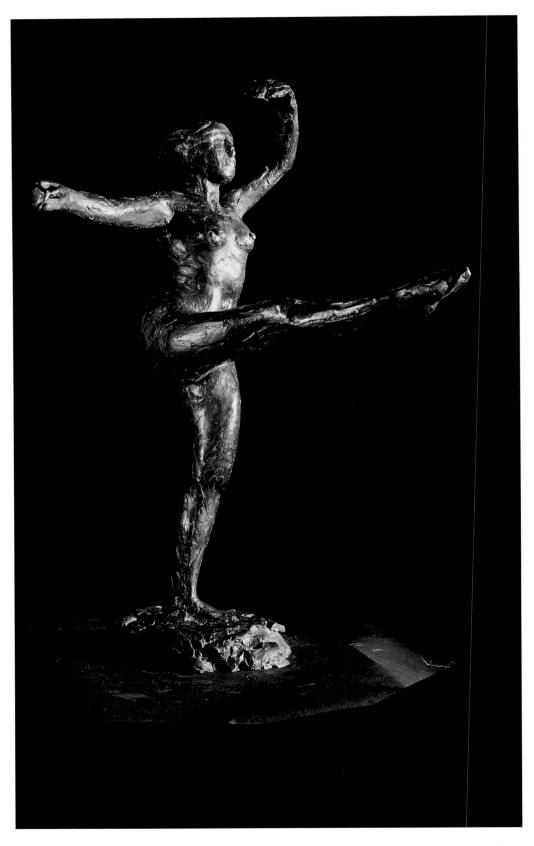

EDGAR DEGAS Dancer, 1884

Musée d'Orsay, Paris. Celimage.sa/Lessing Archive

URING his working life Degas produced at least 500 models of horses, dancers, and women at their toilette as part of the preparation for his paintings and pastels. Of these, 73 were cast in bronze by Degas' great friend Barthélemy toward the end of 1919, two years after Degas died, including the one shown here.

The only sculpture that Degas ever cast during his life was the Fourteen-Year-Old Dancer (1879). She was two-thirds life-size, dressed in real clothes and with a real ribbon in her hair. Degas exhibited her, after much hesitation, at the Impressionist exhibition of 1881. The bronzes cast after his death were shown in Paris in 1921 to such acclaim that another of the casters, Albino Palazzolo, received the Légion d'Honneur—something of which Degas would not have approved.

Many people saw Degas working on models in his studio, adding or subtracting wax, or giving up and starting again. They were a means of experimenting with movement and seeing all around his subject—an idea that the Cubists would embrace in years to come.

The English artist Walter Sickert describes how Degas, in 1910, "showed me a little statuette of a dancer he had ... and—it was night—he held up a candle and turned the statuette to show the succession of shadows cast by its silhouette on the sheet"

EDGAR DEGAS Women Ironing, 1884

Musée du Louvre, Paris. Celimage.sa/Lessing Archive

EGAS had begun to portray women ironing as early as 1869. The weariness of the young girl is touching; so tired that she has to hold her head as she lifts her chin to yawn. Meanwhile, her colleague bears down on her iron with an exhausted weight. Degas, as in other works such as *Portrait of Edmond Duranty* (1879) or *In the Café (Absinthe)* (1875–76) views his subjects across a table that encloses them within their own space. The background, two strong verticals (one of them the stove), echoes the figures. The scraped and patchy oil paint and bare canvas in-between suggests the barrenness of the girls' lives in the sweatshop.

The round figures are heavy and the movements natural—as with Degas' women bathing, these two are unaware of the viewer, who glimpses a moment in their dreary lives. The realism of the textures—the arms, the wool, the glass bottle, are typical of some of Degas' work of the 1880s, especially those showing milliners' shops.

Women Ironing was not well received. The English critic George Moore explained: "it is one thing to paint laundresses amid decorative shadows like Teniers [David the Younger, 1610–90] did; it is another to show these laundresses yawning above the work table, profiled in strong contrast against a dark background."

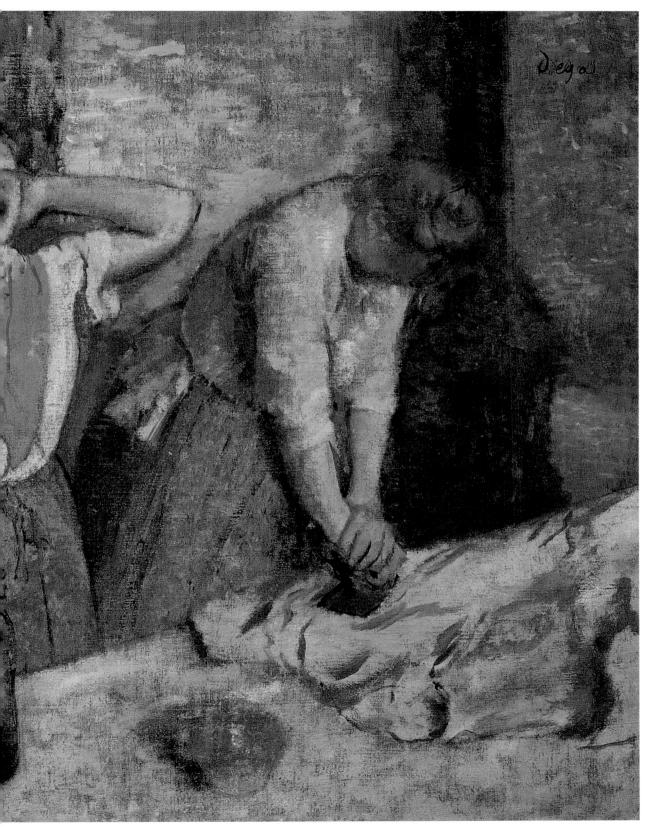

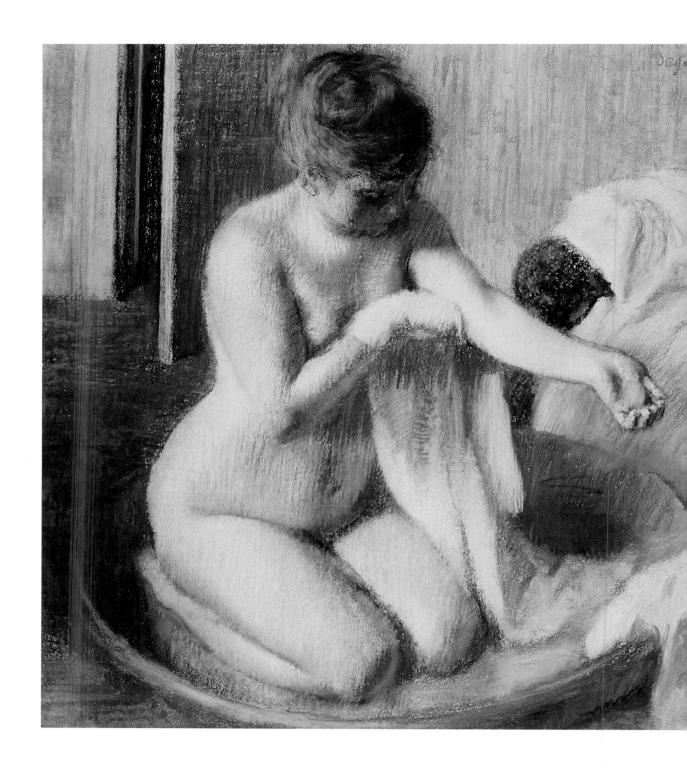

EDGAR DEGAS Woman in a Tub, 1885

Celimage.sa/Lessing Archive

HIS pastel may be one of the series of ten showing women at their toilette that Degas exhibited, to public horror, at the eighth Impressionist exhibition in 1886. In much the same way as Manet's *Olympia* (1863) and *The Lunch on the Grass* (1862–63) had caused shock in 1863, these nudes appalled the public because of their modern subject matter and their ability to make the viewers question their role in the visual process.

Degas' nudes are simple working girls, whom the public will have presumed to be prostitutes. Their portrayal was deemed offensive and the act of washing, particularly showing the postures and contortions required to wash effectively in a tin bath, thought to be degrading. In addition, these women are completely unaware of the viewer—apparently putting the viewer in the position of voyeur. The honesty of Degas' portrayal (which was motivated by considerations of form and movement as much as by anything else) was too much for the critics and the public.

The critic J.-K. Huysmans spoke for the majority when he wrote: "It seems as though [Degas] ... has determined to retaliate and fling in the face of the century the worst insult he can devise, overturning that cherished idol, woman, degrading her by showing her actually in her bath in the humiliating postures of her toilette."

It is interesting to note, however, that over half the nudes were sold before they even reached the exhibition.

EDGAR DEGAS The Tub, 1886

Musée d'Orsay, Paris. Celimage.sa/Lessing Archive

HIS pastel was exhibited at the Impressionist exhibition of 1886. But, shocking though Degas' nudes were to the public, his main interest was in natural, innocent, untroubled form and movement. He once described woman as "the human creature preoccupied with itself, a cat that licks itself," and also himself as seeing his nudes "as if through a keyhole." This comment has caused controversy over the years, suggesting a titillating voyeurism by catching these women unawares. But, from the works themselves, which show a curious lack of objectivity, and Degas' own comments, it is clear that he simply did not want the figures to be selfconscious. "Perhaps I have treated women too much as animals," he later said.

Degas' love of interesting compositions and viewpoints is clear. The overhead view indicates a Japanese influence, as does the cropping on the right side with a strong vertical (actually a receding table edge, only placed in "real" space by the objects upon it). The pose of the nude also owes much to the flood of Japanese prints by artists such as Katsushika Hokusai (1760–1849) and Kitagawa Utamaro (1754–1806), that were coming into Europe for the first time.

Done as pastel on card, this work also shows Degas' fascination and increasing experimentation with color, different media, and new techniques such as crosshatching,

which in some places is rubbed and blurred but elsewhere defining or flattering the form. His Classical concern for drawing (learnt from studying Ingres) is also clear.

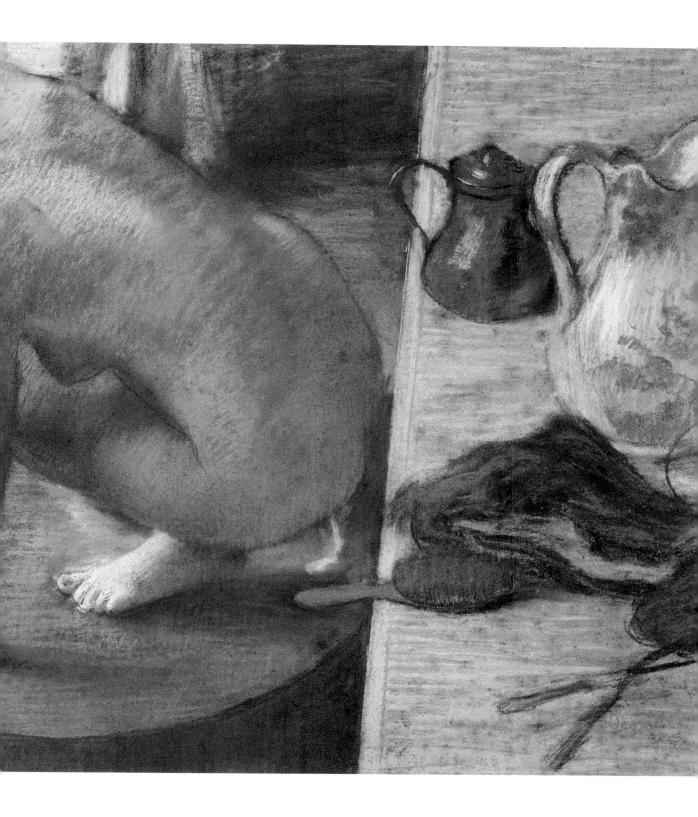

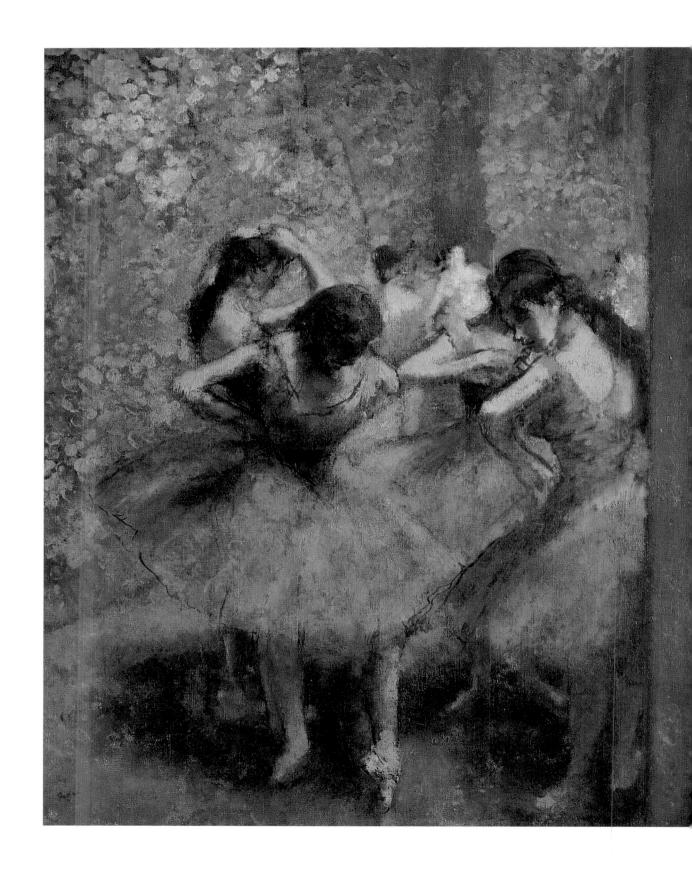

EDGAR DEGAS Blue Dancers, c. 1893

Musée d'Orsay, Paris. Celimage.sa/Lessing Archive

Y 1893 Degas' eyesight, which had begun to trouble him in 1870, was beginning to deteriorate more rapidly. Increasingly, he had to rely on his memory rather than his sight in order to create the images that he wanted.

Here, in oils, he returns to his dancers—four girls in a circle, elbows and skirts sticking out, arranging themselves before they go on stage. The blue of their costumes and the flesh of their décolletage and arms create an almost abstract pattern. The two girls in the foreground are virtually mirror images of each other, viewed from different angles.

In the background Degas creates a Pointillist effect—dabs of pure color side by side. But his aim is not a scientific one concerning the rendition of light. Rather, these marks create a pattern against which the shapes of the dancers stand out and suggests the decoration of the scenery on the stage.

As we look at the scene, a column blocks our view and creates a dramatic vertical element that recalls *The Tub* (1886). Dancers in the background merge with the overall pattern—the flash of orange complementing the peacock blue of the costumes.

EDGAR DEGAS Blue Dancers, 1897

Pushkin Museum, Moscow. Celimage.sa/Scala Archives

N this pastel painted late in his career, Degas has begun to view his subjects from close up—perhaps because of his ailing eyesight or, possibly, in response to the work being produced by his contemporaries Cézanne, Gauguin, and Van Gogh.

It shows four dancers, viewed from above, in similar poses—the two on the right practically identical except for the direction of their heads. Where they are in relation to the stage (although we presume they are in the wings) is not clear. These mirror images and more precise ones occur in many of Degas' paintings and the same poses are repeated many times.

This pastel, as with all the others, would have been created laboriously in the studio from memory, using a number of drawings and sketches—some of which Degas may have used before. He often created the "mirror image" simply by tracing over and pressing paper over a charcoal sketch and reworking the reversed image. He may have worked with photographs—a picture exists of a dancer in this pose, her elbows sticking out, that Degas may have taken.

"Art is artifice," he once said—completely at odds with his Impressionist friends—and, although he created some of the most fleeting-effect images of the entire group, his manner of working was laborious in the extreme.

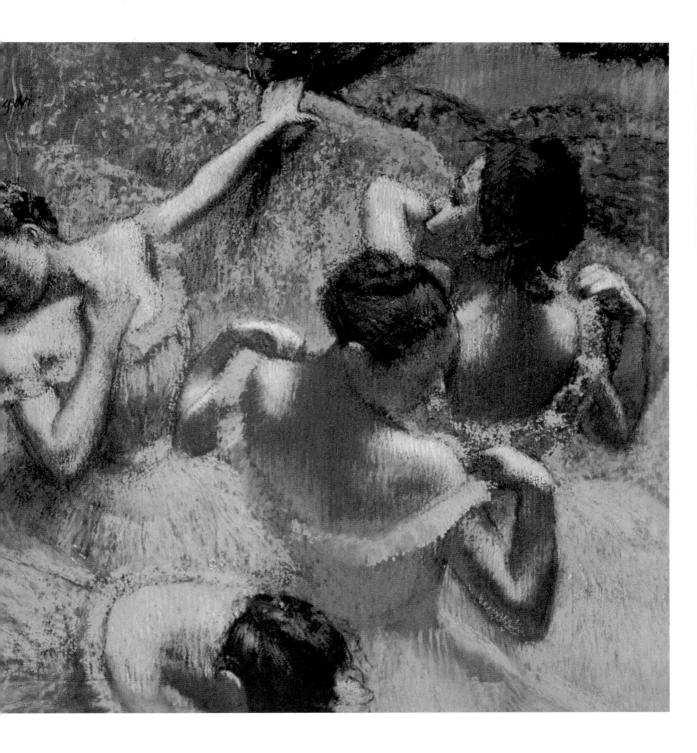

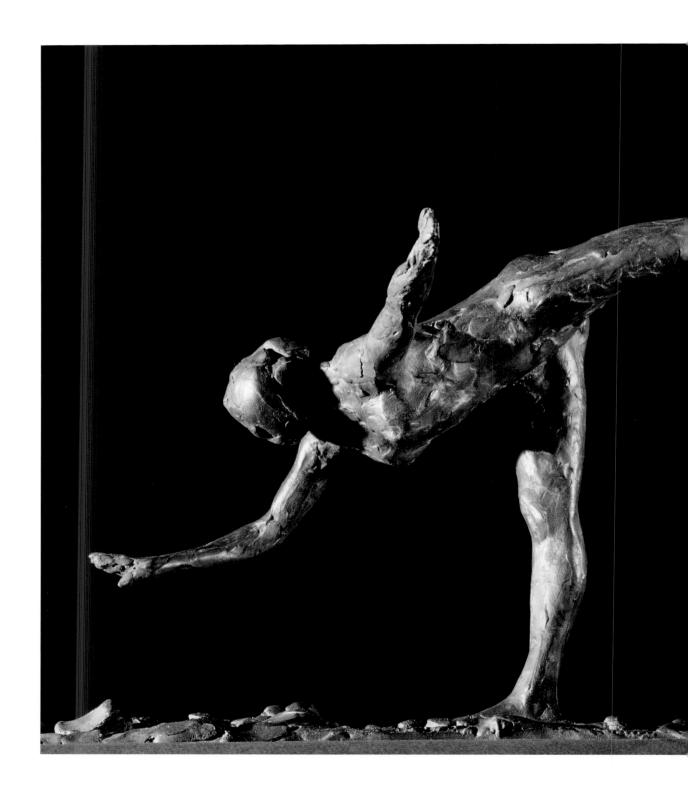

EDGAR DEGAS Dancer: Opening with the Right Leg, undated

Musée d'Orsay, Paris. Celimage.sa/Lessing Archive

EGAS is regarded as one of the masters of the Impressionist period, whose work has set him apart from the other members of the Impressionist group. He experimented with painting, photography, printmaking, and sculpture, becoming one of the most influential and revolutionary artists of the nineteenth century. In his sculptures, Degas contested the traditional perception and appearance of the art form, using ordinary materials to create something powerful and totally innovative.

Dancer: Opening with the Right Leg is a small bronze, measuring only 10 inches in height. Yet this miniature form simultaneously boasts a great elegance as well as a balanced stature. Even though the facial features of the girl are undefined, compositionally the figure is inspiring, as the outstretched arm in front of the dancer's head is balanced by the leg stretching out behind her. The small indentations of the artist's hands are obvious in the areas where light touches the sculpture, adding to its authenticity.

Even though Degas produced these small models of dancers as a basis for his paintings, they can be also be considered on their own merits.

Tragically, Degas' sight deteriorated so much that he was forced to stop working by the year 1912. In his last years he was almost blind. He died in 1917, aged 83.

GUSTAVE CAILLEBOTTE (1848–94) Pont de l'Europe, 1876

Musée du Petit Palais, Geneva. Celimage.sa/Lessing Archive

USTAVE Caillebotte, a naval engineer and amateur painter, studied under Léon Bonnat (1833–1922), the portraitist and historical painter. He met Degas, Renoir, and other artists exhibiting at the Boulevard des Capucines in 1874.

His early work bears affinities with Manet and Degas, both realist painters of city life. Here, Caillebotte provides a fleeting moment on a sunny day on the new Pont de l'Europe in Paris. The viewers walk behind a dog and toward a couple walking and talking, who will pass out of the picture shortly. On the left, a man in a smock-type jacket leans over the bridge, gazing to the view beyond. The sun shines through the girders of the bridge, swallowing up the pavement and decorating it with purple shadows. The painting is overwhelmed by a glistening clarity and the background is not lost in an "impressionistic" haze.

Like Manet, Caillebotte's figures are part of his modern setting and not simply a vehicle for the effects of light and color. The draftsmanship and the palette also reflect Manet and his delight in differentiating between shades of white.

The composition is made up of six triangles, which meet behind the heads of the couple. It is cut off as in a photograph. A large empty space takes up the left side of the painting and the girders of the bridge forge their way in diagonally and dominate the composition. To counter this inward movement, the couple walk toward us, out of the painting.

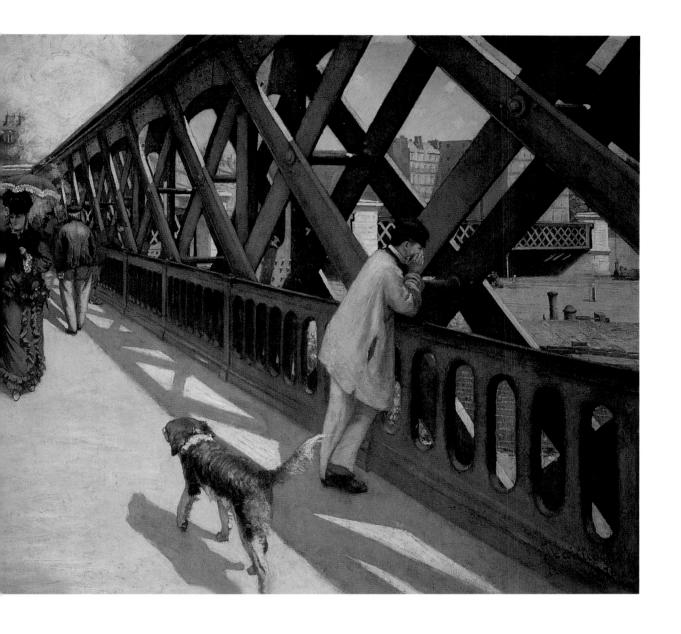

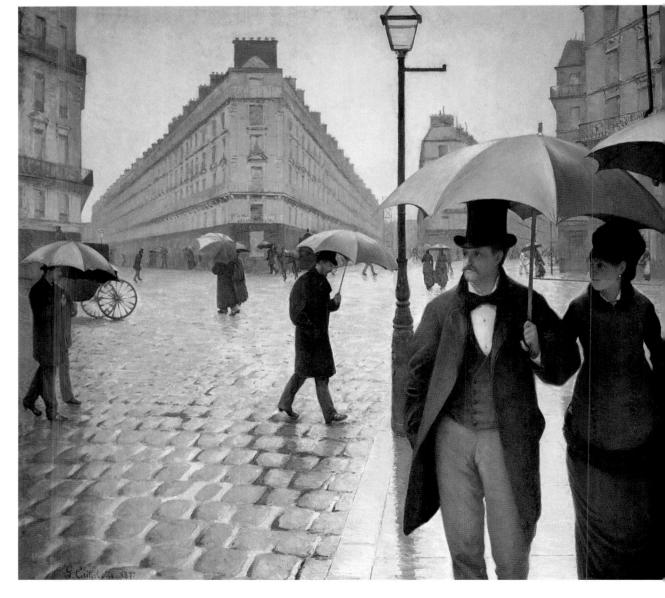

GUSTAVE CAILLEBOTTE Street in Paris in the Rain, 1877

Chicago Art Institute. Celimage.sa/Lessing Archive

HIS is another street scene in which Caillebotte creates a sense of movement in and out of the canvas. It is a geometric design with an emphasis on the vertical. Horizontal movement is created by the people crossing the street. Open umbrellas prevent the design from becoming rigid.

Surprisingly, this is one of the few Impressionist works that depicts Paris in the rain, when the light becomes uniform without any direct sunlight to shine through the leaden sky. This may be because painting outside in the rain, as well as being uncomfortable, did not offer the contrasts of light and shade that lent themselves to the colorful palettes of artists such as Monet and Renoir. Caillebotte's palette is fairly muted although, when not using shades of black, gray, and white, he uses complementary orange and green for the lamp-post and the wall on the right. He makes full use of the wet cobbles and pavement to create reflections and effects of glistening light.

The composition is unusual, with the edges "cut off" and the viewpoint from the left, as if the viewer is walking along the pavement too. Borrowing from Japanese techniques, a lamp-post cuts the canvas in half and divides the close-up, cluttered view on the right from the long, relatively empty view on the left. These experiments in composition are reminiscent of Degas' work.

GUSTAVE CAILLEBOTTE Bathers, 1878

Private Collection, France. Celimage.sa/Lessing Archive

Y 1878, Caillebotte was increasingly using the Impressionist palette and painting naturally lit outdoor scenes. However, although his palette has lightened and his brushwork is more relaxed, he has not yet adopted a fragmentary or sketchy application of paint that might interrupt the contour or three-dimensional solidity of his figures.

This is one of several river scenes showing young men diving, rowing, swimming, and climbing out of the water. The fact that it shows men bathing is quite unusual. Bazille painted his technicolor painting of young men bathing in 1869 and Seurat painted *Bathers at Asnières* in 1883, but virtually all other Impressionist bathing scenes show women and girls bathing.

This painting, along with *Pont de l'Europe* (1876) and *Street in Paris in the Rain* (1877) was exhibited at the fourth exhibition in 1879, which Gustave Caillebotte arranged. Although he was not one of the foremost Impressionists, he supported the group financially and built up a collection of their work. He died in 1894 and bequeathed his collection to the state of France which, typically, was unsure about accepting such an unorthodox collection. The bequest, now at the Musée d'Orsay in Paris, still caused controversy when it was shown in 1897.

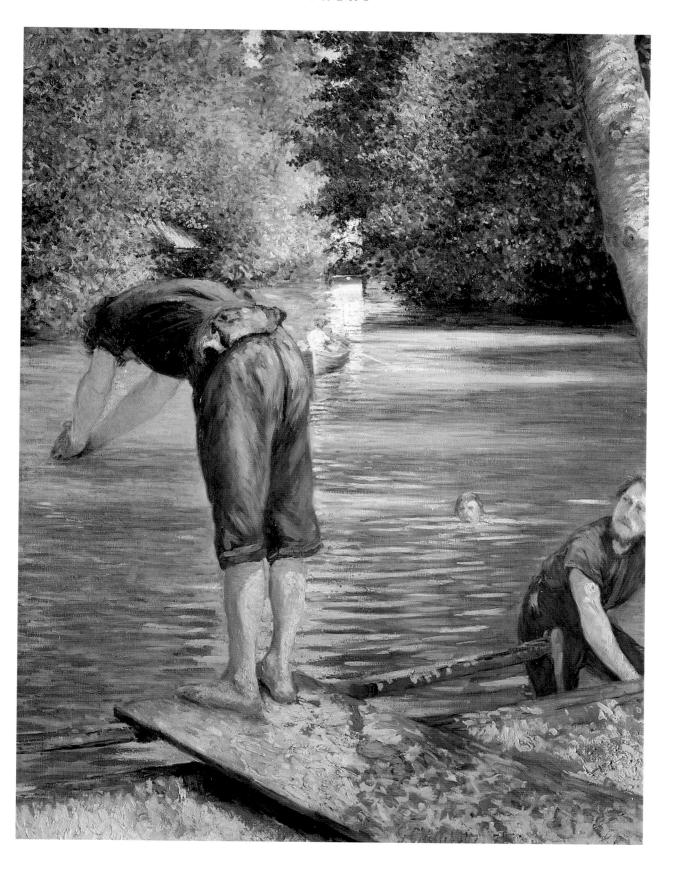

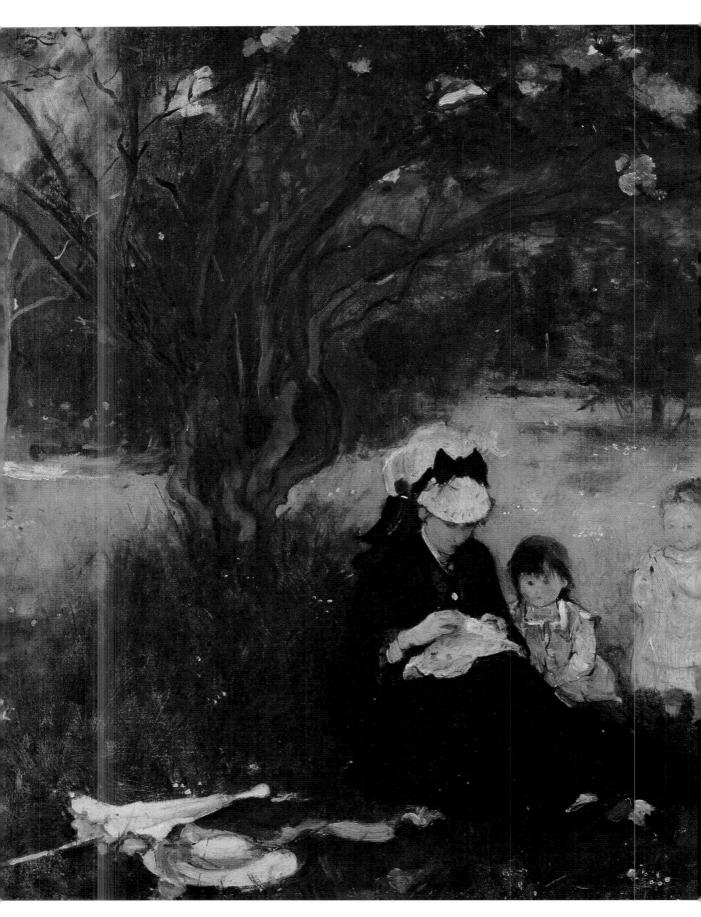

BERTHE MORISOT (1841–95) The Lilacs at Maurecourt, 1874

Private Collection, Paris. Celimage.sa/Lessing Archive

ERTHE Morisot was the daughter of a senior civil servant and the great-great-grand-niece of the painter Jean-Honoré Fragonard.

Between the years 1860 and 1862, she was a pupil of Camille Corot, who advised her to paint out-of-doors. She came into contact with the Impressionists through Edouard Manet, whom she met in the Louvre with the artist Henri Fantin-Latour (1836–1904) in 1869.

Manet's influence on Morisot is obvious in works such as *The Lilacs at Maurecourt*. In Manet's *The Mother and Sister of the Artist* (1869–70) the dominant figure is dressed in black, while the other people in the painting are attired in a soft cream. This contrasting color technique, invented by Manet, was adopted by several of the other Impressionists.

The Lilacs at Maurecourt is a beautiful example of an Impressionist painting. Morisot has smoothed her canvas with a layer of green paint, filling every part of its surface. As we view this private scene, the woman and two children seem completely unaware that they are being painted. A measure of detail has been achieved by using a fine layer of paint to highlight certain parts of the tree and outline the three figures.

BERTHE MORISOT In the Cornfield at Gennevilliers, 1875

Musée d'Orsay, Paris. Celimage.sa/Lessing Archive

Y 1875, when this painting was completed, Morisot had married Manet's younger brother Eugène. She painted many landscapes as well as bourgeois women—rather like Renoir and Mary Cassatt (1845–1926). Here, she was painting at Gennevilliers, where Manet had a house. Painted in the open air, it shows a man standing on a path at the edge of a cornfield. In a typically Impressionist manner, she uses fleeting, dab-like strokes that many contemporary critics considered "slapdash." To others, such as the critic Paul Mantz, "her freshness and improvization" made her the "only Impressionist in the group."

In this light-filled canvas, she is using a palette that hovers around yellow and blue, with very tiny touches of red in the roofs of two houses in the background. The emphasis is on the land and sky, a horizontal that Morisot does not interrupt. Even the man, painted in the same manner as the corn and landscape so that he blends in, is contained within the gold band of the cornfield. True to Impressionist theory, Morisot builds up her scene and the effects of light and the breeze by the way in which she applies the paint and juxtaposes colors. Draftsmanship, edges, and contours are not a priority.

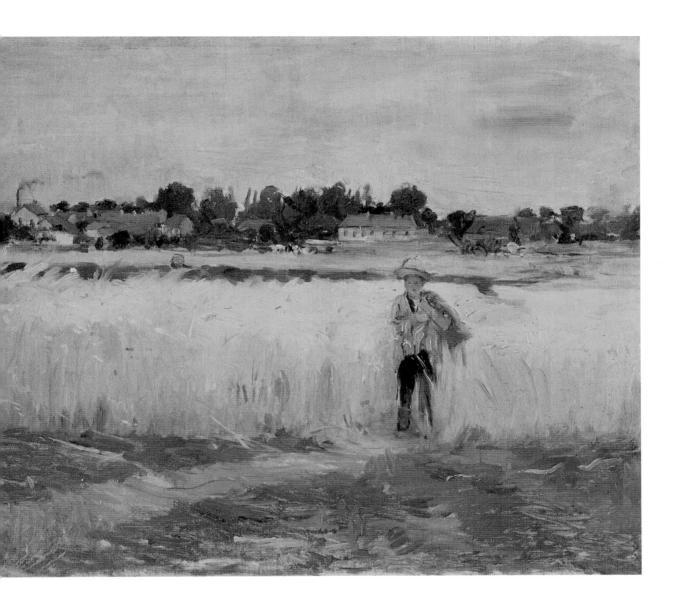

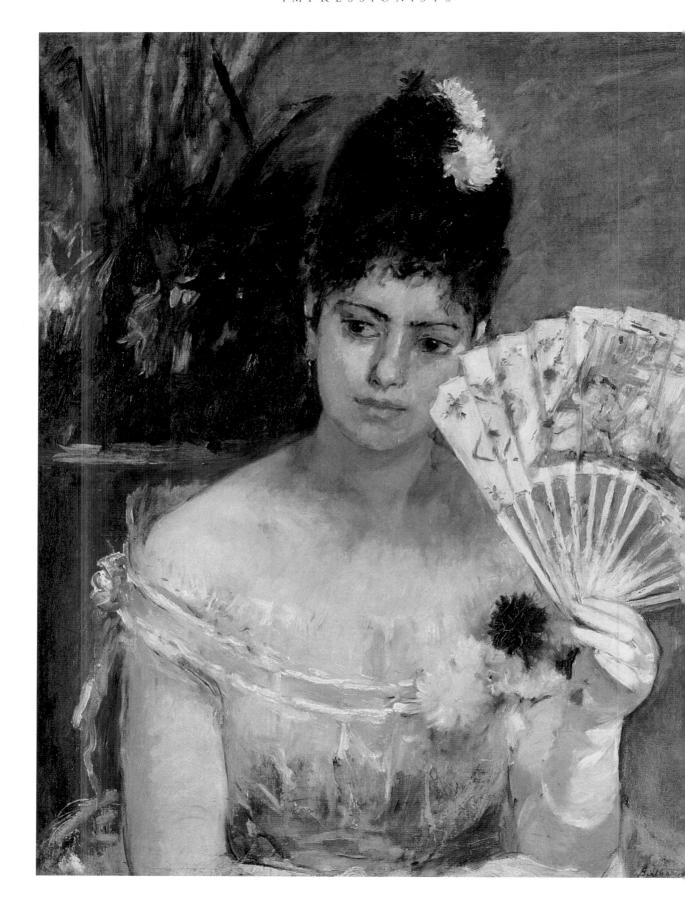

BERTHE MORISOT Young Girl at the Ball, 1875

Musée Marmottan, Paris. Celimage.sa/Lessing Archive

OMPLETED the same year as *In the Comfield at Gennevilliers*, but in a more formal Impressionist style, *Young Girl at the Ball* shows Morisot painting another of her favorite topics—bourgeois women. She painted many scenes of women dressed for a ball and provides a psychological insight into the moods of her models.

In this slightly asymmetrical composition, she makes fine use of color, not dissimilar to Manet's before he embraced a lighter palette. It is at about this time, partly under her influence, that he, too, embraces the Impressionist way of painting. The young girl, her cheek on her fan, gazes to the right, her eyes caught by something or deeply intent on her own thoughts. She holds the fan gingerly, as if she has just been taught how to do so. This is a portrait of a girl in thought as much as a ball scene showing a young girl sitting out a dance. The composition is fairly straightforward but note how the right-hand side of the painting is unadorned and empty apart from the fan, while the left-hand side is busier, and the colors darker.

BERTHE MORISOT Young Woman Powdering Herself, 1877

Musée d'Orsay, Paris. Celimage.sa/Lessing Archive

IKE Manet, Degas, and Renoir, Morisot painted women at their toilette, but her women are bourgeois and her paintings show the intimate details of the daily ritual of women in a circle like her own. There is nothing remotely salacious about them. Young Woman Powdering Herself was painted the same year that Manet painted Nana, a young woman at her toilette. Both used a light palette, painted in the Impressionist style and showed women in front of their mirrors. But Manet's was shocking—his model, Henriette Hauser, was the mistress of the Prince of Orange and Nana was the name of the prostitute in Zola's novel, L'Assommoir (1877).

Morisot did not concern herself with "unsuitable" subjects, which were in the male domain. As a bourgeois lady, she did not even join the rest of the Impressionist group at the cafés where they discussed art and literature. Morisot's is a private modern world; her women are usually dressed and not shown in situations that might be considered degrading. In addition, her models tend to be her friends and family—women posing for male artists, especially in an undressed state, were presumed to be immoral, simply because they posed in the first place. It was known that many of these models sold their sexual favors. For a woman painting women—dressed or not—none of these associations were relevant.

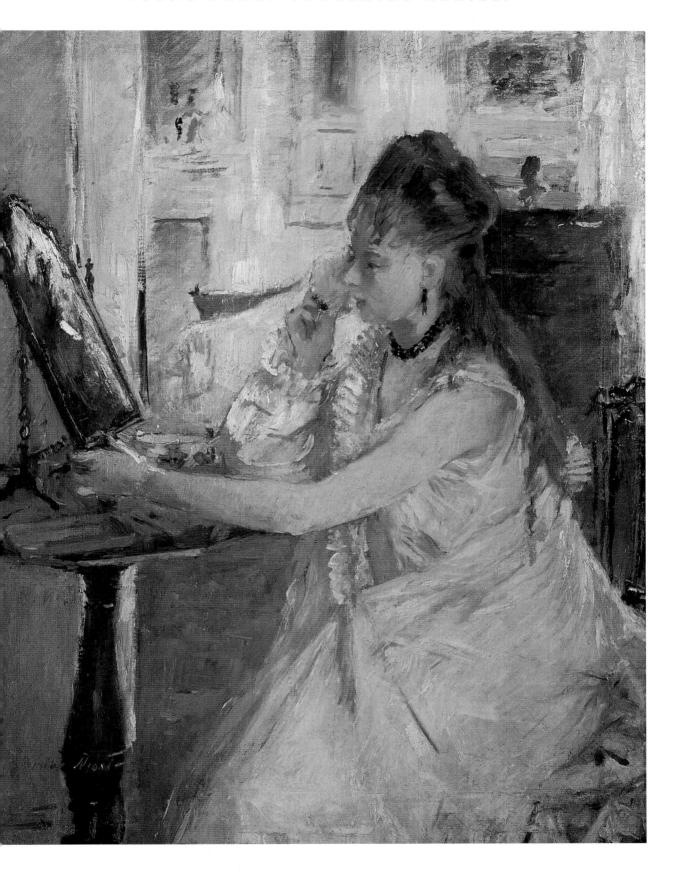

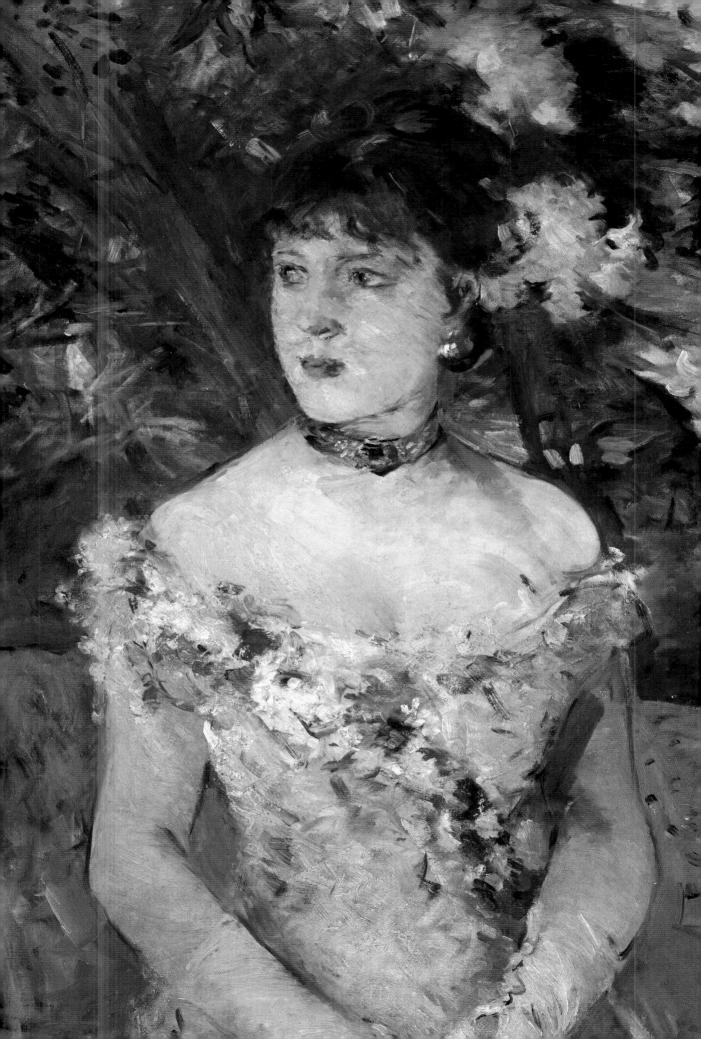

BERTHE MORISOT Young Woman in a Ball Gown, 1879

Musée d'Orsay, Paris. Celimage.sa/Lessing Archive

HIS is a fresh and intimate portrait of a young woman, executed with a light palette in an inherently Impressionist style. Morisot explores the effects of light on the young woman's dress and, particularly, on her face and skin. The cream tones of her ball gown are repeated in the flowers on the green plant behind her, creating a pleasant balance between the subject and the backdrop.

There are elements of this portrait that suggest that this young woman is from the bourgeoisie. Morisot is recognized for her paintings of members of this social class. Her representations of bourgeois women would often have elements of glamor, suggested perhaps in their dress, jewelry, or facial expression. The woman in this portrait is adorned with pearl earrings and a choker, both of which complement her elegant ball gown. She sits in a conventional pose, her head tilted away from the viewer and her hands resting together in her lap.

More often than not, Morisot tried to capture her subjects unawares, so, in this sense, this portrait may seem quite unusual. Although the young woman is not looking at the viewer, it is quite obvious that she is posing for the artist, whereas in Morisot's *Young Woman Powdering Herself* (1877), a portrait of a similar kind, it does not seem as though the subject was posed.

BERTHE MORISOT Bildnis, A Young Lady, 1885

Musée d'Orsay, Paris. Celimage.sa/Lessing Archive

AINTED in 1885, this portrait clearly shows the influence of Renoir, with whom Morisot and her family were becoming friends. Indeed, Renoir looked upon Julie, Morisot's daughter, as the daughter he had never had and was a great comfort to her when Berthe Morisot died in 1895, as her father Eugène Manet died in 1892.

Painted in the loose, Impressionist style—and sketchily finished—the flesh is depicted in shades of pink, white, and blue to indicate the hollows and shadows. But like Renoir at this time, Morisot is showing a concern for draftsmanship—outlining the contours, arms, and waist of her figure in a way that she has not done in her earlier works. The brilliance of her colors, especially the background behind her young model, reiterated in the lips, cheek,s and the outlining of the arms in vermilion, are reminiscent of Renoir and recall the work of Eugène Delacroix.

All the Impressionists revered Delacroix, but in the 1880s many of them, no longer working in the pure Impressionist style of the 1870s, were trying to reconcile his work with the draftsmanship of artists such as Ingres. Renoir, in particular, was working by the mid-1880s in a linear style that Morisot very much admired, finding some of his drawings "as charming as the drawings of Ingres." Much of Morisot's later work shows Renoir's influence either in terms of technique or subject matter.

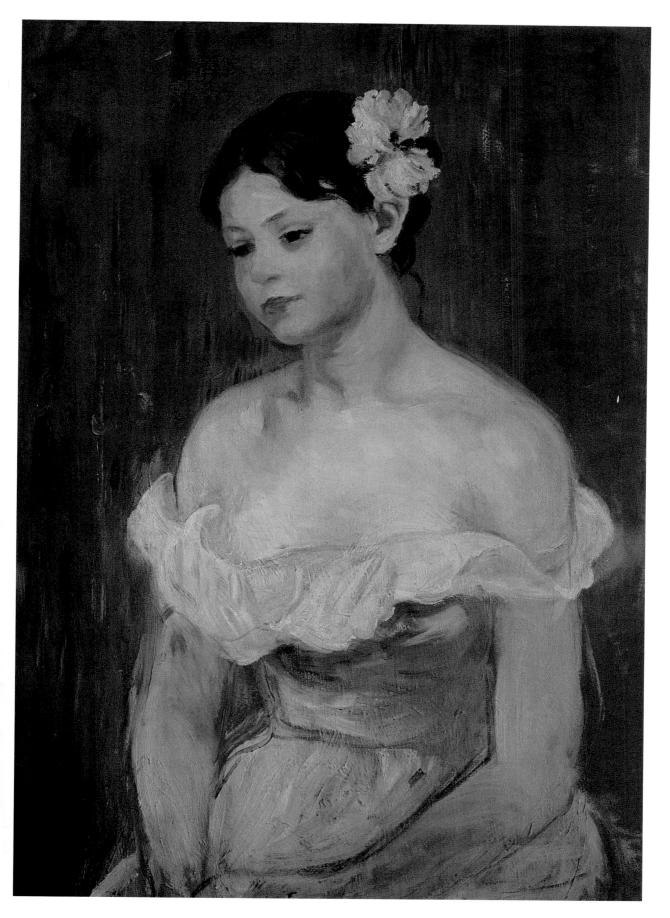

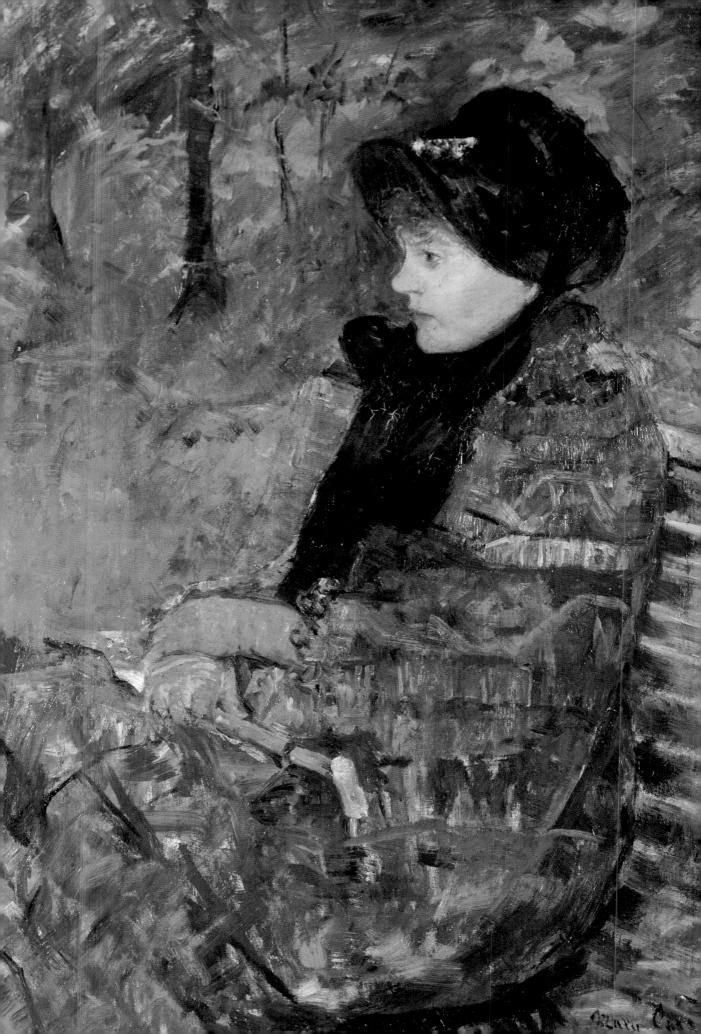

MARY CASSATT (1844–1926) Profile Portrait of Lydia Cassatt, the Painter's Sister, 1880

Musée du Petit Palais, Paris. Celimage.sa/Lessing Archive

ARY Cassatt lived through the reign of Impressionism and also through the movement's demise. She was still painting in 1910, just as Post-Impressionism was beginning to emerge.

As an artist, Cassatt was preoccupied with presenting images of family and domestic life. Her palette was often very soft and considerate of her subjects, as she portrayed their daily lives in an impressionistic style imbued with a subtle realism.

This particular portrait was one of several that the artist painted of her sister Lydia, sitting in a familiar profile pose. She paints her in a very hasty fashion, which is particularly obvious with regard to the bench upon which she is sitting, and the trees behind her. In some places, the white of the canvas shows through underneath Cassatt's liberal use of red and green, although this serves to highlight the softness and detail of Lydia's face. Here, the application of the medium is flat and continuous, compared to the erratic brushstrokes of the young woman's surroundings.

The green of the trees in the background provides a depth to the painting and a contrast to the brightness of Lydia's patterned dress, making it seem as though she is being observed and painted from a very close proximity. Lydia herself looks deep in thought, seemingly unaware of anything around her.

MARY CASSATT Girl in the Garden, c. 1880–82

Musée d'Orsay, Paris. Celimage.sa/Lessing Archive

HIS is one of the many intimate scenes of daily life that Cassatt painted so well. Like Degas, whose art she compared favorably with the Old Masters and which she believed surpassed even that of Jan Vermeer (1632–75), her understanding of form and drawing are superior. By this time, the Impressionists were perceived to be in two groups, the "Romantic Impressionists"—

Monet and Pissarro, who painted out-of-doors and whose forms dissolved in a flood of light, and the "Realist Impressionists," Degas and Manet, whose figures stood out from the backgrounds in their art and who showed a strong regard for line and drawing. Cassatt belonged with the latter.

Based around the colors white, red, and green, this painting in Impressionist style, with its emphasis on sunlight and loose handling, is deceptively simple. The sketchy background and geraniums give the impression of a rich material. The red flowers punctuate the canvas, complementing the green and reflecting the rosy skin and bright lips of the girl who is so intent on her sewing. Look to the patterned background and you will see that this girl is sitting high up and the path, a horizontal stripe that cuts the painting in two, is far below her; the tree to the left and the hazy figures on a bench on the right indicate the height. Cassatt has combined two opposing Japanese effects—showing height but in such a way that the background seems like a flat, patterned backdrop.

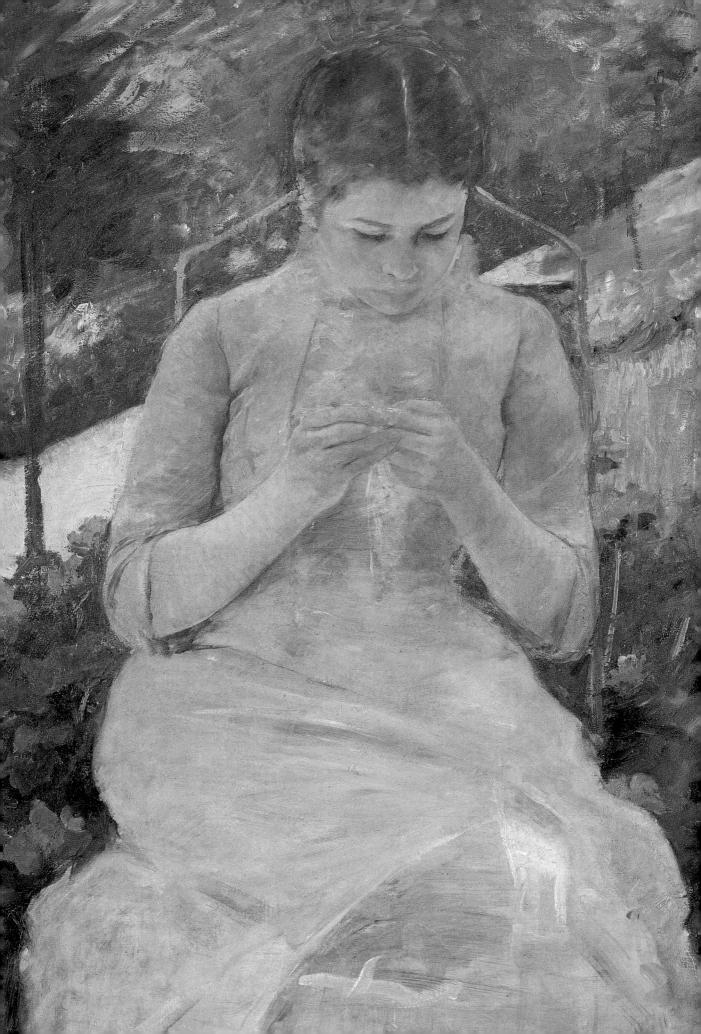

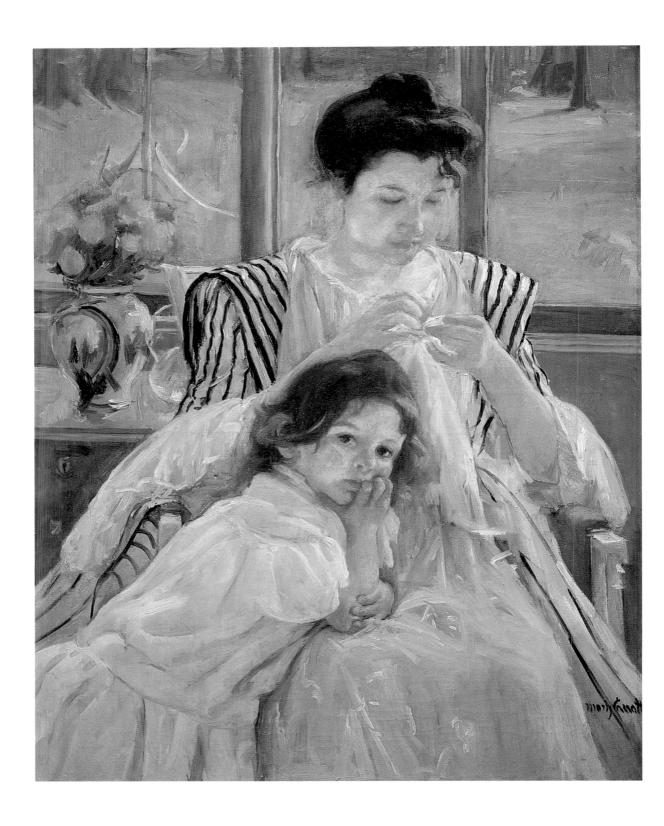

MARY CASSATT Young Mother Sewing, 1901

H.O. Havemeyer Collection, Metropolitan Museum of Art, New York. Celimage.sa/Lessing Archive

HIS charming scene shows a mother sewing while her little girl leans on her knee and looks out at the viewer—a way of involving the viewer that recalls work by Manet. It is a strong composition with the two figures creating a triangular effect in the center, the vertical slats of the window frame on either side of the young mother's head reinforcing her shoulders and bringing the eye to her sensitive fingers, so intent on this delicate work. Her concentration is tangible. The little girl, whose diagonal figure also concentrates the gaze on her mother's fingers, seems faintly peeved that she is receiving no attention. They appear to be comfortably off—but note the blue apron around the mother's neck.

Cassatt's attention to the particular is clear in the background details in the garden—the trees echoing the vertical window frame and creating a link between the indoor and outdoor worlds. There is more refined detail in the light veil being sewn, the flowers in a vase, the handles on the chest of drawers, and the tendrils of hair escaping at the woman's neck.

The colors are light and bright. Sunlight floods the scene, the skin of the child and mother glow in the light, and Cassatt's ability to create texture knows no bounds in the dress materials—especially the diaphanous veil upon which the young mother is working.

MARY CASSATT A Mother Holding her Child in her Arms, undated

Pushkin Museum, Moscow. Celimage.sa/Lessing Archive

HAT is inherent in this piece, is Degas' influence on Cassatt. She uses pastel as a medium, as he was increasingly doing in the 1890s, and her long individual strokes, especially noticeable on the pink of the mother's dress, are evident in much of Degas' work. However, in treating the hands and faces, she smudges the pastel to create a traditional smooth effect, and a gradual blending of colors. Cassatt always paid great attention to the hands of her subjects. A further, more subtle reference is made to Degas' style in the way that Cassatt adds blue tones to highlight certain areas of the skin.

This is, nonetheless, an image that we would associate strongly with Cassatt, a typical domestic portriat if a mother and child. The bond between the pair is suggested through the position of the mother's head, close to her son's, and the way in which she wraps her arms around him.

The heavy, dark blue of the background is almost overpowering, but it sets off the pink that Cassatt has used to paint the mother's dress. Set against the paleness of the skin, this provides a certain depth, subconsciously stressing the closeness of the mother and son in an empty space.

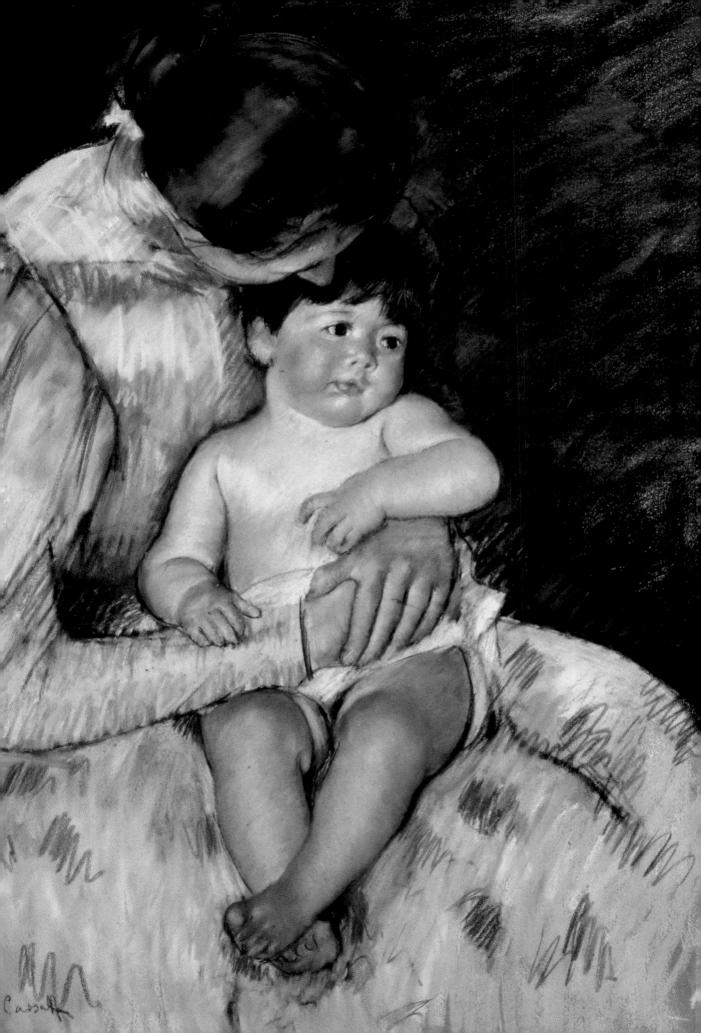

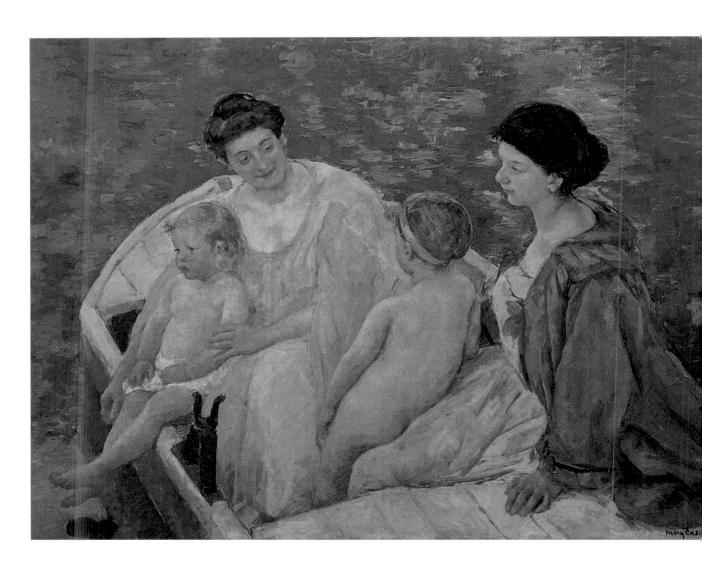

MARY CASSATT Bathing, 1910

Musée du Petit Palais, Paris. Celimage.sa/Lessing Archive

Y 1910, most of the original Impressionist group were dead and a new, younger group of "Post-Impressionists" came to the fore along with even more avant-garde groups such as the Fauves (literally "Wild Beasts," a name given to the group by the critics). They used pure blocks of color and did not concern themselves with natural light effects, taking a step on the path to abstraction. Although Cassatt's work is not Fauvist, she uses broad blocks of color with very little interruption and chooses adjacent colors with great care. Note, for example, the pink peignoir that complements the virulent green of the water (which in turn shows the patchy reflection of trees—see the little area of blue sky bottom left), which extends beyond the figures.

This is a very peaceful painting, viewed from above and cut off at the bottom as if in a photograph. The figures are charming—the two women with their little girls, the central one wearing nothing but a pink headband. The well-defined figures stand out boldly from the background, clearly showing the drawing technique that once led Degas to exclaim somewhat peevishly: "I will not admit a woman can draw like that." Cassatt died in 1926, 16 years after she produced this painting, at the age of 82.

PAUL CÉZANNE (1839–1906) Still Life with Teapot, c. 1869

Musée d'Orsay, Paris. Celimage.sa/Lessing Archive

N 1865 Cézanne was living in Paris. Originally from Aix-en-Provence and destined by his family to be a lawyer, he pursued his art studies at the Académie Suisse from 1862. Here he met both Pissarro and Guillaumin. His work having been rejected by the Salon in 1863, he exhibited at the now-famous Salon des Refusés, where he came into contact with other artists who were unhappy with the Salon system.

Cézanne's still lifes are celebrated for their wonderful tonal variation, intense use of color and individualistic style. He produced many still lifes, some portraits, and some semi-historical and erotic subjects, all infused with an internal frustration and violence. His style varied quite dramatically, until about 1870. In some works he used thick impasto and palette knife and in others, as here, traditional brushstroke.

This still life, painted with a dark palette, was influenced by the seventeenth-century still lifes of Jean-Baptiste-Simeon Chardin (1699–1779). It also refers to the work of Edouard Manet, who was renowned for his dark and contrasting use of black and white.

Still Life with Teapot is quite typical for Cézanne in terms of its composition and subject matter. It features the familiar objects—a knife, a cloth, onions, eggs, and an apple. However, its familiarity does not reduce its impression on the viewer. Cézanne had an innovative way of utilizing his palette that was unrivaled by any other Impressionist painter. This still life presents a familiar subject in a somber and dark light, forcing us to consider thoughtfully what it is he is portraying.

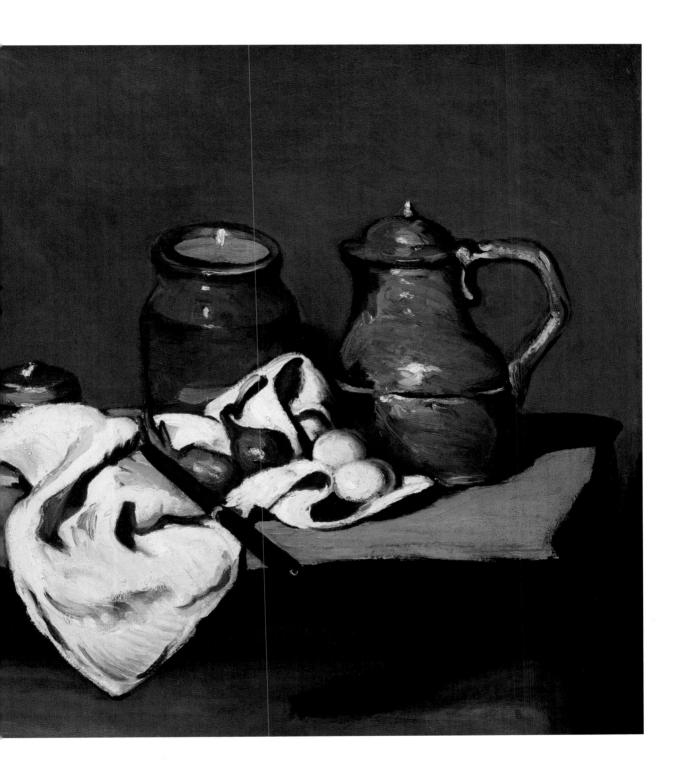

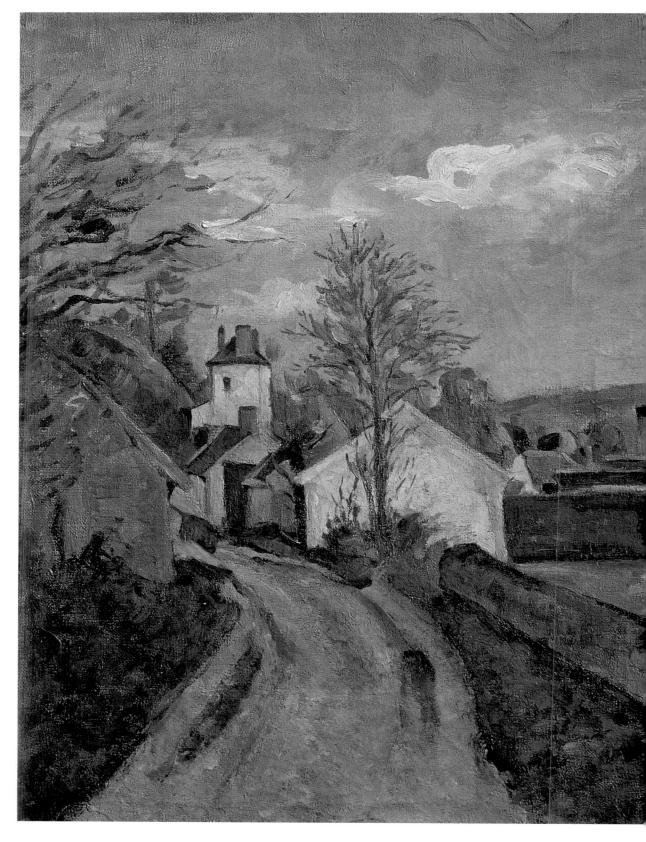

PAUL CÉZANNE The House of Dr Gachet at Auvers, 1872

Musée d'Orsay, Paris. Celimage.sa/Lessing Archive

ÉZANNE was really not an Impressionist, although he had strong links with the group, particularly with Pissarro. As early as 1866 he had reflected, "I shall make up my mind only to do things out-of-doors," but it was not until about 1870 that his palette lightened and he began to show an interest in the reflections of light—ideas that had been current among the group for several years. This change may be due to the influence of Pissarro or perhaps related to time spent by the sea at L'Estaque, where he hid to avoid conscription to the army during the Franco-Prussian War.

In 1872 he went to live in Pontoise where he worked daily with Pissarro, whom he considered his mentor. In 1873 he moved to Auvers to be near Dr Gachet, a friend both of the Impressionists and Vincent Van Gogh (1853–90). He was also a collector of Impressionist paintings and an amateur painter, and offered Cézanne lodging and the use of both a studio and an etching machine.

This painting shows Cézanne working in the Impressionist style. The composition and tendency toward browns and grays in the palette reflect the influence of Pissarro. Cézanne uses the Impressionist technique of cutting off the scene at the edges and creates a sense of movement and time by placing Dr Gachet's house at the end of the road down which the viewer has to travel.

PAUL CÉZANNE L'Estaque, View of the Gulf of Marseille, c.1878-79

Musée d'Orsay, Paris. Celimage.sa/Lessing Archive

HIS painting shows the artist still working in the Impressionist idiom, using a lighter palette than we see in his earlier works, particularly his still lifes, with a greater lightness of touch. The scene is bathed in a fresh, clear light, enhanced by a wonderful blue water and light, airy sky. The brushstrokes are quite defined when depicting the nearby plants and trees on the hill, although in other areas the paint has been applied patchily, especially on the water, where we can see parts of the canvas showing through the blue paint. Viewed from quite a height, overlooking the gulf, the water appears flat, giving no reflection of the clouds or hills.

However, a contrast is created by the opposing directional brushstrokes used for the water and the land. While thicker, vertical brushstrokes have been used for the land and mountains, the water has been painted using a more circular and horizontal method. In the mountains in the distance, we begin to recognize a technique that would later dominate much of Cézanne's work. They are painted with a block-like effect, in what could be described as a semi-Cubist method.

Cézanne was to receive a mixture of positive and negative criticism during the late 1870s. In 1877 he exhibited 17 paintings that, although they had their detractors, won the praise of critic Georges Rivière.

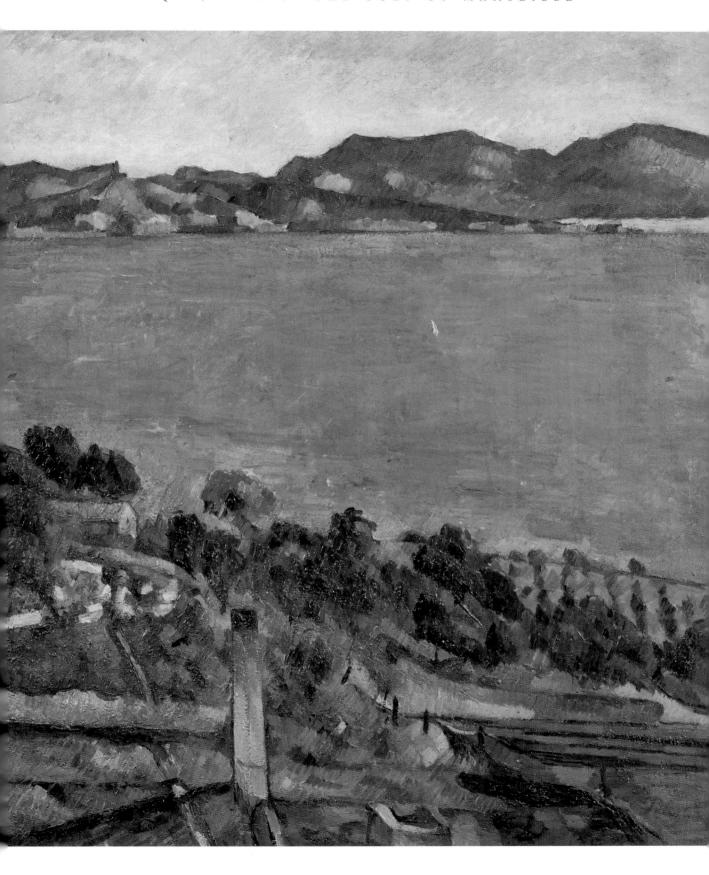

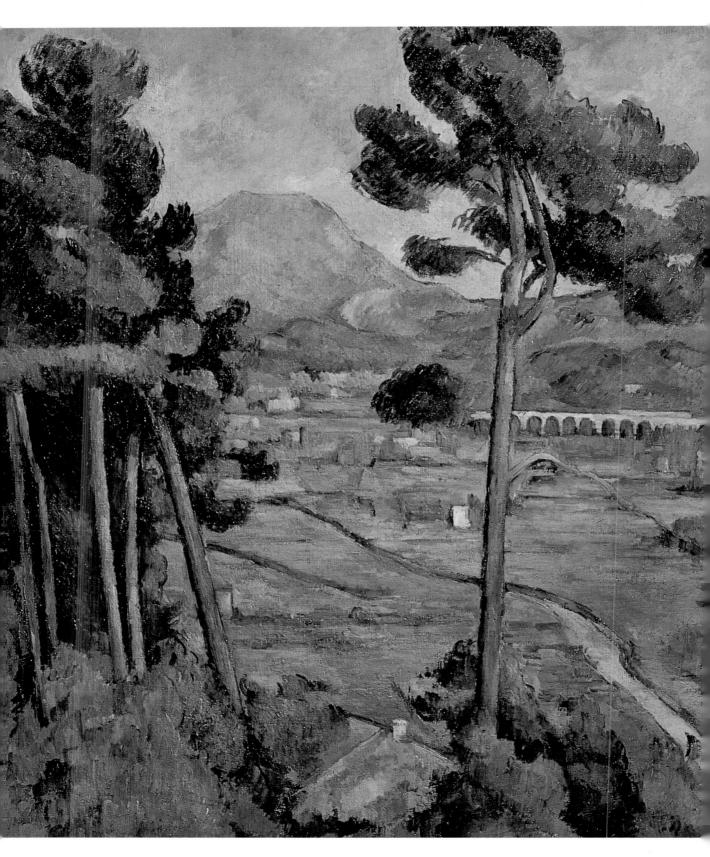

PAUL CÉZANNE Mont Sainte-Victoire, 1882-85

H.O. Havemeyer Collection, Metropolitan Museum of Art, New York. Celimage.sa/Lessing Archive

N 1879 Cézanne wrote to his childhood friend, Émile Zola, "I am using all my ingenuity to find my true path in painting." His Impressionist phase was over, although he continued to paint out-of-doors and modify color in relation to the light that was falling on it.

From about 1880, Cézanne developed a way of painting that he was to spend the rest of his life refining. The key was the way in which he began to apply paint in repeated parallel brushstrokes to produce a subtle patterned, almost woven, effect. His work took on an increasingly monumental and timeless quality.

This is the first in a series of paintings of Mont Sainte-Victoire, the mountain that dominated Cézanne's boyhood home and became his favorite motif.

The view is taken from a height, above a winding road where a small figure makes its way. An aqueduct runs in a pale straight line across the landscape in the same direction as the road and the curving trees on the top of the hill. The color palette revolves around shades of green, blue, and ocher until the eye reaches the pale, pinkish mountain. Patches of color create form. The only visible outlines are up the trunk of the central tree. Although the distance is so clear, Cézanne is beginning to play with the dichotomy of three-dimensional illusion of the painting and its two-dimensional reality in that the patches of paint often overlap and emphasize the flat nature of the canvas.

PAUL CÉZANNE Trees and Houses (Probably near Tholonet), c.1885

Musée de l'Orangerie, Paris. Celimage.sa/Lessing Archive

OUVECIENNES (1872) by Camille Pissarro instantly springs to mind when looking at Cézanne's *Trees and Houses*. The way in which the dark, threatening trees loom in the frame of the canvas, and a small white house appears in the distance, are characteristic of both works.

Set against the strength of the trees a sketchy paint effect is used to depict the ground and the distant houses. These are completed in a lighter color, which defines the outlines of the branches and twigs, so that we have to look closely to see what is beyond their dark layer. They provide a sense of depth, but also act as a patterned screen. Their style recalls Japanese or oriental art; Cézanne was certainly interested in the prevailing fashion for Japanese prints.

However, on closer inspection, we can see how Cézanne confers a cautious unity on the trees and the view beyond. Green color that corresponds with the color of the ground has been added to some of the branches, and the brownyellow used on the ground in front of the trees can be seen on the rooftops and the areas in front of the houses. Around the edges of the painting, and across certain areas of it, the color of the canvas shows through quite obviously. This adds to the sense of the artist's urgency as he painted this scene.

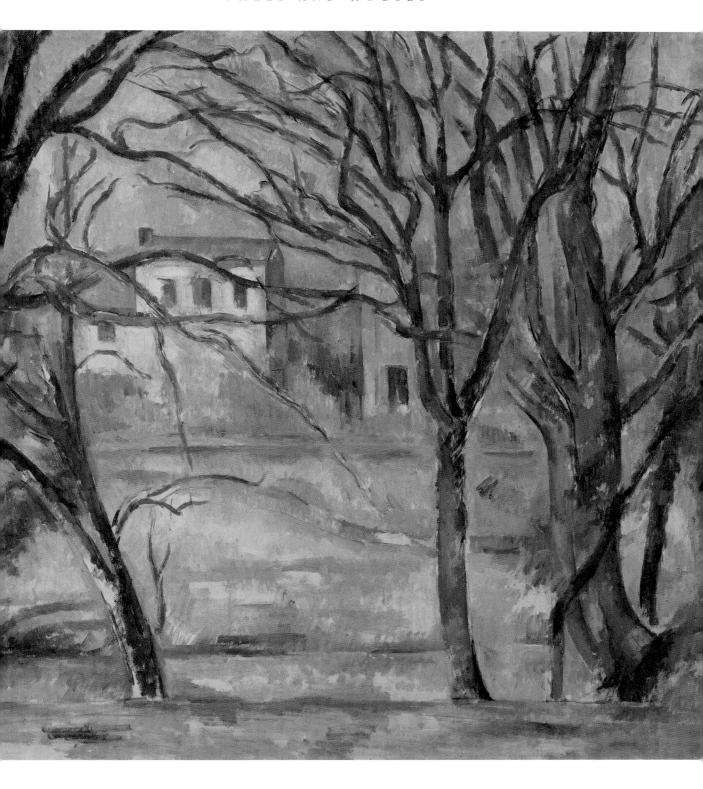

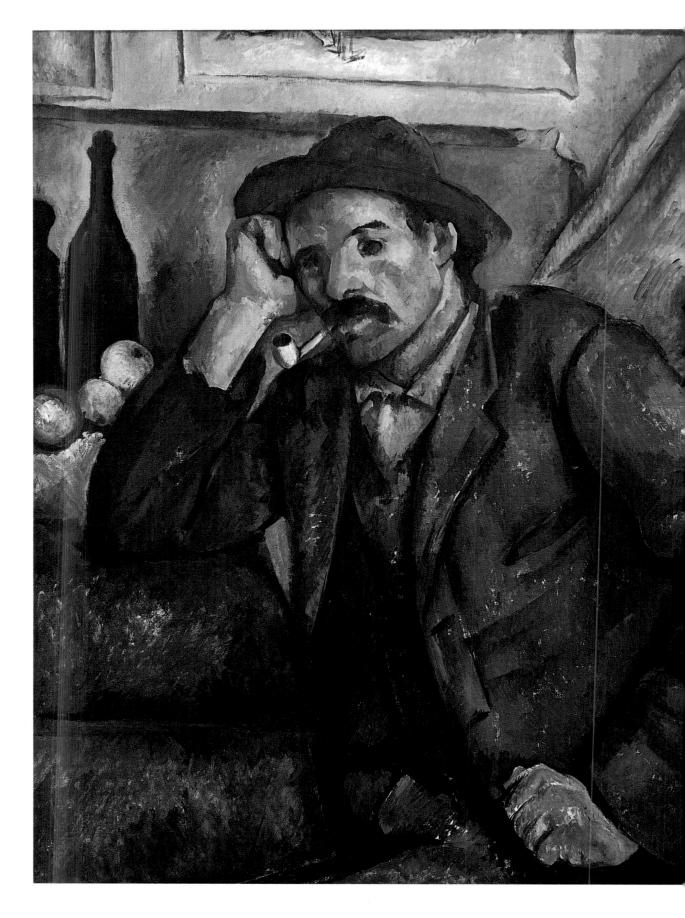

PAUL CÉZANNE The Smoker, c. 1890–92

I.A. Morosov Collection, St Petersburg, State Hermitage. Celimage.sa/Lessing Archive

HE model, Alex Paulin, who was Cézanne's gardener, also posed for the series of *The Card Players* which Cézanne began about this time. Cézanne uses the primary colors, red, yellow, and blue, to great effect. The little patch of white in the clay pipe stands out all the more for its rarity. Viewed from close-up, the figure is weighty, and the patchy, rough treatment of the paint emphasizes the rough skin and ruddy complexion of a working country laborer.

We presume that this man, leaning wearily on his elbow and perhaps a little bored, is in a café. However, close inspection reveals him to be in Cézanne's studio. The wine and the apples that appear to be on his table are part of a still-life canvas propped up against the wall, the curtain on the right a prop. These props are carefully chosen to complement the sitting figure, and create a horizontal with which to frame him and a diagonal that echoes his pose. Note also how the shadow of the bottle in the painting serves to place the sitter's wrist in relief.

Cézanne is again experimenting with the effect of overlapping planes. The blue shadow on the table by the man's elbow, for example, is almost an extension of the painted blue canvas behind him and the apples butt right up to his arms. The table on which he leans is tilted.

PAUL CÉZANNE Apples and Biscuits, c. 1880

Musée de l'Orangerie, Paris. Celimage.sa/Lessing Archive

NLIKE many of the Impressionist group, such as Monet and Renoir, who only painted still lifes if the weather was too bad to paint outside, Cézanne did not regard them as a displacement activity and practiced still-life painting throughout his career. Many only include apples, traditionally symbolic of love and for Cézanne, reminiscent of his childhood. Cézanne once wrote to Zola that he wanted "to conquer Paris with an apple"—subject matter that was simple and everyday and yet full of symbolism.

This painting is typical of Cézanne's style. It shows three compositional, horizontal zones: the front of the chest, the top of the chest, and the wall. One apple rises above the "horizon." The cut-off plate, the wallpaper, and the lock provide the right amount of variation to animate the ponderous static objects that will not move unless pushed by an outside force.

In 1904, Cézanne tried to explain to painter Émile Bernard (1868–1941) how to perceive nature and thus create an effective unity: "Treat ... everything in perspective so that each side of an object or plane is directed toward a central point. Lines parallel to the horizon give breadth, that is a section of nature, or, if you prefer, of the spectacle that the *pater omnipotens aeterne deus* spreads before our eyes. Lines perpendicular to the horizon give depth."

Cézanne's reference to God explains his religious feeling toward nature and art, which he expresses by the monumental solemnity and timeless quality of his compositions.

APPLES AND BISCUITS

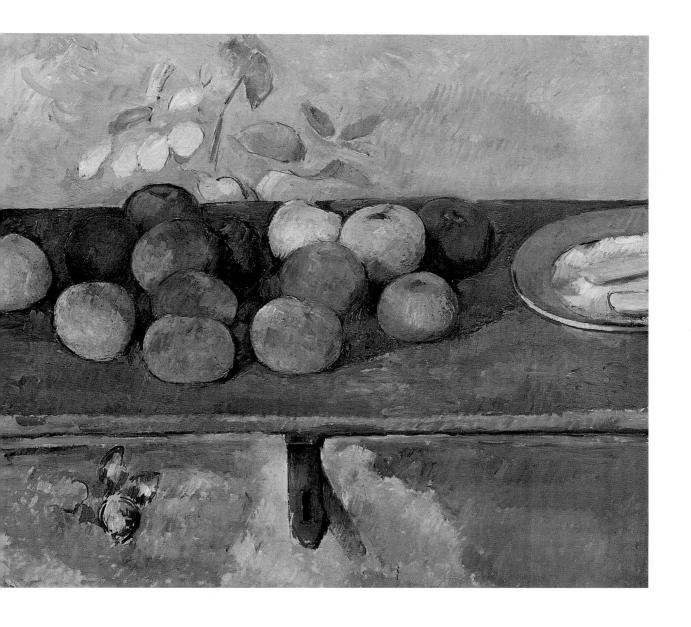

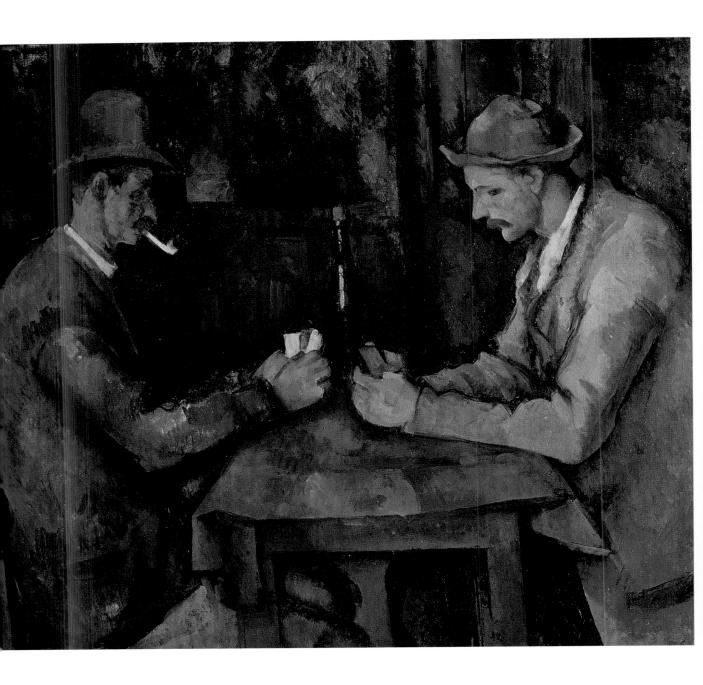

PAUL CÉZANNE The Card Players, c. 1895

Musée d'Orsay, Paris. Celimage.sa/Lessing Archive

ÉZANNE produced several paintings of *The Card Players*; the first was probably in 1890, using his gardener Alex Paulin as a model. However, as he rarely signed and dated his work, an exact chronology of the paintings is difficult.

Cézanne's weighty style was now well-established and his "card players" are as timeless as *Mont Sainte-Victoire* (1882–85) in their ponderous monumentality. They have been compared with the work of Giotto (c. 1267–1337) and Early Renaissance artists. There is no question of a fleeting Impressionist effect, rather an atmosphere of almost religious quiet as the players concentrate. The game has clearly been going on for some time.

The two men are almost mirror images of each other, sitting rocklike on either side of the table. The atmosphere is calm but the tension is palpable. One man is slightly more relaxed and leans forward, while the other is more upright, leaning against the rigid back of his chair, his hands closer to the edge of the table. A bottle, slightly offcenter, separates their hands on the table. The glinting bottleneck, the white clay pipe in the mouth of the man on the left, and the two men's white shirt collars concentrate the gaze on the game in hand.

1886 was the year of the last Impressionist exhibition, although Cézanne had not exhibited with them since 1877. In 1895, the dealer Ambroise Vollard (1865–1939) organized Cézanne's first exhibition since then. In-between times his work could only be seen at the shop of Père Tanguy, a paint merchant based in Montmartre, whom Van Gogh painted and who Pissarro introduced to Cézanne in the early 1870s.

PAUL CÉZANNE Plaster Cupid, c. 1895

Courtauld Institute Galleries, London. Celimage.sa/Lessing Archive

ÉZANNE'S vision at this time looks forward to the abstraction of the twentieth century without remotely losing sight of its subject matter. This large, extraordinary canvas is dominated by a small plaster cast of a truncated Cupid, thought to be by Nicolas Coustou (1658–1733) or François Duquesnoy (1594–1643).

The background is initially confusing, as everything is at different angles and from different viewpoints—something Cézanne began to investigate in the early 1890s. We see a Cupid placed on a table surrounded by apples and onion—rather an odd combination—and viewed from a slightly raised angle. The floor, on which a number of canvases are placed, recedes but not at the expected angle, as it is raised and tilted. An outsize apple in the corner of the room (but almost the middle of the canvas) seems ready to roll toward the Cupid as if it were a skittle. The kneeling sculpture, another painted still life that contrasts with the sculptural (but actually painted) Cupid, reinforces this idea, as do the diagonals of the table and canvas edges that enclose the Cupid and converge upon the apple.

The still-life canvas in the background confuses the sense of reality further in fusing with the "real" still life in the foreground. The painted blue material combines with the "real" blue material on the table and the painted fruits are as round, large, and lush as their "real" relations in the foreground.

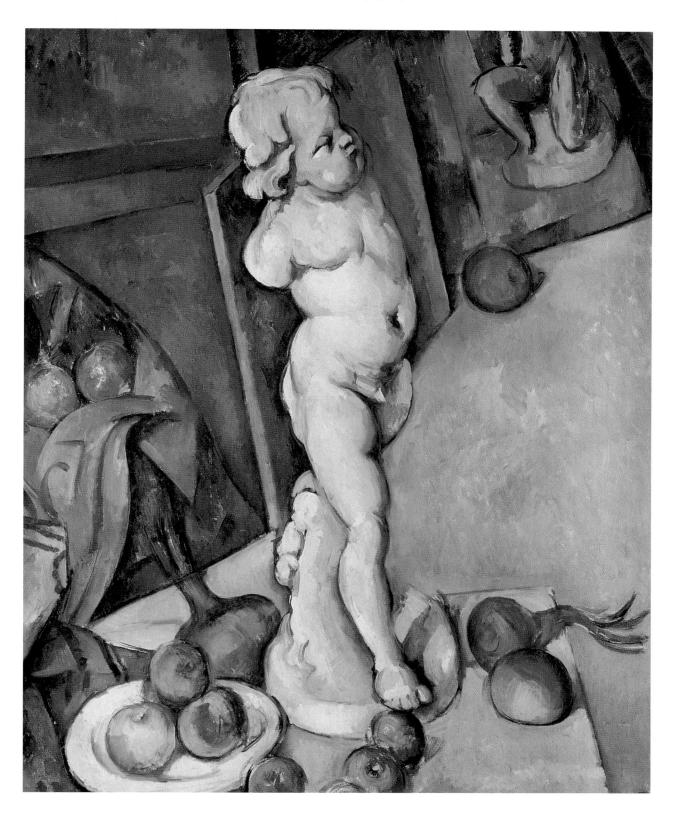

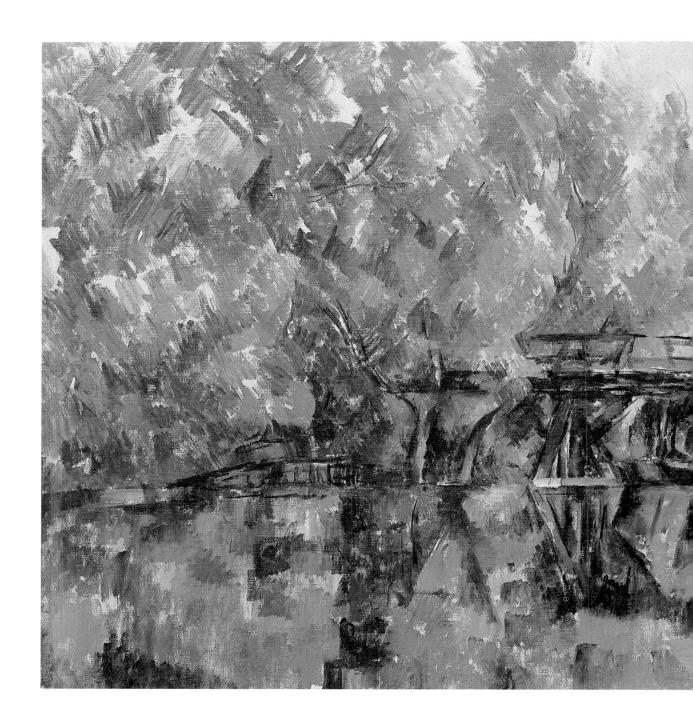

PAUL CÉZANNE Bridge Over the Pond, c. 1898

I.A. Morosoz Collection, Pushkin Museum, Moscow. Celimage.sa/Lessing Archive

HIS picture was painted in 1898, the year that Monet was beginning to paint his Japanese bridge and the pond at Giverny. But the paintings could not be more different. Whereas Monet creates a sunlit, oriental, natural scene with fronds and reflections of nature mirrored in the water, Cézanne's scene is more like the darkened, hallowed interior of a Gothic cathedral with the trees on each side leaning inward to converge, like a roof, at a point above the bridge, drawing us into the picture. The bridge, a short horizontal in the middle plane, almost like a rood screen in a cathedral, acts as a barrier to the vegetation beyond, which opens up to the glories of the sunlit sky.

It is a remarkably structured composition, painted almost entirely in shades of green. The water takes up the foreground in a broad horizontal swathe, the foliage reflected in solid blocks of color made up of small strokes of paint side by side, almost like hatching. By placing the strokes at different angles Cézanne gives a form and shape to the real and reflected vegetation—flat in the water, but softer and more rounded in the trees. He achieves this either by overlapping the strokes in order not to create a sharp edge, or by leaving them surrounded by empty canvas, to give the impression of sun on the leaves.

"I paint as I see," Cézanne once said, "and I have very strong feelings." He never stopped looking at nature and expressing himself in his landscapes, still lifes, portraits, and compositions from his imagination.

PAUL CÉZANNE The Quarry of Bibémus, 1898–1900

Museum Folkwang, Essen. Celimage.sa/Lessing Archive

HE quarry of Bibémus lies on the western flank of Mont Sainte-Victoire, a strangely architectural place where stonecutters had been working since Roman times. Cézanne was drawn to this quiet, stately place and during the summer of 1897, he rented a cabin nearby where he could leave his painting materials and stay the night, if needed.

This painting expresses a great serenity, which Cézanne achieves by painting the rocks—a combination of soft shapes caused by erosion and harder, geometric shapes gouged out of the rock—and the sky and trees in such a way that, while completely separate, they seem to fuse into one great still life. The consistency of the small, even brushstrokes helps to create this feeling.

Perhaps nowhere more than here can we see what Cézanne meant when he wrote to young painter and writer Émile Bernard in 1904: "Treat nature by means of the cylinder, the sphere, the cone ..."

Although the geometry of this picture is natural to the quarry, it is not hard to see how Cézanne's ability to express the essence of what he saw before him appealed to the next generation of avant-garde painters. Max Weber (1881–1961), a pioneer of Fauvism, Expressionism, and Cubism, wrote: "When I saw the first ten pictures by this master ... I said to myself as I gazed ... 'This is the way to paint. This is art and nature, reconstructed...'."

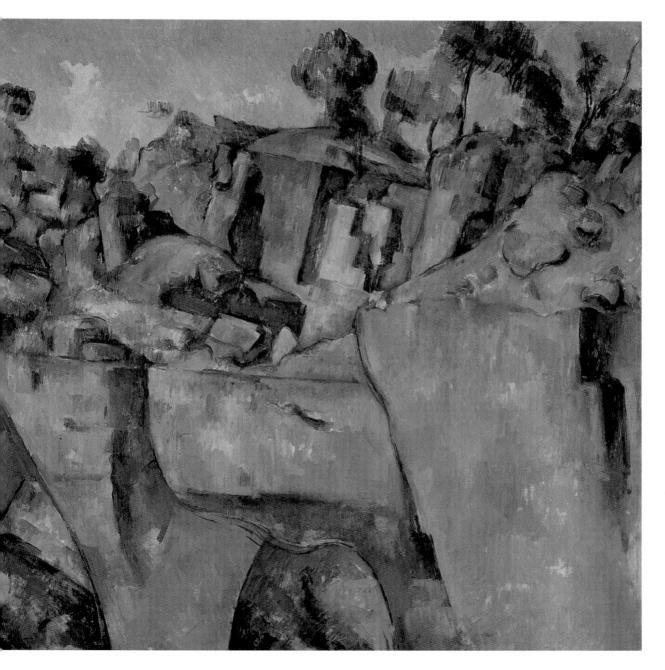

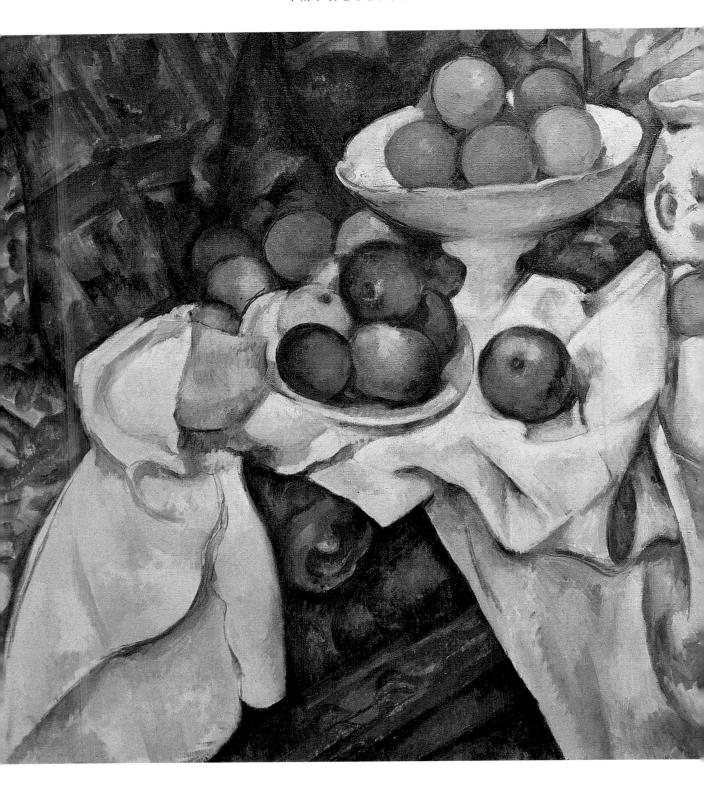

PAUL CÉZANNE Apples and Oranges, c. 1898–99 Musée d'Orsay, Paris. Celimage.sa/Lessing Archive

HIS is one of a series of still lifes that Cézanne painted in Paris, using similar, everyday objects. The chronology of the paintings is not confirmed but it seems likely that this is one of the last. Whereas spatial references can be relied upon in the other canvases—objects are where they appear to be—in this canvas, as in many of his later landscapes and portraits, the planes seem to overlap. Cézanne's art lies in creating pictures that work as an organic whole.

In this still life, each object is a definable entity and yet, together, they create a kind of landscape. The pyramidal structure of the fruit accentuates their volume and locks the objects together. The curtain, like a sun-dappled landscape, shields the still life like a mountain range. The colors of the fruit and also the pattern on the jug create a link with this patterned background. Yet the arrangement stands out, thrown into relief by the white tablecloth, plate, and fruit dish. Secure spatial references cannot be relied upon here. Note also the table, the edge of which appears on the right but which, as you follow the diagonal left, runs into the scroll of an armchair.

PAUL CÉZANNE Still Life with Curtain and Flowered Jug, c. 1898–99

State Hermitage, St Petersburg. Celimage.sa/Lessing Archive

HIS is another of the six canvases painted in Paris between 1898 and 1899 that all feature the same elements. Rather like Monet, whose series of Rouen paintings he greatly admired in 1897, Cézanne paints the same motifs several times. But, unlike Monet, his aim is not to see the effects of changing light but to understand the inner essence of an object and its relationship with the world around it.

Cézanne was very laborious in his painting. In 1914, the dealer Ambroise Vollard described how he had 115 sittings for his portrait in 1899, the year after Cézanne's exhibition in his gallery. He was just as meticulous in setting up and painting his still lifes. His friend, painter Louis le Bail, who worked with him in 1898, described how he arranged his compositions: "The cloth was draped a little over the table with instructive taste; then Cézanne arranged the fruit, contrasting the tones against one another, making the complementaries vibrate, the greens against the reds, the yellows against the blues, fitting, turning, balancing the fruit as he wanted it to be, using coins of one or two sous for the purpose. He took the greatest care over the task and many precautions; one guessed that it was a feast for the eye for him."

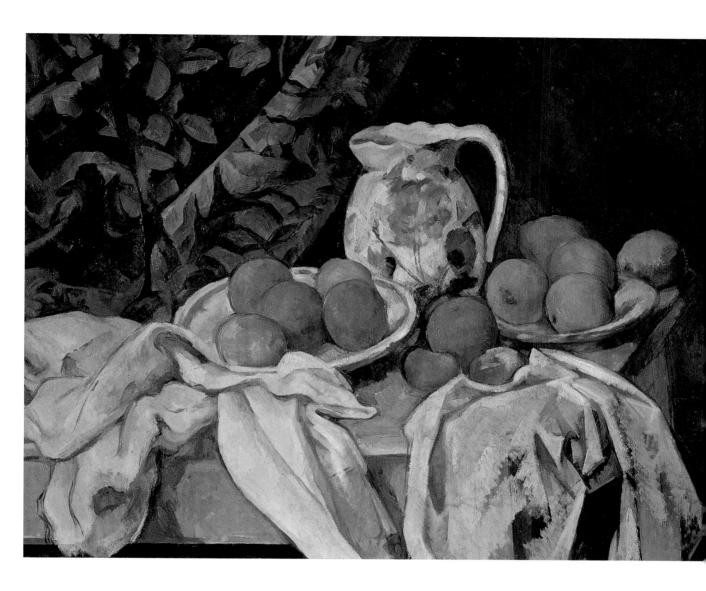

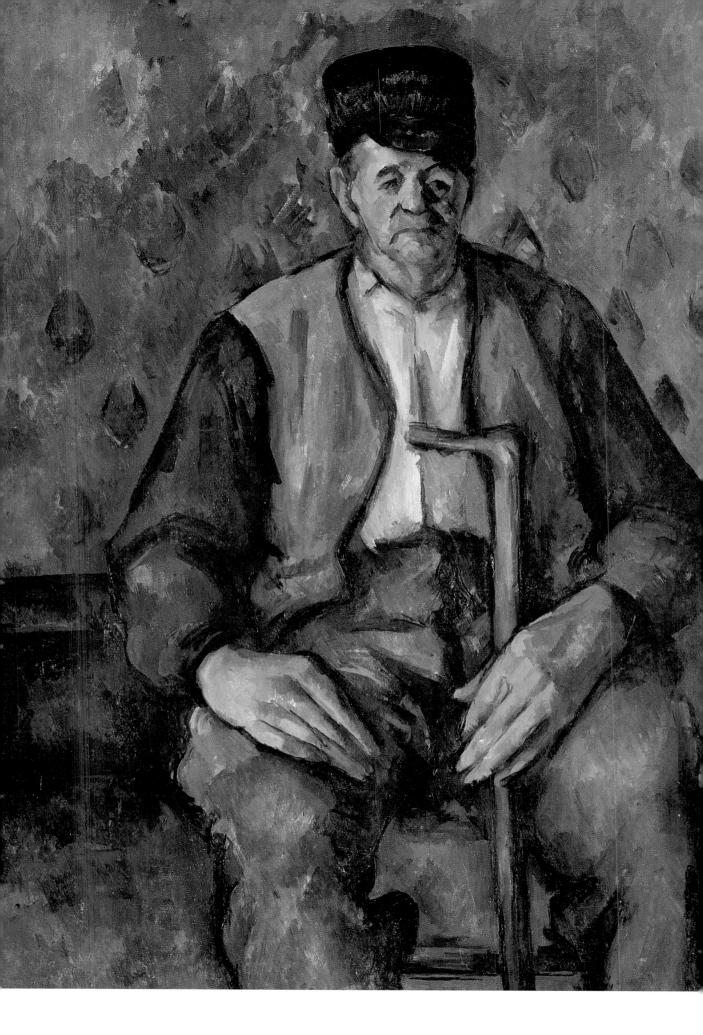

PAUL CÉZANNE Seated Peasant, c. 1900-04

Private Collection. Celimage.sa/Lessing Archive

HE sitter and the exact date of this portrait are unknown but the image is of such unabiding timelessness that it does not seem important. Cézanne creates a mountain of a man, centrally placed and looking forward. His head, arms, and hands create a diamond-shaped composition that is only interrupted by the cane. This is a reference to the frailty of old age but actually enhances the upright, formal posture of the elderly man, whose huge hands are reddened from decades of outdoor work.

The symmetrical, central placing confers a certain grandeur on the massive figure. This is further enhanced by the way in which Cézanne has locked him into the surroundings over which he presides —his top half haloed by the upright pattern of the wallpaper behind him, his arms and legs the same color as the baseboard and the floor. Although a spartan figure, he seems to be in his "Sunday best," an idea emphasized by the formal pose and the crisp, white shirt that draws our attention to the center of the canvas.

This figure brings to mind Cézanne's comment: "I love, above all things, the aspect of people who've grown old without changing their ways, abandoning themselves to the jaws of time."

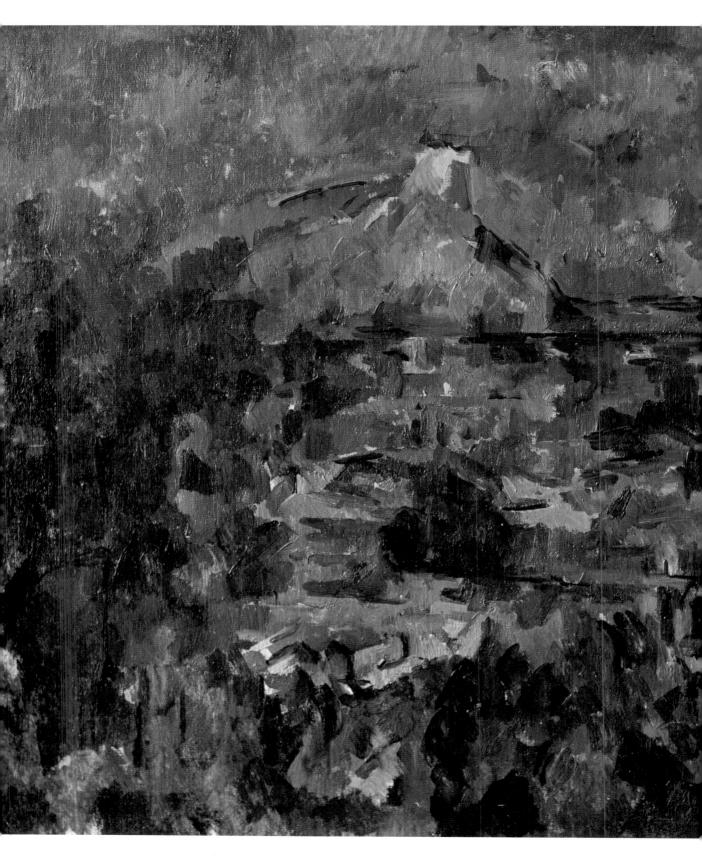

PAUL CÉZANNE Mont Sainte-Victoire, 1905

Kunstmuseum, Basel. Celimage.sa/Lessing Archive

HE years 1902–06 saw Cézanne embark on his concluding series of paintings of Mont Sainte-Victoire. There are 11 canvases and several watercolors. The size and angle of the view vary slightly, although they are all painted from the same place, east of the mountain, with the north-eastern plain below.

Mont Sainte-Victoire is a highly charged landscape painting. As with the majority of Cézanne's works in this series, the canvas is divided into three horizontal bands: the slope below with a cyprus tree on the left and other trees on the right; the golden patchwork plain running along the base of the mountain; and the majestic, blue band of sky, all separate yet united with each other.

The dramatic profile of the mountain and the heavy atmosphere of the sky is mirrored in the agitation and density of the brushstrokes in the foreground. The repeated green strokes in the foreground, coupled with the sharp diagonal from the right, create a sense of depth. The sky is a backdrop to the mountain but it comes forward over the landscape, lowering as if a storm is about to break. This effect is broken only slightly by a small light creeping over the top of the mountain in a cool lilac and pink shade.

Paul Cézanne Bathers, 1902-06

Private Collection. Celimage.sa/Lessing Archive

N the mid-1890s, Cézanne began work on a composition of female nudes beneath some trees. He had already painted male bathers in 1885 and 1890, but now, like Renoir, turned to this more Classical theme. Over the next ten years he executed, at the very least, 30 small sketches in addition to two or three larger canvases.

This large oil sketch is not a preparatory study and is regarded as a substantial work in its own right. Cézanne painted the figures from life drawings that he made at the Académie Suisse and from his memories of the Old Masters—considering it inappropriate for a man of his age to ask a young woman to pose naked for him.

Cézanne places 11 bathers, engulfed in a milky-blue haze, on the banks of a river or lake. Placed in three triangular formations, they almost fill the width of the canvas. The lake, the bank on the other side and the blue-drenched hills open out into the distance. Once again, he creates a cathedral-like setting with the strong diagonals of the trees and figures creating height and depth, converging on a patch of green light in the sky. The rounded, organic bodies, and the caring way in which each group seems to tend something, is suggestive of femininity.

This is one of Cézanne's last works. He died from pneumonia on 15 October 1906—a week after he collapsed unconscious during a thunderstorm when out painting *en plein air*.

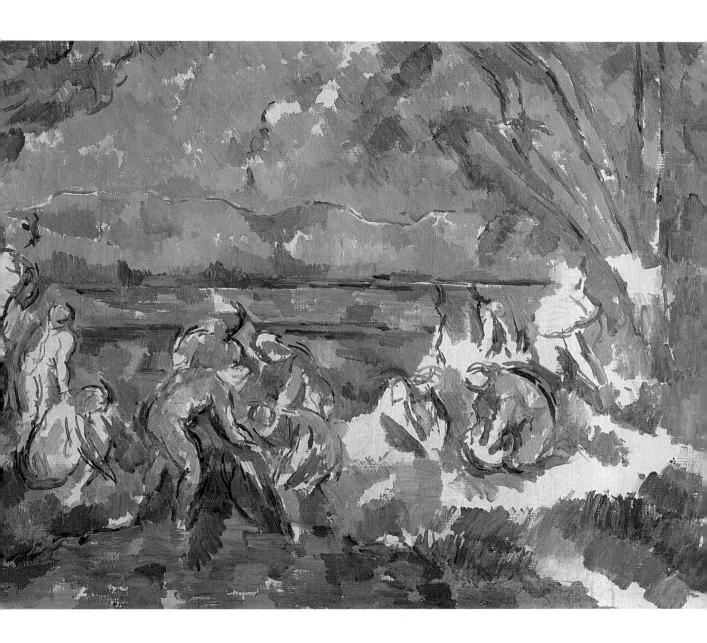

GEORGES SEURAT (1859–91) Bathing at Asnières, 1883–84

Tate Gallery, London. Celimage.sa/Lessing Archive

OUNGER than the Impressionists, Georges Seurat started to paint in about 1881. He was not an Impressionist but knew their work from their fourth independent exhibition in 1879. He exhibited with them in 1886, with the support of Pissarro. Seurat, like many of the younger generation of painters, learnt from Impressionism but eventually moved on to other fields of experimentation and endeavor. This is his first large-scale composition; it was rejected at the Salon of 1884.

Asnières was an industrial suburb of Paris, and this work takes up the Impressionist ideal of painting modern, suburban life in much the same way as Monet and Renoir had both painted La Grenouillère in the early 1870s. But *Bathing at Asnières* has a static, monumental quality created by the massive canvas, the solidity of the figures and the quality of the brushwork that bears little resemblance to the work of the Impressionists. The light, bright palette is that of the Impressionists but the brushwork is tighter and less disordered. Seurat, in his own way, is every bit as concerned with light as the Impressionists, although he is not interested in its fleeting qualities. In this painting, he moves toward a studied approach to the painting of light, based on the science of the light spectrum and the way in which colors are perceived by the eye.

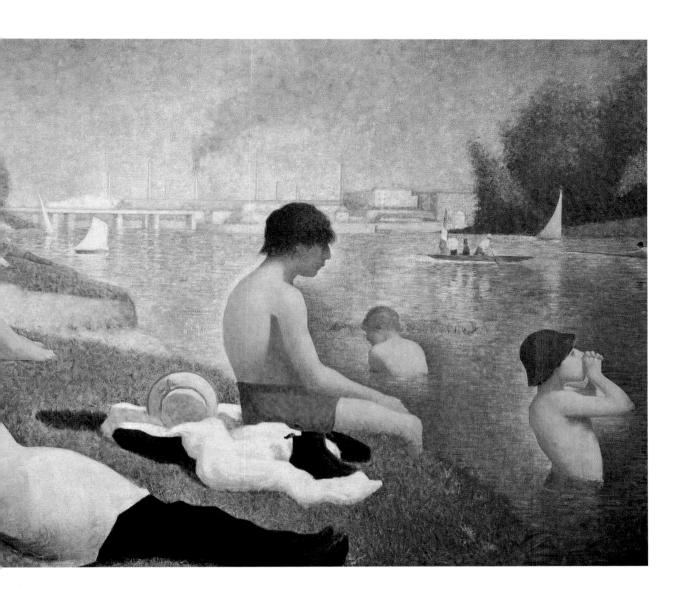

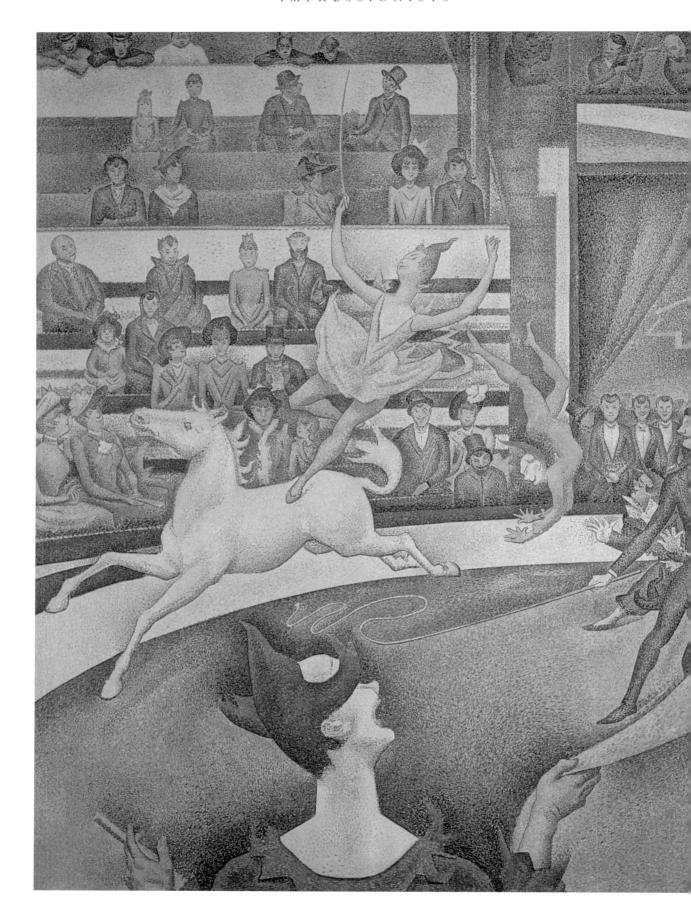

GEORGES SEURAT The Circus, 1891

Musée d'Orsay, Paris. Celimage.sa/Lessing Archive

HE innovation of Seurat's style can be clearly seen in this painting. He adopted a palette that used the pure colors of the spectrum, painting tiny dots on to a flat, colored background. The intention was that these colors should become mixed in the eye of the viewer. Hence, the yellows and blues placed together would seem to be green when the viewer stood at the right distance from the canvas. This technique became known as Pointillism and was also propagated by Paul Signac.

Seurat, who came from a wealthy background, was a highly intelligent, methodical man with reformist political views. He studied color theory as found in the work of Eugène Chevreul (1786–1889) and Charles Blanc (1813–82), which had so influenced the Impressionists, reinterpreting their findings in the light of *Modern Chromatics*, written by the American physicist Ogden Rood, which appeared in France in 1881. He sought to create an art that could be produced through the application of rules, free from messy or accidental improvization, using color and line in a prescribed form to create color and light effects as well as certain emotional responses. Cheerfulness, for example, "means a luminous dominant tone; in terms of color, a warm dominant tone; in terms of line, lines above the horizontal."

The Circus shows Seurat's pictorial science reproduced at an intense level, the extraordinary composition revealing his mastery of line. But, although it was exhibited in 1891, it was unfinished. Seurat died the same year.

AUTHOR BIOGRAPHIES AND ACKNOWLEDGMENTS

For my parents and grandmother, with love.

Antonia Cunningham gained her degree in History of Art from Cambridge University in 1988, where she wrote her dissertation on Degas. She has taught art history to high-school level students and is now a writer and editor of both adult and children's books.

Karen Hurrell is Canadian-born and educated, and is the author of several art books, including works on Monet, Renoir, Turner, and the Pre-Raphaelites. She lives in London with her two sons.

Additional and updated text by Image Select International, with special thanks to Joanna Nadine Roberts and Peter A. F. Goldberg.

While every endeavor has been made to ensure the accuracy of the reproduction of the images in this book, we would be grateful to receive any comments or suggestions for inclusion in future reprints.

With thanks to Image Select for sourcing the pictures in this book.